Character Animation in 3D

006.696

KOB

Focal Press Visual Effects and Animation

Debra Kaufman, Series Editor

A Guide to Computer Animation: for tv, games, multimedia and web
Marcia Kuperberg

Animation in the Home Digital Studio
Steven Subotnick

Character Animation in 3D: Use traditional drawing techniques to produce stunning CGI animation
Steve Roberts

Digital Compositing for Film and Video
Steve Wright

Essential CG Lighting Techniques
Darren Brooker

Producing Animation
Catherine Winder and Zahra Dowlatabadi

Producing Independent 2D Character Animation: Making & Selling a Short Film
Mark Simon

Stop Motion: Craft skills for model animation
Susannah Shaw

Character Animation in 3D

Use traditional drawing techniques to produce stunning CGI animation

Steve Roberts

AMSTERDAM • BOSTON • HEIDELBERG • LONDON • NEW YORK • OXFORD
PARIS • SAN DIEGO • SAN FRANCISCO • SINGAPORE • SYDNEY • TOKYO

Focal Press is an imprint of Elsevier

ELSEVIER

Focal
Press

Focal Press
An imprint of Elsevier
Linacre House, Jordan Hill, Oxford OX2 8DP
200 Wheeler Road, Burlington MA 01803

First published 2004

British Library Cataloguing in Publication Data
A catalogue record for this book is available from the British Library

Library of Congress Cataloguing in Publication Data
A catalogue record for this book is available from the Library of Congress

ISBN 0 240 51665 6

For information on all Focal Press publications visit our website at:
www.focalpress.com

Typeset by Charon Tec Pvt. Ltd, Chennai, India
Printed and bound in Great Britain

contents

preface

This book is the culmination of almost 10 years of teaching drawn animation techniques to 3D computer animators.

You may think, 'why on earth does a 3D computer animator need to learn how to do drawn animation?' The answer to this question is that the basics of animation are all the same and often you can get an idea of the movement far more quickly using pencil and paper. A computer can take a lot of the drudgery out of animating, but you can end up doing a piece of animation without quite understanding how it happened and whether it works or not.

One of the most valuable things I have learnt over the past 25 years of animating is to keep things simple!

The main value of an animation teacher is somebody who can cut to the chase and tell you the fundamental things that you need to know. You can then elaborate on top of this in your own way.

I have kept the examples and the animation exercises in this book as simple as possible, so that you are able to build a firm foundation of skills on which you can develop your animation further.

The form of the book is as follows. In each chapter I will go through the fundamentals of a given topic. Then there will be a drawn animation exercise to complete. Then and only then can an identical animation exercise be attempted using the software package of your choice.

The fundamentals, the drawn animation exercise and an overview of how to do the same exercise in 3D will be in the book. On the CD-ROM at the back of the book there will be specific .pdf files where you can follow how to do these exercises in 3D Studio Max, LightWave, Maya and SoftImage XSI. There are also 20 models on the CD-ROM, all fully rigged and ready for you to load onto your computer and to do the exercises.

Although this book is specifically about animation there is also a section of the CD-ROM that shows how to build each of these models in each specific program. Software developers are always improving their products, so for up-to-date models and exercises have a look at www.characteranimationin3d.com, the website that accompanies this book.

I have been in love with animation since the age of seven when my mother took me to see Disney's *Sleeping Beauty* at the cinema. Compared to the little Murphy black and white television we had at home I found the colours, the huge size of the screen and the wonderful sound almost overwhelming. I still always think of an animated film as something special.

I became obsessed with becoming an animator at the age of 10 when I saw a TV show called *The Do It Yourself Film Animation Show* presented by Bob Godfrey. If there is anybody to thank (or blame) for my being involved with animation it's Bob. It's wonderful to have worked with him and to be regarded by him as a friend. Other great inspirations to me have been Tex Avery and Chuck Jones. My favourite cartoon characters as a kid were Screwy Squirrel and Droopy (both Tex Avery creations) closely followed by Daffy Duck and Bugs Bunny (generally the incarnations of these characters in Chuck Jones's films).

The list of animators I'm in awe of is almost endless. John Lasseter, Joanna Quinn, Hayao Miyazaki, Nick Park, Brad Bird, Jan Svankmajer, … I could go on and on.

Hopefully this book will inspire you.

acknowledgements

Of course this book would not have been possible without the following people:

Dee Honeybun for going through my unintelligible notes and turning them into something worth reading.

Marie Hooper for commissioning the book in the first place and putting up with every missed deadline.

Christina Donaldson for all the stupid questions I've asked her and all the things she's had to do to put this book together.

Margaret Denley for putting up with so many different versions of this Acknowledgements page and all the little corrections.

Claudia Lester for being my 'best man' and persuading me that function curves are my friends.

Kevin Rowe for help with Maya and Acting.

Birgitta Hosea for making time for me.

Bob Godfrey for getting me into animation in the first place – I was bought his book *The Do It Yourself Film Animation Book* at the age of ten.

Paul Stone and Mal Hartley for being my animated best mates.

Central St Martins College of Art and Design for their support and the use of SoftImage XSI and Maya.

Cavendish College for their support and the use of 3d studio max 5.

Kent Braun for the use of DigiCel FlipBook 4.

Nick Manning and Karen Williams at Discreet for the loan of 3d studio max 4.5. Screen shots and models with permission of Discreet, a division of Autodesk Inc.

Marc Gaillard and Audrey Chambeaud at NewTek for the loan of LightWave 7.5 and permission to use screen shots and models from LightWave 7.5. LightWave 3D is a registered trademark of NewTek, Inc.

Many thanks to Ben Vost from NewTek, Europe for all of his help.

Jane Bryan for the use of Maya 4.5 and 5. Screen shots with permission of Alias Systems Ltd. Models created in Maya®.

Pierre Tousignant and Christine Charette for the loan of SoftImage XSI 2. Images courtesy of SoftImage Co. and Avid Technology, Inc. Models created in SoftImage XSI.

Vasco Carou for the wonderful footage of his horse Inato (a thoroughbred Lusitano).

All of the students I have ever taught animation to (more that 600!) – believe me, I've learnt as much from you as you have from me. (A very big thank you to all the students who replied to my inane email questions.)

All the people I've known, argued with, watched, listened too, agreed with, ignored and generally experienced that have made me the animator I am today.

My mum and Dad who had faith in me getting a job that involved scribbling all day.

But most of all Dee, Felix and Emily who haven't seen nearly as much of me as they should have done for the past three years but have loved me all the same.

chapter 1

introduction to 2D-animation working practice

During this chapter I will take you through two things – the equipment needed to make a basic animation studio and some simple animation. We will look at x-sheets and how they help timing, flipping, flicking and rolling, how to use a line tester and how to put the lessons learnt from your drawn exercises onto a 3D-computer program. By the end of the chapter you will have learnt how to organize yourself and how to plan a piece of animation.

I make no apologies for taking you right back to basics. Many of you may know much of this but bear with me – it is worth refreshing your knowledge and reinforcing the basic principles behind animation.

how animation works
the basics

2D drawn animation consists of a series of drawings shot one after another and played back to give the illusion of movement. This animation can be played back in a number of ways.

- In the form of a 'flipbook' (basically a pile of drawings in sequence, bound together and flipped with the thumb).
- The drawings could be shot on film one drawing at a time with a movie camera and played back using a cinema projector.
- They could be shot on a video camera and played back with a video player.
- They could be shot with a video camera attached to a computer and played back on the same computer using an animation program.
- Or they can be scanned into the computer and played back.

frames per second

Animation shot on film and projected is played at 24 frames per second.

Animation for television in Europe, Africa, the Middle East and Australia is played at 25 frames per second. In these countries they use a television system called PAL which plays at 50 fields (frames) per second and 25 frames per second is compatible with this. If we played an animated film at 24 frames per second on the television, we would see a black bar rolling up the screen. The Americas, the West Indies and the Pacific Rim countries use NTSC, which runs at 60 fields per second. This means you should be animating at 30 frames per second (60 is divisible by 30). Quite often some sort of digital converter is used to transfer one speed of film to another speed of video, allowing 24 frames per second film to be shown on a 60 fields per second (NTSC) TV. If you stop frame through a video of an animated film, you will find there are points at which one frame will blur into another. This is how they overcome the incompatibility of the two systems (stop framing through animated movies is a very good way of learning about animation). The most important thing to find out when animating something is at what speed the animation will be played back. All the animation taught in this book will be played back at 25 frames per second.

what you need for your studio

In order to complete all the drawn exercises in this book you will need the following things (all of which are available from the professional animation equipment suppliers listed at the back of this book):

- animation paper
- peg bar
- light box
- x-sheets
- line tester
- pencils

animation paper

When animating, you often find that you are working with four or more layers of paper. A level of translucency is necessary to see all the drawings. Professional animation paper is made with this in mind.

It also comes in different sizes. These are referred to as field sizes – 12 field and 15 field are the most popular; 15 field is 15 inches wide, 12 field being 12 inches wide (I'll explain this in more detail later in the chapter when I refer to field guides, the grid that measures field sizes).

Most professional animation paper comes with three punched holes. It is possible to buy this paper with no holes. (This is cheaper but you will need a specialist animation punch, which is very expensive). Used with a peg bar, the holes allow accurate placing of each piece of paper with the next. This is important, as the slightest movement in a drawing will show when the sequence is shot.

It is possible to use A4 paper with standard ring binder punched holes and a peg bar with two pins that fit the holes. This will work out far cheaper than professional animation paper.

peg bar

Professional peg bars are a strip of steel or plastic with three pins. These are industry standard and are used with professional animation paper. These are used to register each piece of animation paper against the next.

It is possible to buy two pin peg bars – these are often called junior peg bars.

It is equally possible to make your own using a strip of wood with two pieces of dowel that correspond to the holes in your paper, or even to tape two 5 mm countersunk bolts onto your

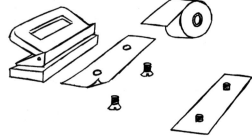

light box. These can then be used with ring binder punched A4 paper.

As with the paper, bear in mind that if you want to use your animation professionally, it is advisable to buy a three-pin peg bar.

light box

In its most basic form, a light box is a flat sheet of opal Perspex over a light. Professional light boxes use a rotating disc. They should also have the ability to change the angle of the drawing surface. This makes drawing easier both on the wrist and on the back.

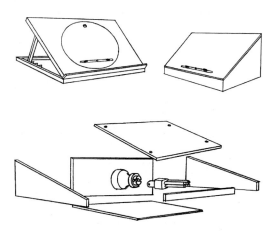

Simple light boxes are relatively straightforward to make. You could use a wooden storage box with the top part cut off at an angle with a neon bulb mounted inside. A piece of 6 mm opal Perspex is then fastened to the top with screws.

x-sheets

X-sheets are also referred to as dope sheets or exposure sheets. They are used by the animator to record all the necessary information relating to how the animation should be shot. A standard x-sheet consists of several columns that run from top to bottom and 100 rows that run from left to right. Each row represents one frame of animation. If the animation is to be played back at 25 frames per second, 100 frames will equal 4 seconds of animation.

The columns on an x-sheet mean the following things.

1. sound column

This contains the sounds that are relevant to the animation. Very often this is the dialogue spoken by the characters. For animation the dialogue is recorded first. It is then 'broken down'. This means that someone, usually an editor, will go through the sound track frame by frame. They work out where each word starts and ends and where each of the major vowel and consonant sounds are. These are then marked on the x-sheet in the sound column, frame by frame. You then know that at a certain frame in a scene a particular sound is made.

ANIMATOR;										
PRODUCTION;										
SCENE NO;		SEQUENCE NO;			LENGTH;				SHEET NO;	
NOTES;										

ACTION	SOUND	FRM NO	LEVELS;							CAMERA
			6	5	4	3	2	1	B.G.	
		1								
		2								
		3								
		4								
		5								
		6								
		7								
		8								
		9								
		10								
		11								
		12								
		13								
		14								
		15								
		16								
		17								
		18								
		19								
		20								
		21								
		22								
		23								
		24								
		25								
		26								
		27								
		28								
		29								
		30								
		31								
		32								
		33								
		34								
		35								
		36								
		37								
		38								
		39								
		40								
		41								
		42								
		43								
		44								
		45								
		46								
		47								
		48								
		49								
		50								

(This blank x-sheet can be photocopied or you can print up an x-sheet from the folder X-SHEETS in chapter001 of the CD-ROM.)

2. action column

This contains the instructions on when a given piece of animation will start and end. An experienced animator will fill out this part of the x-sheet before they start animating. Sometimes the director will fill this out. The process is often referred to as 'slugging out'.

ANIMATOR;

PRODUCTION;

SCENE NO; SEQUENCE NO; LENGTH; SHEET NO;

NOTES;

ACTION	SOUND	FRM NO	LEVELS;						B.G.	CAMERA
			6	5	4	3	2	1		
		1								
		2								
		3								
		4								
		5								
		6								

ANIMATOR; STEVE ROBERTS

PRODUCTION; BOUNCING BALL

SCENE NO; 3 SEQUENCE NO; 2 LENGTH; 3 SECS SHEET NO; 1

NOTES; BALL BOUNCES INTO SCREEN, HITS GROUND AND BOUNCES OUT!

ACTION	SOUND	FRM NO	LEVELS;						B.G.	CAMERA
			6	5	4	3	2	1		
		1						1	BG 1	
		2								12 FIELD CENTRE
		3						2		
		4								
		5						3		
		6								
		7						4		

3. the frame numbers column

As the heading suggests, this is where the number of each frame is inserted. One of the main ways of 'cheating' in drawn animation is to do your animation on 'twos'. This means that each of your drawings is shot for two frames. This saves a huge amount of work. For example, if you have to animate 4 seconds you only have to do 50 drawings, rather than 100 drawings if you did a drawing for each frame (assuming a rate of 25 frames per second). You will also find that at times you will want to 'hold' your animation. For example, at a given point in the action a character may move into a position where they stand still for a second or so. At this point you could just have one drawing 'held' for however many frames are needed.

There are two ways to number your drawings. The first way is to number them by the drawing. This means that drawing number one will be numbered 1, drawing number two will be numbered 2, etc. The other way is to number them by the frame. This means that the drawing on frame one will be numbered 1. The drawing on frame three (if the sequence is shot on twos, this would be the second drawing) will be numbered 3, the drawing on frame five would be numbered 5, etc. Each method has its advantages and disadvantages. It is

SOUND	FRM NO
H	1
E	2
L	3
L	4
O	5
O	6
/////	7
/////	8
H	9
O	10
O	11
W	12
/////	13
A	14
A	15
R	16
/////	17
Y	18
Y	19
O	20
O	21
/////	22
/////	23
/////	24
/////	25

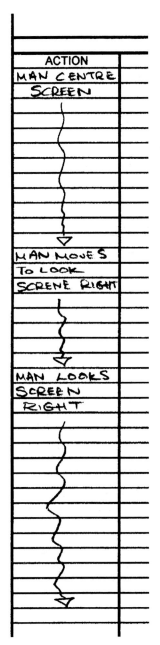

	LEVE
FRM NO	6
1	
2	
3	
4	
5	
6	
7	
8	
9	
10	

probably better for the aspiring computer animator to number drawings by the frame so that when you look at your drawings in order to copy their position with your computer model you know exactly what frame that pose should be on. All the exercises done in this book will be numbered by the frame.

The columns show the order in which the levels are placed. Background at the bottom level, foreground at the top with the character in the middle.

Numbered by the frame

Numbered by the drawing

Each drawing will have its own number. Each unit represents a frame. The drawing number is inserted to show where that frame of animation will be in the sequence. This varies depending on how many frames per second each drawing represents. The example shows a sequence that is shot on twos (i.e. each

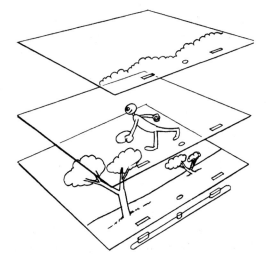

drawing is shot for two frames). When something is on twos the first row has a number and the second is left blank. It is unnecessary to fill in every frame, if at the end of a sequence the last drawing is held for 10 frames (i.e. the drawing is shot for 10 frames) a line should be drawn for the 9 frames after the written number. This is indicated by the line that runs from the bottom of the drawing number to the last frame that the drawing is held for. If the drawing is held for more than two frames, it is necessary to insert a line to show how long the drawing is held for.

4. the levels columns

When a sequence is animated, even if there is only one character, the drawing for one frame of animation may be on several levels of paper. If the body remains still during the sequence, but the head and arms are moving, there will be only one drawing of the body for the whole sequence. If the head is moving at a different rate to the arms, the head will be on a separate piece of paper and the arms on a further piece. If there is a background and the character is stood behind, for example a tree, this will again be on a separate piece of paper. However accurate the final drawings are, if you have to retrace exactly the same drawing 20 times or more, there will be variations between the drawings that will show when the animation is played. It also is an unnecessary use of time. Before the use of computers, the finished drawings were traced and coloured onto Cel (cellulose acetate or clear plastic sheets). This allowed for a maximum of six levels before the thickness of the cell made the colours on the lower levels look muddy. Today, each of these levels would be painted and assembled together with programs such as Soft|Image Toonz or Animo. This allows for infinite levels without any loss of quality.

LEVELS;								
10	6	5	4	3	2	1	B.G.	
					OL 1	A 1	BG-1	
						A 3		
						A 5		
						A 7		
						A 9		

5. the camera column

Information in this column instructs the camera how you want the scene to be shot and pinpoints the area within the artwork.

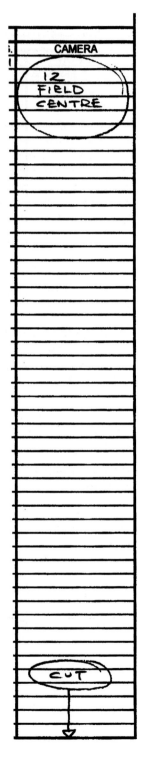

CAMERA

12 FIELD CENTRE

CUT

The most important piece of information is the field size. The most popular paper is 12 field, which means that the camera at its maximum setting will shoot an oblong area that is 12 inches wide.

Traditional 2D animators use a field guide, also called a graticule, to work out the position of the shot. For example, to shoot your animation using the full size of the paper it is marked on the top of the camera column as 12-field centre. As a 3D-computer animator, you won't be using field sizes. However it is worth understanding how they are worked out.

The field guide has North, South, East and West printed at the top, bottom, right and left. It consists of 24 columns and 24 rows in a grid. The columns are half an inch wide. By using these compass points and grid references you can specify any area on your paper that you want to be shot.

The illustration below shows an oblong area at the top right of the paper that is 5 inches wide. This would be 5 field at 7 east/7 north of 12-field centre. Using the field guide you work out where the centre of the oblong is in relation to 12-field centre (the centre of the field guide). To find the centre you would count along 7 lines east and 7 lines north from the centre of the field guide (12-field centre). See illustrations over page.

Using this method, you can place a field of any size in any area.

All exercises in this book are at 12-field centre (or if you are using A4 photocopy paper, 10 field at 2 south of 12-field centre).

line tester

A line tester is a device that captures your drawings and plays them back. It is a quick and easy way to see if the roughly drawn sequence works. There are a number of ways to set up a line tester. You could use a film camera, a video recorder that can record single frames or a line testing software program and a computer. The movie examples on the CD-ROM were produced using

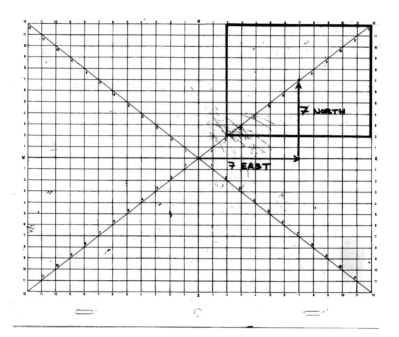

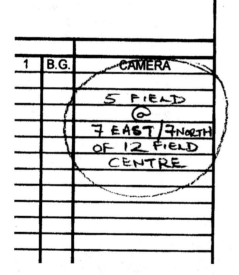

a program called 'Digicel Flipbook' (there is a demonstration copy on the CD-ROM with instructions). Other alternatives are available. I would suggest looking for a program that contains an x-sheet, as this is best for working out timing.

The simplest and cheapest way of setting up a line tester is to use a web-cam together with a computer and the line testing software. Set the camera to point down onto the table. The camera could be mounted on a tripod or even stuck to a steel rule that is then attached to the top of your computer. Stick your peg bar to the table, put a piece of your animation paper onto it and align it under the camera. The peg bar is important for the accurate placing of drawings. It is also possible to scan drawings into the computer using a flatbed scanner, but it takes an awful lot longer than using a camera.

Now would be a good time to load the demo copy of Digicel Flipbook onto your PC and familiarize yourself with its operation.

pencils

When doing drawn animation it's always best to work in rough with a Col-Erase blue pencil and then 'clean up' your drawings afterwards with a graphite pencil. This means you can define the correct lines of the character and add details in graphite pencil on top of the rough Col-Erase lines. Also, when you line test your animation the graphite line will show up more distinctly than the blue lines underneath.

An HB or B pencil is needed for the clean drawing whilst a coloured pencil is used for roughing out the animation. Sold under the trade name of Col-Erase, these are coloured pencils that can be easily erased and are great for drawing with. You can work rough with a graphite pencil but it can get very confusing when it comes to cleaning up the drawings.

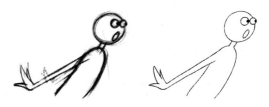

let's get animating

There are two ways to animate a sequence using traditional 2D animation. These are animating 'key to key' (also known as 'pose to pose') and 'straight ahead'.

key to key animation

'Key drawings', also referred to as 'keys', are important drawings that sum up the essence of the action during a scene.

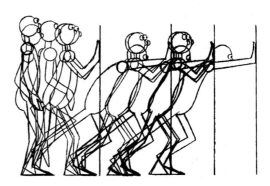

Key to key animation is when the 'key positions' or 'poses' in a sequence are drawn before completing the sections between them ('in-betweening'). I always like to think of the key positions as being the plot or a précis of a scene. They give a rough overall feel of the animation. The in-between drawings ('in-betweens') provide the characterization or detail.

Animating key to key allows for a large degree of control over your animation. It can prevent the character or object from changing size or distorting where you don't want it. It also means you have control over the timing of your animation and can more easily predict what action will happen when and where. By line testing the keys you can see the basic movement of a sequence before completing the full animation.

In the end all the frames of your animation are important and if you put too much emphasis on the key positions the animation can look clunky and stiff.

Below is an example of key to key animation.

A man sits at a table with a glass of liquid on it. He picks up the glass and drinks from it.

- Key number 1 – He looks at the glass.
- Key number 2 – He grasps the glass in his hand.
- Key number 3 – He raises the glass to his lips.
- Key number 4 – He tips the contents of the glass into his mouth.

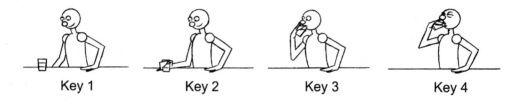

Key 1 Key 2 Key 3 Key 4

How many in-betweens and where they are positioned (the timing) depends upon the character and the mood of the man.

If he was thirsty, he would quickly grab the glass (only a few in-between drawings and spaced far apart) pull the glass up swiftly to his lips (maybe spilling some liquid), pulling back his head and tipping it straight down his throat.

To create the illusion of speed you have less in-betweens with larger gaps between each drawing.

If he was an alcoholic he may pick up the glass carefully to avoid spilling any liquid (a lot of in-between drawings, positioned closely together). Just before the glass reaches his lips he might dip his head, so as to avoid spilling any liquid in case his arm fails. He would then drink long and slowly.

To show slower movements there are more in-betweens and smaller gaps between the drawings.

If the man were hesitant about drinking the liquid, he may pull his hand back just before grasping the glass and, holding it with the tips of his fingers, bring it slowly and delicately to his lips so he could take a small sip.

animating straight ahead

This is when images in the sequence are drawn directly one after the other. It can produce a more vibrant form of animation with more energy and exuberance. Unfortunately there is far less control with straight-ahead animation and distortion and changes in size are more likely. It is also more difficult to work out the timing because you can only check the animation with a line tester when it is all done and then it may be wrong and you have to throw away a lot of drawings and redo it.

flipping, flicking and rolling

There are three skills that are invaluable when animating with pencils and paper. These are flipping, flicking and rolling. These allow you to see the drawings moving while you are animating. To practise these skills, we are going to animate a ball bouncing into the screen, hitting the ground and then bouncing out of the screen. Each of these bounces describes an arc, which is referred to as a parabola.

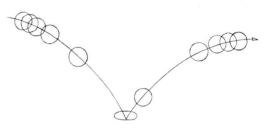

This is a good example of timing in animation. To create the dynamics of the movement of the ball, the drawings are spaced at different intervals. As the ball bounces, it accelerates towards the ground in an arc, pulled by the force of gravity. At the fastest point the drawings are furthest apart. At the highest point of the bounce (the apex) the ball is travelling more slowly. Here the drawings are closer together. To create acceleration as the ball falls to the ground, the drawings of the ball are placed further and further apart. As the ball hits the ground, it squashes down, absorbing the energy of the fall. It then un-squashes and accelerates into the next bounce, slowing down as it reaches the apex of this next bounce.

This principle of animation timing is relevant to all animation. The closer the drawings are together, the slower the movement, the further apart they are then the quicker the movement.

flipping

Grab an old exercise book, sketchbook or block of Post-It notes. With these we are going to make a flipbook. We are going to use this flipbook to bounce a ball across the page using straight-ahead animation.

With the spine furthest away from you, lift the pages until the bottom page is facing you. Draw the ball in the top left-hand corner of the bottom page of your flipbook. Following the illustration draw one ball on each subsequent page. When the ball hits the ground remember to squash it so that it is almost flat. As it leaves the ground, stretch the ball along the arc it is following.

When you have completed the sequence, hold the flipbook at the spine with your right hand, place your left thumb at the bottom of the flipbook, with the left-hand index and forefinger at

the top page of the flipbook. Bend the flipbook up towards you with your left hand and allow the pages of the flipbook to slide away from your thumb. All being well you should see your ball fall in an arc from the top left of the page to the centre bottom of the page where it squashes and bounces up to the top right of the page (open flipbook.avi in chapter001 of the CD-ROM for a demonstration of how to do this).

You have just created a piece of straight-ahead animation, i.e. where images are drawn one after the other.

This exercise should have given you an idea about timing and spacing. Try experimenting with the distance between one ball and the next (e.g. if the balls are very close together they will move slowly and appear to float).

Flipping is a good way to see how your animation is working when you are using animation paper. Arrange your drawings with the first drawing of the sequence at the bottom of the pile and the last drawing at the top. This is called the flipping order. Hold up your drawings with your right hand at the top of the pile and your left hand at the bottom. As with the flipbook, pull the drawings towards you and let the drawings slide off your left-hand thumb one at a time as they fall flat. If this is too awkward (your pile of drawings is too thin), try putting some blank pages on top of these drawings to make the pile thicker (open up flipping.avi in movies001, chapter001 of the CD-ROM).

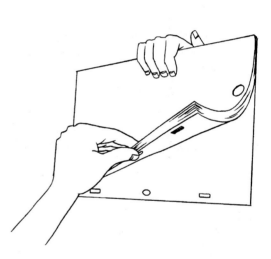

flicking

Flicking is a technique used to look at your animation while you are sitting at your light box. When mastered it means you can see how your animation is moving and you can adjust your animation accordingly by re-drawing.

For this next exercise we will use our punched paper, the peg bar and light box. Put your light box on the table in front of you in a comfortable position.

Always animate with the peg bar at the bottom of your piece of paper. It's much more difficult to flip and flick with the peg bar at the top.

We are going to animate a piece of key to key animation using the same sequence as for the flipping exercise. We will be numbering these drawings by the frame and each drawing will be shot for two frames (twos).

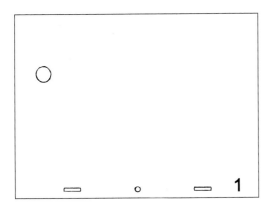

Place your first sheet of paper onto the peg bar. At the bottom right-hand corner of the paper, label this drawing no.1. This is our first key drawing.

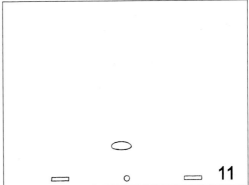

Place a second sheet on top, using the peg bar to register it. Draw a squashed ball and label it drawing no.11. This is our second key drawing.

Lastly place a third sheet over the previous two and draw a ball at the top right-hand corner and label this drawing no.21. This is our third and final key drawing.

Remove drawing no.21. We will in-between drawings no.1 to no.11. This means we will draw the drawings that go between no.1 and no.11.

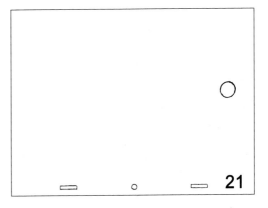

The first in-between we draw will be no.9. This is half way between no.1 and no.11. This may seem rather odd, but it will help give the impression of the ball speeding up as it hits the ground. If we look at the timing chart, we see that, because the ball was at its slowest on the apex, there are more drawings closer together at this point. As the ball falls out of the sky the drawings get further and further apart. This is why the drawing half way between no.1 and no.11, is drawing no.9.

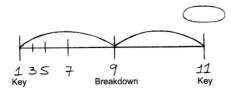

The first drawing you do as an in-between is often referred to as a 'breakdown' drawing. This is the major in-between.

Timing charts (also known as breakdown guides, in-betweening guides or telegraph poles) are used to show where the in-between images should be drawn. They are generally placed at the bottom of the key drawing and should relate to the drawings between that key and the next. They consist of a horizontal line with a vertical line at each end representing the key drawings. The breakdown (major in-between) drawings are indicated by a vertical line with a couple of arcs between it and the key drawings. The remaining in-between drawings are represented by shorter vertical marks.

This illustration shows the breakdown guide for drawings no.1 to no.11.

Drawing no.7 is half way between no.1 and no.9, drawing no.5 is half way between no.1 and no.7 and drawing no.3 is half way between drawing no.1 and drawing no.5.

When we in-between our sequence, we need to 'flick' our drawings. Place drawing no.11 over drawing no.1 and a clean sheet over these. Label it drawing no.9. Hold

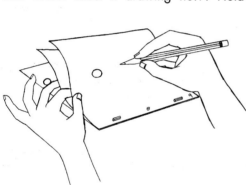

drawing no.9 with your left thumb and fore-finger. Slip your index finger underneath drawing no.11. Leave drawing no.1 flat on the light box.

Now draw the ball on drawing no.9. Remember the ball is moving through an arc and that it should be half way between the balls on drawings no.1 and no.11.

In order to see how the ball is moving, fold back drawings no.11 and no.9 towards you

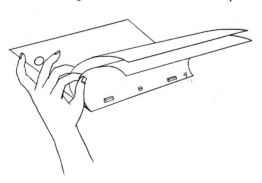

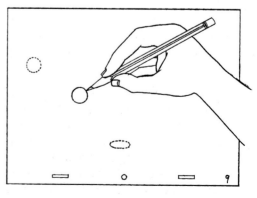

(while still attached to the peg bar) and look at drawing no.1.

Fold drawings no.11 and no.9 flat against the light box and look at drawing no.9.

Then fold drawing no.9 up towards you and look at drawing no.11.

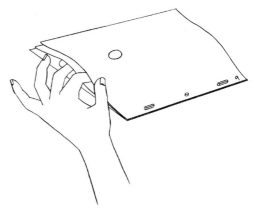

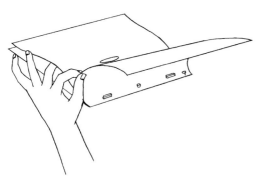

When this is done in quick succession the ball will move along the arc. You are now flicking. Sometimes it helps to put a rubber band over the pins on the peg bar to stop the paper slipping off. If the ball in drawing no.9 doesn't appear to be in the correct position, rub it out and re-draw it. Keep flicking and drawing until it looks right. (See flicking.avi in movies001, chapter001 of the CD-ROM.)

Repeat the in-betweening process for drawing no.7 (between drawing no.1 and no.9), drawing no.5 (between drawing no.1 and no.7) and drawing no.3 (between drawing no.1 and no.5). Once you've drawn all these you can have a go at rolling.

rolling

Place the first five drawings of the sequence onto the peg bar with drawing no.1 at the bottom and no.9 at the top. Interleave each of these drawings between the fingers of your left hand. You can only ever roll with five drawings.

Fold all the drawings towards you and look at drawing no.1. By moving your little finger forward allow drawing no.3 to fall flat over drawing no.1 and look at this. See top illustration on p. 18.

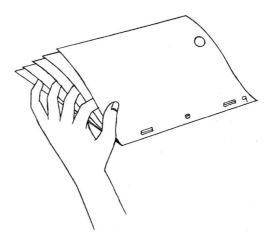

Let drawing no.5 fall flat over drawing no.3. Look at this. Let drawing no.7 fall flat over drawing no.5. Look at this. Finally allow drawing no.9 to fall flat onto drawing no.7 and look at this. Bring your hand back and repeat the process. Make sure your fingers stay interleaved with the paper at all times. When this is done in quick succession, you will see the ball falling from the top left of the

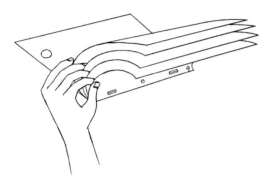

page and hitting the ground, accelerating as it falls. You are now rolling (see rolling.avi in movies001, chapter001 of the CD-ROM).

Complete the exercise by in-betweening drawings no.11 through to no.21.

This is the timing chart for drawing no.11, showing how you should in-between the drawings between drawing no.11 and no.21.

The X in the chart shows that the distance has been divided into three. The first in-between you will do is drawing no.15. This is the breakdown drawing. It is one-third closer to no.21 and two-thirds further away from no.11. (The X is there to show the relative position of drawing no.15.) The next drawing to do is no.17. This is half way between no.15 and no.21. Then do drawing no.19. This is half way between no.17 and no.21.

There is no drawing at the position X. The next drawing to do is no.13. This is half way between X and no.11. By using this spacing,

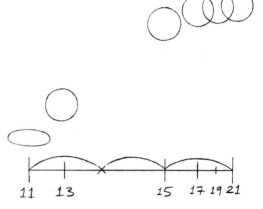

the ball will accelerate from drawing no.9 and decelerate as it reaches no.17. Make sure the ball follows the arc through the sequence. When you have completed all the drawings have a go at flipping them. Pick up all the drawings you've animated with the first number at the bottom and the last at the top. Hold them up with the right hand and flip with the left.

Finally shoot the sequence with the line tester to see accurately how the animation moves. Each drawing should be shot for two frames each. If you haven't worked out how to use a line tester yet, never fear! I'm going to take you through how to use one in the next section (see ball_bounce.avi in animations001, chapter001 of the CD-ROM).

how to use a line tester to help your animation

In the last exercise we looked at the timing for a ball bouncing across the screen. Learning the timing for the key positions is one of the hardest things in animation to do. Using a line tester enables you to see how the timing is working and will hopefully help you to learn timing skills more quickly.

For the next exercise we will make a ball drop into screen, fall straight to the ground and bounce a few times before coming to a halt.

The first thing to do is to animate and shoot the key drawings on the line tester. The resulting movie is called a pose test or a key test. The number of frames that each of the key drawings

is played back for can be adjusted on the x-sheet part of the program. When this is working satisfactorily, the drawing numbers are marked onto a paper x-sheet and from this the timing for the in-between drawings are worked out. Work out timing charts for where the in-betweens will go. Do the in-betweens and finally the entire sequence is shot on the line tester.

how this book works

Every exercise in this book will follow the basic format below. Animate the exercise in 2D and then use the drawings as a guide to how the animation will move in 3D. Computer program specific .pdf notes will be found on the CD-ROM.

exercises
ball bouncing

Draw the following key positions onto each subsequent piece of paper and number them as shown.

Open up DigiCel Flipbook on your computer. Click Create New Scene. Specify a Frame Rate of 25. # of frames = 44. # of levels = 2. Click the radio button for PAL (768 × 576). Then click OK.

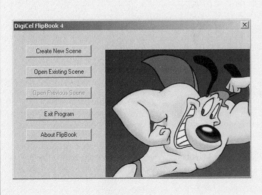
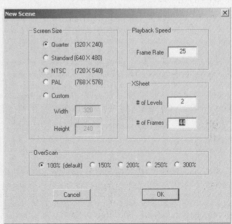

If you are going to be using a video camera, click on the Capture icon. Hopefully up will come a live screen of what your camera is seeing and a Video Capture toolbar.

We need to play the key drawings back at roughly the same speed and length as the finished sequence. (Remember that we have yet to do all the in-betweens for this piece of animation.) We do this by 'holding' each of the key drawings for the estimated number of frames between each of the keys. The line test helps us to work out the number of frames needed. We need to see this sequence as a series of keys that demonstrate the main positions for the correct timing. In DigiCel Flipbook you can specify how many frames each key drawing is captured for (the Hold box on the Video Capture toolbar) and you can also adjust the amount of frames the drawing is held for on the x-sheet part of the program.

We now need to capture your key drawings. For this exercise we will start by capturing each drawing for 1 frame each.

On the Video Capture tool bar set the Frame box to 1 and set the Hold box to 1. This means that when they are captured your drawings will be numbered the same as above. These are referred to as the key numbers. Set the Level box to 1.

Place key drawing no.1 under the camera and when it is positioned correctly on the peg bar, left click on the Capture button. Place key drawing no.2 under the camera and press the Capture button. Repeat this process for all eight key drawings. When you have captured all your keys, press the Quit button. Now press the Play Forward button at the bottom of the DigiCel FlipBook window. It's running a bit fast isn't it? That's because it's running on 'singles'. This means that each drawing is being played back for one frame. The way to correct the timing and slow it down is to make each of the key drawings 'hold' for longer than one frame. To do this we need to drag each of the key drawings down the dope sheet for the appropriate number of frames.

If you look at the XSheet panel you will see that the drawings are called 1–1 to 1–8. This is because they are on the Back Ground level.

In the XSheet window left click onto 1–2. Left click on it again whilst holding down the Alt key on your keyboard and drag it down the XSheet until 1–2 is next to the frame number 9 on the XSheet window.

This means that key no.1 (1–1 on the XSheet window) is now held for 8 frames. This means that when it is played back your audience will see it for 8 frames.

Click on 1–3 and (while holding the Alt key) drag that down to frame 17. This means that key no.2 (1–2) is held for 8 frames.

Drag 1–4 down to frame 23. Drag 1–5 down to frame 29, 1–6 down to frame 33, 1–7 down to frame 37 and finally drag 1–8 down to frame 41.

When you have adjusted the XSheet, press the Play Forward button on the main screen. How does your animation look?
(You can compare your key sequence with the ball_drop_keys.avi in animations001, chapter001 of the CD-ROM.)

It will be jerky, but at this stage that doesn't matter. The important thing is to work out the timing. You have to imagine what it would look like when it has all the in-between drawings included. This is a skill that comes with experience. The more you animate and look at pose tests, the more adept you become at working out the correct timing.

If any of your key drawings appear to be playing for too long or too short a period, 'hold' them for less or more frames. With Digicel Flipbook, highlight it on the XSheet by left clicking on the image that you want to change the frame value of. Then click on it a second time and hold the mouse button down, while holding down the Alt key on the keyboard. Drag the column up or down depending on whether you want to lengthen or shorten the amount of frames.

When you are happy with the result, mark the key positions onto a paper x-sheet (photocopy up the one I put in the book earlier or print the x-sheets found in the folder X-SHEETS in chapter001 of the CD-ROM). Use the far-left level column and use a pencil (these keys are marked here for temporary reference). If key drawing 1 starts on frame 1 of the digicel XSheet, mark it into frame one of the paper x-sheet. If key drawing 2 starts on frame 9 of the digicel XSheet mark it onto frame 9 of the paper x-sheet and so on. If the animation is on twos we need to know where these will be during the sequence. In the far right level column mark in the correct drawing numbers, i.e. drawing 1 on frame 1, drawing 3 on frame 3, etc. See illustration on p. 22.

You can now re-number your key drawings by the frame number they correspond to. Key drawing 2 corresponds with frame 9 so we re-number it drawing no.9! Key 3 is drawing 17, key 4 is drawing 23, key 5 is drawing 29, key 6 is drawing 33, key 7 is drawing 37 and key 8 is drawing 41. Draw a ring around each of the key drawing frame numbers (see top illustration on p. 23). Erase the key numbers in the far-left level column. Re-number your key animation drawings as per the frame number.

The next stage is to work out the in-between drawings and place a timing chart at the bottom of each key. Remember that to show a gain in speed as the ball is dropped, the drawings will be further and further apart.

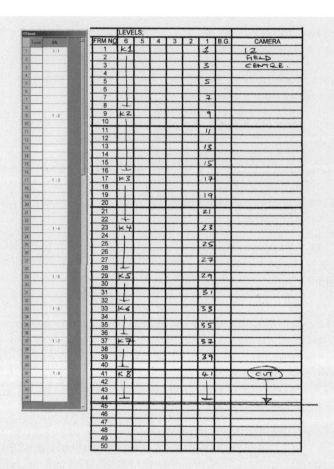

The bottom illustration on p. 23 shows the timing charts for all the keys and the correct numbering. As the ball bounces up, it will accelerate to the optimum speed and then start to slow as gravity takes over, and it reaches the apex of the bounce. As the ball hits the ground for the second time, the squash will be slightly less (it will have fallen from a lower height). This pattern is repeated for the remaining bounces. Each bounce will be lower and lower until the ball comes to a stop.

Complete the in-between drawings for the sequence by following the timing charts and then line test it (shoot each drawing for two frames each).

You may have or may want to work out your own timing for the sequence. The finished piece of animation should be similar to the balldrop.avi in animations001, chapter001 of the CD-ROM.

how to relate your 2D animation to your 3D animation

There are specific .pdf files called Maya_info, XSI_info, 3DSMax_info and LightWave_info in the file, chapter001 of the CD-ROM. These show the basics of each of these programs.

It might be a good idea to print them up and stick them on the wall by your computer. (You could copy them onto any Personal organizer that will display .pdf files, I have them all on my Psion organizer!) Take a look at the .pdf file that relates to your program and then have a go at the following exercise.

overview of the 'ball drop' exercise in 3D

(In order to do this exercise have a look at 3DSMax_balldrop.pdf, LightWave_balldrop.pdf, Maya_balldrop.pdf or XSI_balldrop.pdf to find out how to do this in more detail.)

Open up your 3D-computer program and take out the 'balldrop' animation drawings and the related x-sheet (or have a look at the illustration below). Create a ball. Make sure that the Timeslider or Frameslider is at the first frame and move the ball to a position similar to drawing no.1 of your 2D animation. Set a key position.

Move the Timeslider/Frameslider to frame 9 and position the ball as in drawing number 9 (the second key position).

FRM NO	6	5	4	3	2	1	B.G.	CAMERA
				LEVELS;				
1						①		1 2
2								FIELD
3						3		CENTRE
4								
5						5		
6								
7						7		
8								
9						⑨		
10								
11						11		
12								
13						13		
14								
15						15		
16								
17						⑰		
18								
19						19		
20								
21						21		
22								
23						㉓		
24								
25						25		
26								
27						27		
28								
29						㉙		
30								
31						31		
32								
33						㉝		
34								
35						35		
36								
37						㊲		
38								
39						39		
40								
41						㊵		CUT
42								
43								
44								
45								
46								
47								
48								
49								
50								

Copy each of the key positions from your animation onto the computer in this way and setting a key at the key positions of your drawn animation.

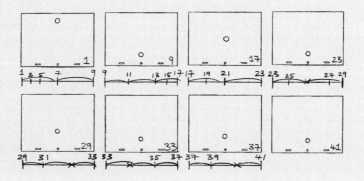

Play back your animation (or have a look at ball_drop_keys_3D.avi in animations001, chapter001 of the CD-ROM). It will look odd because of the way the program in-betweens the key positions. It does this by accelerating out of one key and decelerating into the next. In order to adjust this we

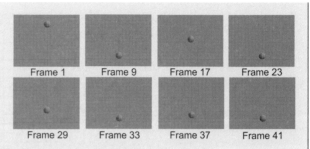

Frame 1	Frame 9	Frame 17	Frame 23
Frame 29	Frame 33	Frame 37	Frame 41

need to manipulate the Curves (called either Animation Curves or Function Curves) that relate to the animation of the ball. In all 3D-computer animation programs the movement is broken down into a graph-like mathematical interpretation. If you take the up and down movement of the ball as the vertical value and the time it takes to do it as the horizontal value, you will end up with a series of points on the graph where you have

set your key frames. The computer program will join these points together to produce a curve and this will provide the in-between movement of your object. The default type of line linking the curves is called a 'Spline'. You can change the way the computer in-betweens your key positions by adjusting these curves.

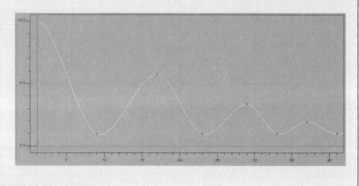

There are a number of different options. 'Linear' is a straight line between each key. A 'stepped' or 'constant' line continues at the same value as the first key, before jumping to the value of the next key.

The key points can also be given 'handles' making it possible to adjust the angle of the curve (curves with handles can be called 'bezier splines').

For our bouncy ball we need to 'break' the curve at the key position where the ball hits the ground. This means we need to make the curve ascend and descend between the keys in a nice parabola. From here we need to have a second parabola for the second bounce, a third parabola for the third bounce and so on.

Take a look at ball_drop_3D.avi in animations001, chapter001 of the CD-ROM. The ball is now bouncing more like a ball should!

Of course I don't expect you to always work this way, but while you are learning to animate it will help you pick up timing all the quicker. By the end of the book you will only need to work out the basic key positions in 2D (in a very rough form) before animating in 3D.

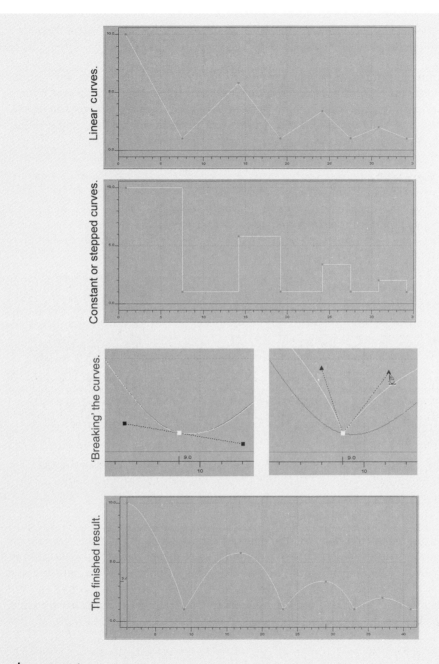

drawing!

A good animator (whether 2D or 3D) should be able to sketch out a pose for a key frame of animation in a simple concise form. You don't have to be brilliant at drawing. However, drawing is the best way there is to interpret the world around you. So draw as

much as possible. Drawing something means you observe it for a relatively long period of time, helping you to understand the way it moves.

Attend life drawing classes and focus on short poses (less than 10 minutes). If the model is going to pose for an hour or two, draw them from one angle for a short period of time and then move around the room and draw them from another angle. The reason for this is that it teaches you to capture the essence of a pose with a few simple lines. Concentrate on getting the structure, weight and balance correct.

Go to zoos and sketch the animals. You'll have to draw quickly in order to capture an animal on the move! This will be far more informative than drawing from books or from the TV.

Sit at street cafés or in parks and draw the people around you. This is a great way to find out about human nature. How do people talk to each other, how do they walk, sit, run and play?

The most important thing about drawing is that it makes you sit down and look at the world around you in detail. Things that you would not normally notice, the way people pick things up, the faces they pull or the body language that they adopt become more apparent to you. A sketchbook is valuable reference material for your animation.

chapter 2

matter and the animation of inanimate objects

If you can cast your mind back to your first ever physics lesson, you were probably told that the world is divided into three states of matter: solid, liquid and gas. At some point you are going to animate all three of these. Just to make life difficult there are also energy sources you'll need to animate: electricity, fire and explosions. The animation of liquids, gases, electricity, fire and explosions are the preserve of the special effects animator and although I will touch on them in this book, they are not really in its remit. However, an understanding of the movement of solid inanimate objects is vital to the understanding of character animation and that's primarily what this chapter is about.

One thing that will always help your animation is to study real life. We are going to be spending most of this chapter looking at how balls bounce. Almost anything we need to know about the movement of matter can be condensed down to its most basic form with the movement of bouncing balls. So get some balls and start bouncing them!

This chapter is also about familiarizing yourself with the 3D program you are using. I've gone into a lot of detail with how to use your chosen program!

inanimate objects

My definition of an inanimate object is any object that does not display 'life': these fall into two categories. The first are objects that do not move by themselves; they have to be dropped, pushed, pulled or propelled by an individual. The second are inanimate objects that are able to move. Cars, motorbikes, ships, aircraft, machines, engines, etc. I would still describe these things as inanimate objects because they are not alive, they show no character or emotion.

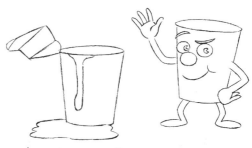

In animation there are many examples of previously inanimate objects that do display life. Cars, gas boilers, yoghurt pots, toilet cleaners, gherkins, etc., have all been given the breath of life by sticking on a couple of eyes, a mouth, some arms and some legs and animating them displaying emotions. These have all ceased to be inanimate objects.

When animating any inanimate object we have to take the following things into consideration.

weight

How heavy is the object? A bowling ball will fall differently to a balloon.

environment

A plank of wood on land may be very heavy but the same plank of wood floating in water

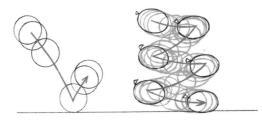

will appear to be much lighter. Another consideration is interaction with other objects, for example, a person bowling a bowling ball. The ball rolls along gathering momentum before coming into contact with the skittles. As it hits the skittles, the force from the bowling ball is transferred into the skittles causing them to fall over or leave the ground whilst the ball itself loses energy and therefore slows.

solidity

How solid is your object? A brick when dropped will not display any squash and stretch as it hits the ground – if anything bits may fall off it with the impact. It has no inherent elasticity. A rubber ball will. Rubber has a lot of give. The force of the impact will cause the ball

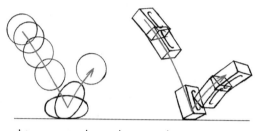

to squash down as it hits the ground before stretching as it rebounds into a bounce.

force

What type of force is being applied to the object? A shot putter throwing a heavy ball will cause the ball to move in a different way to a cannon firing it!

construction

How is your inanimate object constructed? A balloon full of water will move differently from a solid box full of water. A feather will float down whereas a bowing ball will fall with great speed straight to the ground.

how to animate inanimate objects

It's always best to base your animation on real life. Even the most cartoon like animation will have one foot in reality to make it believable. If your animation involves dropping a bowling ball, find a bowling ball and drop it. This way you can observe the motion! Bear in mind that to make the action more convincing for your audience, you will have to exaggerate the way the ball moves. All animation can be thought of as a performance, in the same way that an actor will produce a performance that is an exaggerated version of real life. If you make the animation too 'realistic' it can often look stiff or insignificant. Exaggerating the movement can make a piece of animation more convincing.

A good example of this can be seen in many live action films that feature explosions. The explosion will usually be shown in slow motion. This emphasizes the power and force of the explosion drawing your attention to the smoke and debris flying through the air.

Think of all animation as being an exaggerated ideal of real life.

the animation of solids

a bowling ball

A bowling ball being dropped (this is a good example of a heavy object).

Once dropped, the bowling ball will accelerate rapidly to its optimum speed (deriving its energy from gravitational pull). It will then bounce (with no squash and stretch) as it hits the ground (unless it smashes straight through the floor, when it will keep going). The optimum speed is reached just before the ball hits the ground. As the ball is a solid object and is rigid, when it hits the ground it displays no squash and stretch. The weight of the ball combined with its rigidity means that the curve or angle of the bounce will be steep. As it accelerates away from the ground and decelerates into the apex, the movement will be short and quick before accelerating back towards the ground as gravitational pull takes over. This could be repeated a couple of times. The apex of the bounce will become lower each time. Each bounce will become increasingly closer together, whilst the curve of the bounce remains quite sharp.

animating this sequence

You start with a still picture of the ball being held. When the ball is dropped the time elapsed between each drawing rapidly increases until you reach optimum speed at which point the drawings will be an equal distance apart. This means that each subsequent ball will be further and further apart on the drawings.

When it hits the ground it will bounce. The reason it bounces is that when the ball hits the ground the energy contained within the ball has nowhere to go but back up, lifting the ball into a bounce. The ground absorbs a small amount of energy, which gives each bounce less power. The height of the first bounce will be lower than the height from which the ball was initially dropped. As more energy is absorbed by the ground, each successive bounce will be lower than the last.

Ball drops... ...bounces once... ...twice... ...three times... ...and stops.

If you were to propel a bowling ball, the acceleration would be slow as you transfer energy from your hand to the ball. It's as if the ball is reluctant to take on the energy. You need to give it a very hard shove to get it going. The ball will be at its optimum speed as you stop pushing. Once it gets going the weight of the ball combined with the energy from the push gives it the momentum to keep it travelling and it will decelerate very slowly before stopping.

animating this sequence

The first drawings of the hand propelling the bowling ball are close together, giving the initial thrust of speed. The time spacing between the drawings then increases gradually until

the optimum speed is reached (the point at which the hand stops pushing the ball). The drawings gradually get closer and closer to each other as the speed of the ball slowly decreases and it comes to a graceful stop. It has to be remembered that a lot of energy has been passed to the ball to get it rolling. It has a large amount of momentum. So it will take a lot of force (or a very strong object) to stop it prematurely.

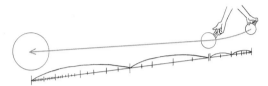

a soccer ball

A soccer ball when dropped will accelerate at a slightly slower pace than a bowling ball. It will squash slightly as it hits the ground. The reason for this is that a football is flexible. It consists of a membrane holding in compressed air. As the ball hits the ground, the energy contained in the ball is forced outwards and not up because there is still energy at the top of the ball that will prevent the energy at the bottom of the ball from bouncing straight up. Only when the energy at the top of the ball has reached its lowest limit will the ball bounce up. Because a soccer ball is lighter than a bowling ball it is affected less by the pull of gravity as it bounces and will bounce higher, if they are both dropped from the same height. A membrane filled with compressed air has a certain amount of give, making it springier. This means that a soccer ball will also bounce more times than a bowling ball before coming to a stop.

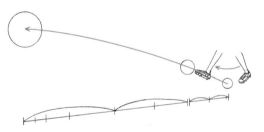

A soccer ball being kicked will be far easier to move than a bowling ball (it is a soccer ball after all). The energy will be passed easily from the foot to the ball and it will probably travel further than the bowling ball. It will be easier to stop though because it is flexible and will squash against any object in its path and it doesn't contain as much kinetic energy as a shoved bowling ball.

a balloon

A balloon, on the other hand, when dropped will accelerate very slowly to optimum speed, squash slightly, bounce slowly a couple of times (each time a smaller bounce) and come to a stop. The reason it squashes less than a football is that it has gained far less momentum from its fall, so there is less energy to push outwards at the point where it hits the ground. It will also slow down just before it hits the ground. This is because a balloon is so light a cushion of air above the ground will give a small amount of resistance and add to the impression of the balloon's lightness.

A balloon being pushed along the ground requires very little energy to get it moving, so it will accelerate rapidly to its optimum speed, but absorb a lot of energy by being squashed against the hand that is pushing it. As it leaves the hand it will decelerate rapidly to a stop. Very little energy has been passed to the balloon from the hand so it contains very little forward momentum. As such it will come to a stop rapidly.

a water-filled balloon

A balloon full of water, when dropped will accelerate rapidly because it is heavy. It will also adopt a tear shape as it falls. This is because the balloon is a flexible membrane and all of the water wants to be at the bottom of the balloon because of gravity. The membrane will flex to a certain limit at the bottom of the balloon and any water that can't fit in at the bottom will stay at the top. When it hits the ground the water will push the membrane

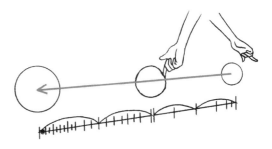

out sideways, helped by the water at the top of the balloon. When the water has pushed the membrane out as far as it will go (without bursting) the water is forced upwards all around the inner surface of the balloon's membrane. When it meets at the top, whatever energy there is will lift the balloon. As the balloon reaches the top of its apex the water will fall back down within the middle of the balloon. It hits the ground again and the water is forced outwards, causing another squash of the balloon. This time, because the force of the fall is less, the balloon will squash less. The water is forced upwards by the membrane of the balloon. At the top

it meets water coming from the other side of the balloon and is forced down. The balloon does not take off this time. The water circles round within the balloon and pushes the membrane out into another squash, this time even less than the last squash. This action can be repeated several times. The extent of the squash and the height to which the water travels to the top of the balloon gets less and less. Finally it will come to rest in a slightly squashed position.

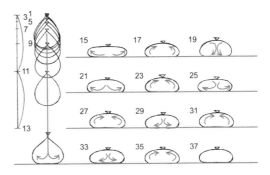

Depending on the force of the fall, the balloon will ether burst, if dropped from a great height (because it will be travelling faster), or will not bounce into the air at all if dropped from a low height. It will just do the flexing upwards action.

If you try to push this water-filled balloon along the ground, the water absorbs a huge amount of the energy passed to it and rapidly comes to a halt. The water within the balloon is rotating round at a speed faster than the balloon is rotating along the ground. This produces a forward moving, undulating effect across the top of the balloon. The basic principle of what is happening is this. The water flows forward pushing the membrane at the front of the balloon until it reaches its elastic limit. This stretches the balloon out flat. When this occurs, the

water flows under itself towards the back of the balloon. When the water reaches the back of the balloon it is stopped flowing back by the rear part of the balloon's membrane. The water then goes up and over itself towards the front of the balloon pushing the membrane at the top of the balloon upwards as it goes. Finally to complete this cycle the water pushes against the front part of the balloon and we gain forward momentum. As this cyclical action is repeated the water is losing energy and is able to push against the membrane of the balloon less and less. So when the water is at the top of the balloon it will push up the membrane less and less. When the water is at the front of the balloon it will push the membrane forward less and less. You can see a very simplified version of what is happening in the illustration.

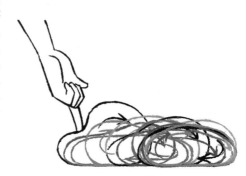

When the balloon comes to a halt the water within the balloon will still be rotating within it. The water does not have the force to push the balloon forward any more but it can affect the outer membrane shape. With the balloon now stationary, the water pushes the membrane as far forward as it can go and then flows under itself, towards the back of the bal-

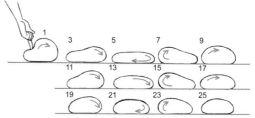

loon. At the back of the balloon the membrane stops the water going back any further and forces the water up over the top of itself, pushing the membrane up. It flows toward the front of the balloon and pushes the membrane forward. As the water has less energy than the last time it was at the front of the balloon it will not push the membrane out as far as it did last time. The water will again flow under itself, towards the back of the balloon and repeat the same action as before but with less force. After this process has been repeated a few times, each time with less exaggeration, the balloon will come to a halt in a slightly squashed position.

All of these examples of how a water-filled balloon will move are animated at a much slower rate than a real water-filled balloon will move in real life. This is because an audience tends to understand what's going on in a piece of live action film more quickly than in an animated film. Consequently a lot of animation movement has to be slightly slower than movement in real life.

the animation of liquids

a drip

Liquids, unlike solids, have the ability to break apart and reform easily.

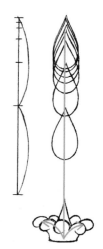

As it falls a drop of liquid takes on a tear shape (a bit like the water-filled balloon). Surface tension creates a membrane, which holds the majority of the water at the bottom of the drop. When the drop hits the ground the surface tension is broken and the water breaks apart. As the first amount of water hits the

ground it bounces outwards and upwards at an angle. It is prevented from bouncing directly upwards by the water that follows.

The water caught in the bounce, separates from the main body and creates smaller drops. As each of these smaller drops bounce they follow a parabola like a bouncing ball.

Radiating outwards from the central point of impact, as each smaller drop reaches the apex of its bounce, it slows down. As it comes out of its own apex the smaller drop then speeds up and breaks away from the middle. The water behind these smaller drops may form other drops that continue to radiate outwards or, as they run out of energy and can't complete a full arc, they may fall back on themselves.

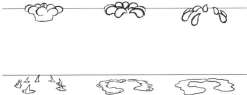

Depending on the momentum of the water, this sequence may continue for a number of bounces, or as the drops hit the ground they run out of energy and the water flows forward over the surface.

See the drip.avi in animations002, chapter002 of the CD-ROM.

a splash

A splash will follow the same principles of a drip, but consists of a lot more water. To help visualize this, I always think of the water bouncing off the ground as looking like sheets folding over

on themselves. For the first bounce, the sheet of water remains in a mass as it radiates outwards before separating into smaller drops during further bounces or running out of energy and flowing over the ground.

See splash.avi in animations002, chapter002 of the CD-ROM.

object falling into water

When an object is dropped into water, the object penetrates the surface forcing up a splash from the outside edge of the object.

In the illustration you will notice that a column of water bounces up in the middle of the splash. This happens because, as the object sinks, it leaves a hollow column. The water surrounding

this hollow fills in. It meets in the middle with equal force and wants to rebound. It can't bounce back because of the following water. It can't go down because the object below is in the way, so the water is propelled up. When the column of water reaches a certain height it runs out of energy and gravity takes over. The water at the very top has the most energy. As the

water below runs out of energy it breaks away and falls back on itself. This leaves a blob of water floating in the air. As gravity takes over, it then starts its descent to the water surface. It may also cause another smaller splash, when it hits the water surface. See pond_splash.avi in animations002, chapter002 of the CD-ROM.

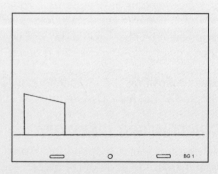

exercises

the bouncy ball in 2D

These exercises look at the principles behind the movement of inanimate objects. Using the previous examples we will animate five different balls rolling off a roof of a shed and bouncing on the ground before rolling to a stop. This exercise looks at momentum, the force of gravity and how different objects react when hitting the ground.

These objects will be:

- a bowling ball
- a soccer ball
- a beach ball
- a ping-pong ball
- a water-filled balloon

Each of the balls should be 1 cm in diameter.

background level

First draw a shed at the side of your paper in the same position as the illustration. Draw it in black felt pen to make the lines as dark as possible, so that when you combine it with the animation it will be as clear as possible. Make the shed 5 cm wide, 5 cm tall (at the highest point) and 4 cm tall at the lowest point (these same dimensions are going to be used in your 3D-computer animation).

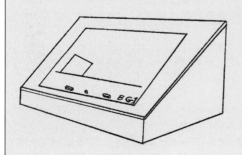

You will only need to draw this once. This is your background. When you are animating your balls, keep this background on your peg bar on the light box. Call it BG 1 by marking this in the bottom right-hand corner.

I will go through the bowling ball exercise in detail. The method is the same for all five balls and can be used as reference for the other exercises. Take a look at the ball_trajectories.pdf, chapter002 of the CD-ROM.

animating a 2D bowling ball

Here is the rough trajectory of a bowling ball and the key positions that should be drawn first. Note that a bowling ball will not demonstrate any squash and stretch. Keep it solid!

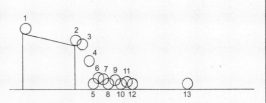

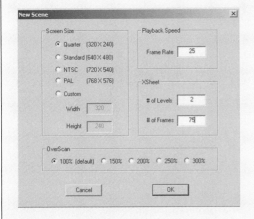

Draw each of these key positions on separate pieces of paper.

Open up DigiCel on your computer. When setting up DigiCel, have # of Frames; 75, Frame Rate; 25 and # of Levels; 1.

Place the background on the peg bar under the camera. Then lay your first drawing of the bowling ball over this. Hopefully you should be able to see the background through the animation drawing (later, when all the in-betweens are done, we'll capture

two levels, the background and the animation). Click on the Capture button.

Set the Hold box to 1, the Frame box to 1 and the Level box to 1 before you begin. Then capture your bowling ball key drawings.

When you've finished capturing, click OK and the XSheet will look like this.

Click Play. A bit quick isn't it. So we have to give extra frames to our drawings. Experiment by prolonging the amount of frames that each of the drawings are held for (see top left illustration on p. 38).

As a guide arrange them on the XSheet as shown in the illustration. Note down in the 'action column' what is happening and where. If the ball hits the ground on frame 22, write 'ball hits ground' in the row that corresponds with frame 22. This is called 'slugging

out' and is good to do so that you get a feel for the timing. After a while you will be able to fill in the column before you even start animating!

Play your key animation back. How does it look? If it looks like the animation in bowlingball_keys.avi (chapter002, CD-ROM), you're doing OK. If not adjust the amount of frames that each of the key drawings is played for until you are happy with it. Show it to other people such as friends, loved ones or complete strangers. If they identify it as a bowling ball falling off a shed, you know you are on the right track. Here is an illustration of the bowling ball with the correct drawing numbers (the frame number that each of these balls should be captured on).

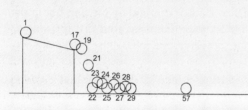

Now you have to do the in-between drawings. We will follow the same procedure as in Chapter 1 by changing the preliminary numbering sequence for the key drawings to the correct sequence including the in-betweens. Note down the numbers for the key drawings on a paper x-sheet in column 6. In column 1, write the animation drawing numbers on every other frame. These will be the correct animation drawing numbers (we are going to be numbering our drawings by the frame). Transfer across the correct animation drawing numbers to the key drawings. So key drawing number 1 will now be animation drawing 1 (it corresponds with frame 1). Key drawing 2 will become animation drawing number 17 (it corresponds with frame 17), key 3 is 19, key 4 is 21, etc. Once you have re-numbered your key drawings with the correct animation number drawings, rub out the key drawing numbers on the paper x-sheet. See the illustration on p. 39.

Note that the drawings between key drawing number 4 (animation drawing 21) and key drawing number 12 (animation drawing 29) are 'singles'. This means they are shot for one frame only.

The next stage is to put timing charts on to each of your key drawings. These help you plan the positions for the in-between drawings. The timing chart is drawn at the bottom of your key between the peg bar holes. The first timing chart will be drawn on the bottom of key 1 and relates to the in-betweens from key drawing 1 (renamed animation drawing 1) and key drawing 2 (renamed animation drawing 17). As the ball rolls down the

shed roof it speeds up, so in each of the following drawings, the ball should be further and further apart.

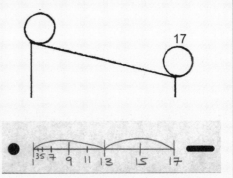

You will notice that there is a looped line between 1 and 13 and between 13 and 17. This is to indicate that drawing 13 is exactly half way between 1 and 17. The ball on drawing 13 should be half way between the ball on drawing 1 and the ball on drawing 17. Follow the timing chart – each time completing the next half-way drawing. 15 is half way between 13 and 17. Drawing 9 is half way between 1 and 13, etc.

You've done all the animation necessary between animation drawing 17 and animation drawing 29 (where the ball is bouncing on singles), so the only other timing chart to do is between animation drawing 29 (the drawing formally known as key drawing 12) and animation drawing 57 (key drawing 13).

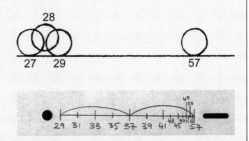

Once you've completed your in-between drawings, capture them with your line tester, following the instructions below.

When setting up DigiCel specify 2 in the # of Levels box.

Press the Capture button and the Video Capture box comes up.

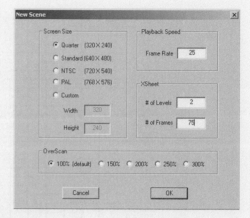

- Capture the background. Change the Level box to 0 and click Capture.
- To capture the drawings on top of the background, change the Level box to 1 and change the Frame box to 1.
- Drawings 1–19 will be captured for 2 frames each. Set the Hold box to 2.
- Drawings 21–28 will be captured for 1 frame each. Set the Hold box to 1.
- Drawings 29–57 will be captured for 2 frames each. Set the Hold box to 2.

When you've finished click OK. Your x-sheet should look something like the left-hand illustration on p. 41. When you play the drawings back, your animation should look like the bowlingball_ 2D. avi in animations002, chapter002 of the CD-ROM.

animating a 2D soccer ball

The top right illustration on p. 41 shows the rough trajectory for the soccer ball and key positions. A soccer ball will undergo a certain amount of squash and stretch. As the ball hits the ground it squashes. As it flies through the air, at the fastest point of each arc, it stretches.

Draw the 12 key positions of the soccer ball and capture them. Number each key by the drawing: 1, 2, 3, 4, etc. The sequence will be 120 frames long (set up DigiCel to be # of Frames; 120, Frame Rate; 25 and # of Levels; 2). Play the keys back and adjust the frames until you are happy with the timing of the sequence (left click and hold down the Alt key while dragging down). Use the right-hand illustrations on p. 41 for reference. Check out soccerball_keys in animations002, chapter002 of the CD-ROM.

Once you are happy with the sequence, re-number the key drawings by the frame number. You then know how many in-between drawings are needed. Mark them up on a paper x-sheet (see the top illustrations on p. 42).

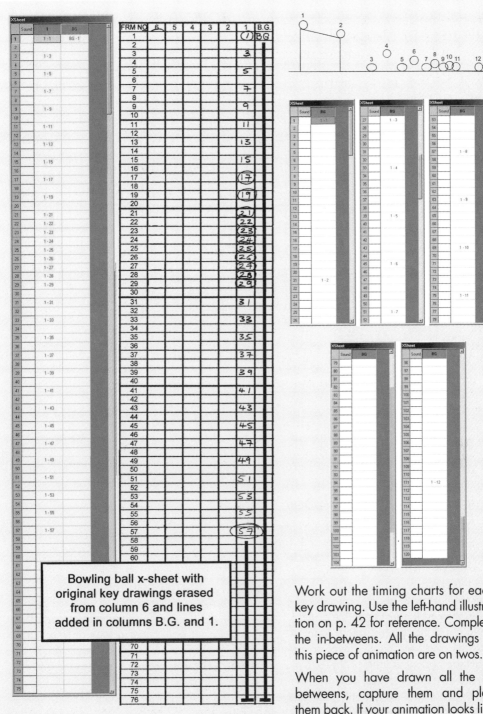

Bowling ball x-sheet with original key drawings erased from column 6 and lines added in columns B.G. and 1.

Work out the timing charts for each key drawing. Use the left-hand illustration on p. 42 for reference. Complete the in-betweens. All the drawings in this piece of animation are on twos.

When you have drawn all the in-betweens, capture them and play them back. If your animation looks like soccerball_2D.avi in animations002,

chapter002 of the CD-ROM, well done. If not, try to find where you've gone wrong. For example, if the ball spends too much time in the air, take a drawing out, or hold one of the drawings for a single frame rather than a double. Don't be afraid to experiment.

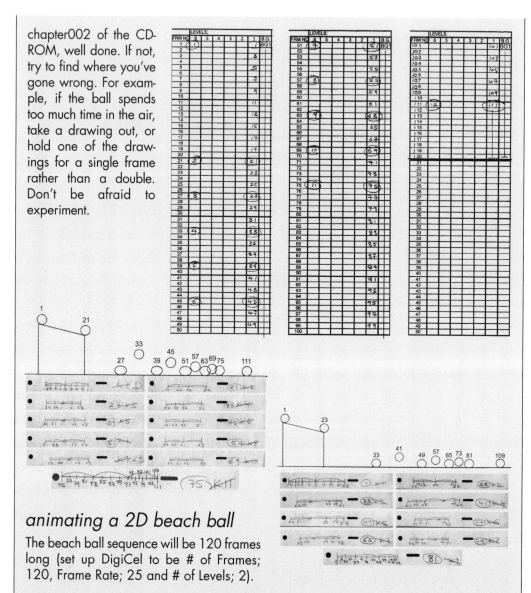

animating a 2D beach ball

The beach ball sequence will be 120 frames long (set up DigiCel to be # of Frames; 120, Frame Rate; 25 and # of Levels; 2).

Use the same procedure as for the bowling ball and soccer ball. This time experiment with the timing. A beach ball will travel more slowly through the air than a football. It might roll slightly as it bounces on the ground and not bounce as high. It will crumple at the bottom when it hits the ground rather than squash like a soccer ball. Have a look at beachball_keys.avi and beachball_2D.avi in animations002, chapter002 of the CD-ROM. As the beach ball bounces there will be an in-between drawing just before it touches the ground. This slows the beach ball down. The reason we do this is to emphasize the lightness of the beach ball, suggesting that the air above the ground gives a small amount of resistance to such a light ball. See the illustration at the top of p. 43.

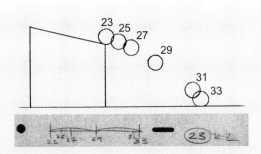

animating a 2D ping-pong ball

A ping-pong ball will bounce quite high with fairly short distances between the apex of each bounce. it will not squash or stretch at all. The upwards bounce is quite quick.

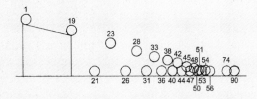

When it reaches the apex it slows, before almost floating down to hit the ground. Adjust your in-betweens accordingly. The illustration shows the trajectory of a ping-pong ball. Once it hits the ground it bounces very quickly. To show this, the drawings between 19 and 56 will be on singles.

Use the same procedure as for the bowling ball and the soccer ball. The ping-pong ball sequence will be 100 frames long. Set up DigiCel to be # of Frames; 100, Frame Rate; 25 and # of Levels; 2.
Have a look at ping-pongball_keys.avi and ping-pongball_2D.avi in animations002, chapter002 of the CD-ROM.

animating a 2D water-filled balloon

This is probably the most difficult sequence to animate, but is also the most fun to watch when it's working well.

Work out the basic trajectory. Think of the water flowing around the inside of the balloon as it moves, pushing the balloon forward.

The sequence will be 75 frames long. Set up DigiCel to be # of Frames; 75, Frame Rate; 25 and # of Levels; 2.

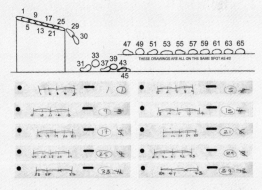

Start with the basic key positions of the balloon rolling down the shed roof. The in-between drawings of this sequence should be on singles. The illustration below shows the in-betweens from key 1 to key 5. The rest of the sequence of the balloon rolling down the roof will follow this pattern.

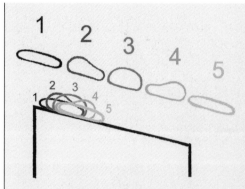

Try to make sure the balloon doesn't slide down the roof. Most forward movement occurs at the point at which the balloon is most stretched. When stationary, the water rotating inside the balloon stretches the rubber slightly backwards, upwards, then ahead. As the water inside the balloon moves forward it stretches the balloon and pulls it onward.

Have a look at waterballoon_keys.avi in animations002, chapter002 of the CD-ROM.

The water-filled balloon will fall quickly when it leaves the edge of the roof because it is very heavy. When it lands it will squash slightly more on one side than the other because of the slight angle at which it leaves the roof.

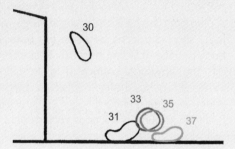

When you have animated the full sequence capture the drawings and the background and see how it looks.

Take a look at waterballoon_ 2D.avi in animations002, chapter002 of the CD-ROM.

When you are happy with the five different sequences – and it is easy to identify what sort of balls they are – you are ready to do them all again in 3D!

the bouncy ball in 3D

To animate the five different balls in 3D we will follow a similar approach to the exercises in 2D. First we need to make a background. This consists of a cube that has been given a sloping top. It is built to the same proportions as the shed in our 2D background (5 units × 5 units × 4 units). We also need to make a floor for the ball to bounce on. This consists of a grid that is the same width as our shed and is long enough to fit all of our ball bounces on (5 units × 40 units). This only has to be built once. It can be re-used for each ball we animate.

Then we need to make our balls. These will all be the same size! We want an audience to be able to tell what sort of ball they are from their movement rather than their size. The balls will always be 1/5 the size of the width of the shed.

Each of the balls will have to be constructed with a 'hierarchy'. A hierarchy is an abstract graphical interpretation of how a model is constructed. It will consist of a 'parent' which

could then be linked to any number of 'children'. Let's say we have two objects on screen, a big cube and a smaller cube. They will be linked together, in a hierarchy. The large cube is the parent, the smaller cube is the child. When you select the large cube (the parent) and move it, the small cube (the child) will move with it. But when you select and move the small cube (the child) it will move on its own, leaving the large cube (the parent) behind.

Select Large Cube and rotate... ...and Small Cube will follow... ...but the Small Cube will rotate independently

Movement given to the parent will affect all of the children, but movement given to a child will work independently of the parent.

The ball hierarchy will consist of three parts, a parent, a child and a child of the child. The parent and the first child will be invisible objects the second child (grandchild?) will be the ball. These invisible objects are devices that do not render in the final version of your animation. (They are called 'Point Helpers' in 3D Studio Max, 'Locators' in Maya and 'Nulls' in LightWave and Soft|Image XSI.) The first two parts of the hierarchy will have a different 'movement' ascribed to them. The parent object will deal with the movement (or translation) of the ball and the first child will deal with the rotation. In order to save confusion it's a good idea to rename these invisible objects 'movement' and 'rotation'.

First we work out the key positions of the movement (or translation) of the ball and setting keys on the movement part of the hierarchy (this will take the other parts of the hierarchy with it). We do this by following the key positions of our drawn animation. The first key position will be at the top of the shed. This will be on frame 1. So select the movement part of the hierarchy and set key positions on this. The second key position will be just as the ball reaches the end of the shed roof. The frame number of this key position depends on which ball you are animating (with the bowling ball it's frame 17). The key position where the ball leaves the roof is on frame 19. The remaining key positions are worked out by measuring the height and the distance travelled by each of the drawn key balls, and then

putting the ball, in the 3D-computer anima- tion program, in the same position and at the same frame number as the drawn key ball. Take all your measurements from the centre of the block for the distance and the height of the ball above the ground.

Don't be afraid to draw on the monitor screen with a 'chinagraph' pencil (although I accept no responsibility for any damage that you may do; don't draw on a LCD screen). Draw the rough positions onto the screen of where the ball looks like it should go according to your drawn keys and then position the 3D ball underneath.

Once the 'movement' key positions are in place the computer will do the in-betweens for us. As we saw in Chapter 1, the in-betweening that the computer does will not be correct. We have to tell it where to put the in-between balls. We do this either by putting in all the in-between balls ourselves or by mani-pulating the animation curves, as in Chapter 1.

SoftImage XSI Animation Editor

Maya Graph Editor.

3DS Max Track View.

LightWave Graph Editor.

Once the movement is done we can go back over our animation and set keys for rotation on the rotation part of the hierar-chy. Select the rotation part of the hierarchy and set a key at the very start of the piece of animation. Work out how much the ball will rotate over the length of the scene by measuring the distance travelled in relation to the circumference of the ball. Then, go to the very end of the scene, rotate the ball by the correct amount and then adjust the curves to make it look right.

You will find how to animate each of the five sorts of balls in more detail in chapter002 of the CD-ROM in .pdf files that relate to each of the 3D animation programs that are cov-ered in this book. The .pdf files are called 3DS_Max_bouncy_balls.pdf, Maya_bouncy_ balls.pdf, LightWave_bouncy_balls.pdf and XSI_bouncy_balls.pdf.

the construction of a simple character, its articulation and balance

chapter summary

the push in 2D
the push in 3D
the pull in 2D
the pull in 3D

Animating inanimate objects like bouncy balls gives you an idea of weight, timing, spacing and squash and stretch. However, they are not the most interesting things to animate. During this chapter, we will animate something with life, something that initiates movement and has forces imposed upon it. The human character.

Our first task is to design our character. Before doing this we need a basic understanding of human anatomy. I will go through the construction of the skeleton and types of joints. As well as looking at the structure of these – I will also explain how they move and the importance of arcs when animating.

basic human anatomy

A whole book could be written on human and animal anatomy, so I'm going to stick to the absolute minimum that we need to know.

Let's start with the main part of the human skeleton, the spine.

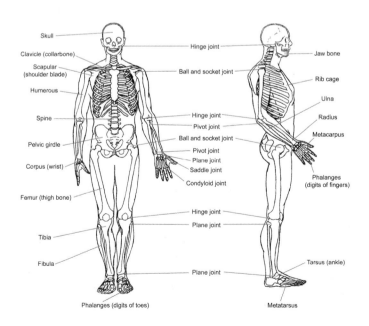

the spine

At the centre of the human skeleton is the S shaped spine. This is made up of 24 individual bones, called vertebra. These are linked by discs of cartilage and have a limited amount of angular and twisting movement. This combination gives the spine great flexibility allowing forward and backward and side-to-side movement and a degree of twisting.

At the top of the spine are the seven vertebrae that make up the neck.

the rib cage

Attached to the next twelve vertebrae are 24 ribs (two per vertebra) which constitute the rib cage. The role of the rib cage is to protect the heart, lungs and internal organs. At the bottom of the rib cage is the diaphragm; this in conjunction with the rib cage controls the breathing. The rib cage restricts the bending and twisting movement of the 12 vertebrae that the ribs are attached to. The lower five vertebrae make up the lower spine. Most of the twisting and bending of the spine during the body's movement occurs between these five vertebrae.

the pelvic girdle

At the base of the spine is the pelvic girdle. This solid set of bones plays a

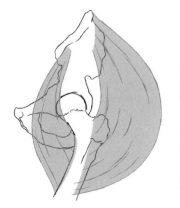

role in keeping us upright. Attached by ball and socket joints are the two femurs of the upper legs. The largest muscle in the body (the gluteus maximus) is attached to the upper thighbone (the femur) at one end and the pelvic girdle at the other end. This muscle is used to hold the body upright when stationary and moves the femur during walking. It is used when picking things up and jumping. It also helps with the balance of the body.

the skull

At the top of the spine is the skull. Attached to the skull is the jaw bone, this hinges from the point at

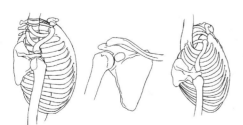

which it meets the skull. It can have an up-and-down and a side-to-side movement.

Between the skull and the rib cage is the neck. This also displays a large amount of twisting and bending, giving about 90 degrees backwards and forwards.

It also gives about 180 degrees of twist.

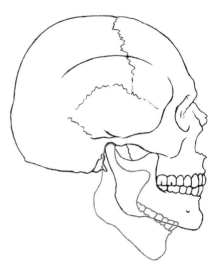

the shoulders

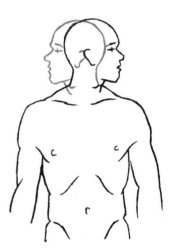

At the top of the rib cage, are the two collarbones (clavicles) at the front and two shoulder blades (scapulars) at the back. Each of the collarbones is connected to the front of the rib cage at the inner end and to the shoulder blades at the outer end. When viewed from the top, these form a triangle, which holds the upper arm (humerus) in place, at a ball-and-socket joint.

The shoulder blades are almost 'free floating' and can move in a number of directions. Up and down, inward so that they are almost touching at the spine and outwards to the edge of the rib cage. The main things restricting their movement are the collarbones.

The movement of the shoulder blades affects the position of the arms. For example, by raising the shoulder blades, the arms raise and give the body the appearance of a shrug. When

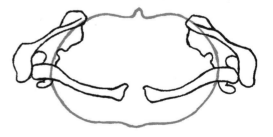

picking up a heavy object the shoulder blades and collarbones will be lowered, lowering the position of the arm. Much of the character and mood of a person is conveyed by the positions of the shoulders. See shoulder-joint.avi in chapter003 of the CD-ROM.

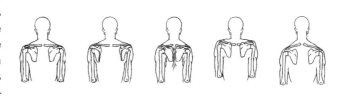

joints

The limbs of the skeleton are linked by joints, of which there are six types. These are:

- plane joints
- pivot joints
- hinge joints
- ball-and-socket joints
- saddle joints
- condyloid joints

Understanding how these joints work gives us a clue to understanding movement.

plane joints

The surfaces that meet at a plane joint are flat or slightly curved. This allows only a small amount of movement, about 90 degrees backwards and for-wards and approximately 45 degrees from side to side. Examples are the wrist and ankle. See planejoint.avi in chapter003 of the CD-ROM.

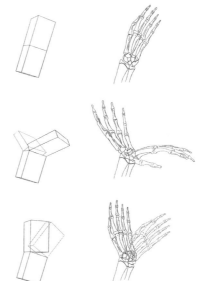

pivot joints

This consists of a cylindrical bone twisting within a complete or partial ring. The best example of this is the joint just below the wrist between the two

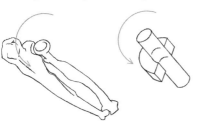

bones of the forearm, the radius and the ulna. This movement combined with the plane joint of the wrist produces the very expressive movement of the wrists. See pivotjoint.avi in chapter003 of the CD-ROM.

hinge joints

The hinge joint, as its name suggests, moves in one plane, like a hinge. The end of one bone ends in a cylinder, the other in a cylindrical excavation. Depending on the joint, it will give up to 160 degrees of movement. Examples include; knees, elbows, fingers and toes (excluding the first knuckle). See hingejoint.avi in chapter003 of the CD-ROM.

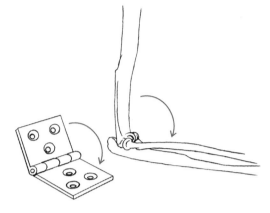

ball-and-socket joints

The ball-and-socket joint allows a huge amount of circular movement in most directions. A sphere at the end of one bone fits into a spherical excavation at the end of the other bone. Examples include the hip joint and the shoulder joint. See ballandsocketjoint.avi in chapter003 of the CD-ROM.

saddle joints

This is a joint that is almost a combination of a hinge joint and a ball-and-socket joint. It's a hinge joint that allows for a certain amount of side-to-side movement. The main example is the joint between the hand and the thumb. See saddlejoint.avi in chapter003 of the CD-ROM.

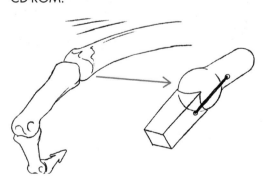

condyloid joints

A bit like the saddle joint but with more circular movement. Examples of this joint are the

first row of knuckles between the fingers and the hand. See condyloidjoint.avi in chapter003 of the CD-ROM.

moving in arcs

Most movements undertaken by the human body will describe arcs. For example if you keep your arm straight and raise it above your head your hand will move in an arc.

When we watch someone walking, we are aware of how the joints of the body are moving. Subconsciously we see how they move in arcs in relation to each other and from this we deduce that this creature is a human being. Anything that doesn't move in this way will look strange.

As an experiment, I built a human character in 3D. Rather than having a skin, I put a white ball at each of the joints. Set against a black background, all you see is a collection of white spheres. I then animated a basic walk cycle, with the character walking on the spot. When playing all

you can see are some white balls moving through space. Despite the abstract nature of the sequence, it is surprisingly easy to work out that it is a human character walking on the spot. This emphasizes how important it is to have one foot in reality when moving human characters. Take a look at arcs.avi in chapter003 of the CD-ROM and see if you can work out whether it's a person walking or not.

1 7

When somebody looks to the side, their head will bob down through an arc. When somebody jumps in the air, his or her trajectory will describe an arc. Almost all movements made by any living thing will follow an arc. If the character doesn't follow arcs with its movement, your animation can look stiff and robotic.

13 19

designing a basic human character

Human beings are one of the most difficult things to animate convincingly. From the moment we are born, we are interacting with other humans. This gives us a subconscious knowledge of how they move. Having this knowledge gives us something to compare the animated character with; the real thing!

When designing a character it is often preferable to simplify and slightly stylize it. The more realistic the character, the more the audience expects it to move realistically. This is why hyper-realistic humans in 3D-computer animation can end up looking like animated shop dummies. The whole point of animation is to make the char-acter look believable rather than real. Real people have many subtle nuances in the way they move that are difficult if not impossible to animate. Just watch a real human being and see how much their face moves when they talk. Remember that you want your audience to follow the story, rather than thinking that there is something a bit weird about your char-acter. This is equally true of 2D and 3D animation.

A good way of working in drawn animation is to divide your character up into a series of simple three dimensional shapes. An oval for the head, a bean shape for the body and sticks for the arms and legs. When animating, animate these shapes first. When you are happy with the movement, start adding the details.

For the 2D animation exercises outlined in the book, we will be using a very simple character, as shown in the illustration.

For the 3D animation exercises outlined in the book, we will be using a very simple character as shown in the illustration below.

The character is made up with two arms, two legs, a sphere for the head, a body like a bean and

basic mittens for hands. The feet have a joint at the ankle and toe.

You can design your own character, but bear in mind that it is easier to do the exercises and then apply the timing and spacing learnt to a 3D character that is similar to the 2D drawn one.

When designing a character there are a number of points to look at:
● complexity
● graphic nature of character

- strong silhouettes
- weight and balance

complexity

Decide how much animation you wish to do. In full animation (the kind of animation that you will see in feature films, where the character is moving all the time) the characters tend to be simpler. There will be few buttons, frills or details. Too many details will distract the eye and can cause full animation to look clumsy. It also takes a considerable amount of time to animate a waistcoat full of buttons throughout an entire film. Disney knew this in the 1930s.

It was estimated that each button on a character would cost several thousand dollars for the length of a feature film.

For limited animation (the kind of animation that you see in TV series, where the characters tend to stop and start, or jump from one strong pose to another), characters can be more complicated. Mainly because they won't be moving as much.

This is also true of 3D animated characters. The more textures and details you add to your model, the more difficult it is to read what the character is doing. Also the more complicated the character, the more difficult it is to achieve elegant animation.

the graphic nature of characters

The more complex the character is the slower the animation has to be.

A simple flat graphic character that consists of blocks of colour will read (the audience will understand what it is doing) more quickly than a complicated three-dimensional one. For the same reason that adding lots of details affects the speed at which you can animate a character, the flat, graphic character can be moved at a faster pace than the complicated three-dimensional one. It's because there is so much more to look at. With a 3D character you've got shadows and highlights, colour and texture, various details that you may have added as well as the animation.

Line drawings also need more time to read than coloured animation. When animating for a black-and-white sequence (or if you are going to convert the movement to 3D) make the animation for the line test slightly slower than you think it should be. If the line test is going to be coloured using flat colours, make the line test slightly faster.

The shapes of the character will also affect how it animates. Characters made from rounded shapes tend to be easier to move in three dimensions and easier to make strong poses with.

The rounded shapes also suggest softness. Angular characters made from hard sharp shapes look clumsier when moving and tend to look more aggressive.

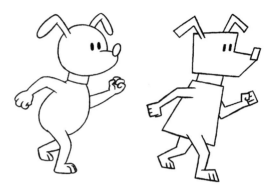

The type of animation used also influences the pace of the animation. 2D drawn animation is suited to a fast, frenetic pace. It is not very good for slow moving or subtle close-ups of a character's face. However, clay or puppet animation works better with subtle, slower, close-up movements and is not so good at the fast frenetic stuff. Computer 3D animation has both the advantages and disadvantages of these two disciplines. It can move faster, with more fluidity than clay or puppet animation, but is not as good with the subtle, close-up work. It is better at close-up work than 2D drawn animation, but is not as good with fast, fluid or aggressive movements.

Please remember that these very general rules and there are many brilliant exceptions to them.

strong silhouettes

When drawing your key positions, make sure they have good silhouettes. If you were to black out the character, would you still be able to understand what the character was doing? If the answer is yes, this will help the audience to understand what is happening faster.

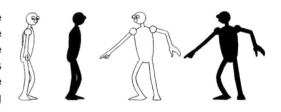

When animating in 3D always think of the camera angle that your final animation will be viewed from and make sure that you have good strong silhouetted poses that work from that angle. Don't do the animation and then sort the camera angle out later. If you want to do a flying camera move make sure that every frame is well composed during the sequence.

weight and balance

For your audience to believe that your character is a living, breathing being (rather than graphite scraped onto paper or a collection of pixels on a screen), you need to follow a few basic rules. Two of these are giving your character weight and ensuring your character is balanced correctly.

gravity

Assuming we are animating a character on planet Earth, the first thing it has to deal with is gravity. In the same way that our bouncy ball falls to the ground and bounces, when rolled off the roof, so our character will fall to the ground and bounce if it jumps off the roof.

If the character jumps into the air, this takes effort and will always result in the character falling back to earth.

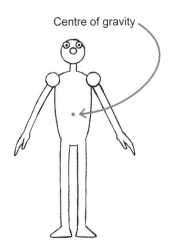

Centre of gravity

Every object (including our character) has a centre of gravity. With our balls it would be in the dead centre. With a character it will be roughly at the bottom of the rib cage (about the centre of the body). If the object or character is taller, then the centre of gravity will be higher. If it is shorter, then the centre of gravity will be lower.

The centre of gravity is not always in the same place within a character. It will change position as a character changes its body posture.

balance

The stability of an object is affected by its shape. The wider the base then the more stable it will be. For example, a cube is a very stable object. It is difficult to push over or roll down a slope.

A ball, on the other hand, is much less stable. It is easy to push along or roll down a slope. Because of this instability it is much more susceptible to the forces of gravity.

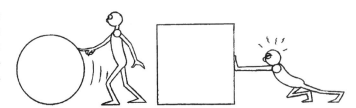

Our character maintains stability by spreading its legs. The wider the legs are spread, the lower the centre of gravity and the more difficult it is to knock over the character.

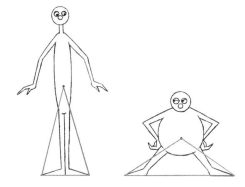

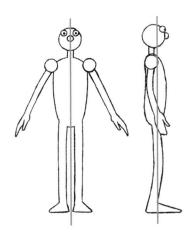

To ensure that your character looks balanced, imagine a plumb line running top to bottom through the centre. There should always be an equal amount of weight either side of this line.

As the character leans in one direction, the plumb line will move with the centre of gravity. If it swings far

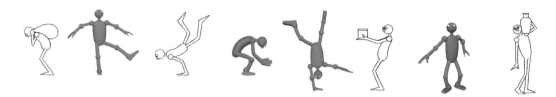

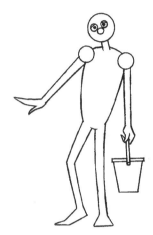

enough to reach a leg, then other parts of the body will need to be moved to maintain balance and to stop the character from falling over. For example, if a person leans forward to maintain their balance they need to stretch their arms out behind them. If they lean further, they will then need to stretch one leg out behind them.

If a person holds a heavy bucket of water, they will lean their body at the opposite angle to the arm holding the bucket.

Someone who is over-weight will need to lean back to balance his or her large stomach.

planning a scene

Before animating a scene, it is always a good idea to plan the action with a series of thumbnail sketches. These are simple illustrations showing all the major key poses adopted by your character during the scene. They act as a reference guide and as such are generally small and can be quite rough.

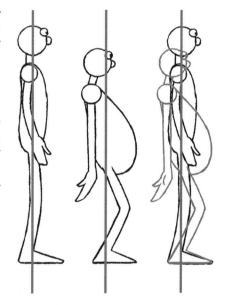

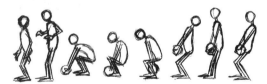

It can be very helpful to have these above the light box as you can often save time by refer-ring to them when drawing the full size keys. You could even have a go at shooting these thumbnails with your line tester to get a rough idea of the timing.

Sometimes it is helpful to sketch these thumbnails onto your x-sheet, roughly at the frame at which these key poses would occur.

To make this easier I've developed a form of x-sheet called a thumb-sheet. This is an x-sheet with small panels in which you can sketch thumbnail drawings.

THUMB-SHEET 01

ANIMATOR:											
PRODUCTION:											
SEQUENCE NO:		SCENE NO:		LENGTH:			SHEET NO:				
NOTES:											
THUMBNAILS:		ACTION	SOUND	FRM	5	4	3	2	1	BG	CAMERA
THUMB NO:				1							
				2							
				3							
				4							
				5							
				6							
				7							
				8							
				9							
				10							
THUMB NO:				11							
				12							
				13							
				14							
				15							
				16							
				17							
				18							
				19							
				20							
THUMB NO:				21							
				22							

There are empty thumb-sheets in chapter003 of the CD-ROM.

animating your characters

(Using the left and right sides of the brain)

The human brain is divided into two halves. There is a theory that different thought processes are associated with each side of the brain.

The left-hand side deals with the logical, practical, analytical, conscious world. It deals with language and speech and the visual interpretation of the world around us. It also deals with the right-hand side of the body.

The right-hand side of the brain deals with the creative, spiritual and subconscious aspects of us. It's the side that's working when we have a 'feeling' about something. It's also the side of the brain that thinks of the body as a whole.

When you are animating you should be using the right-hand side of the brain. In order to do this, it is best to work fast and rough. Don't rub anything out. If the lines are in the wrong place, re-draw them until the drawing looks right. Don't be precise about the drawing at this stage. Also, don't think too much, just draw.

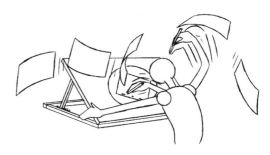

Remember to use a colour erase pencil for the rough drawings. You can then mark a clean, correct line with a graphite pencil. Always keep flipping, flicking and rolling.

For this way of drawing to work, you need to have studied the movement beforehand. Get a friend to act it out or watch yourself in a mirror. Study how the limbs move, any twists to the body. Look at the balance and the weight.

While acting out the move, use a stopwatch to work out the rough timing, If you don't have a stopwatch, the phrase 'one little monkey ... two little monkeys ... three little monkeys', takes about a second to say or about a third of a second to say each of these words. Use this to help with the timing. Slug out your x-sheet. This uses the left side of the brain. This deals with the logical, practical, analytical, conscious world.

exercises

To understand weight and balance we will animate a human character lifting a heavy ball and pulling and pushing a heavy object.

The three exercises have been set out step by step as follows.

- Working out the key drawings (I've included timing charts with each of the key positions to show where the in-betweens should be placed).
- Completing the in-betweens.
- Animating each exercise in the four 3D programs covered in this book, using the drawn animation as a guide. These can be found on the CD-ROM.

You can follow the exercises I've done or use them as a rough guide and animate something that you've acted out yourself.

the lift in 2D

In this exercise we will get our character to pick up a heavy ball. For the majority of the time, the character should be balanced, i.e. there should be an equal amount of weight on either side of the imaginary plumb line.

Before you put pencil to paper, act out the movement. Find a reasonably heavy object (I would suggest a bowling ball, but not everyone has one of these lying around) and have a go at picking it up. Remember to lift the ball correctly.

Keep your back as straight as possible and bend your legs to bring yourself down to the ball. When you pick up the object, use your legs to provide most of the momentum (the largest muscle in the body is at the top of the leg) and keep your back straight.

By acting out this sequence, you should have an understanding of the movement, getting the different stages clear in your head. I have provided some thumbnail sketches but use these as a guide. Use your own research to guide your animation for this sequence. This will influence the way you animate the scene, bringing something of you to your animation.

When you act the sequence, exaggerate the weight of the object you are picking up. This will help the animation to work better. By exaggerating the weight of the object it makes the action more clear to the audience.

It can also help to study mime artists. These performers are trained to give the illusion of acting with props that don't exist. In animation the props exist, but they have no substance.

working out the key positions

The first stage is to draw the key positions and then shoot them on a line tester. There are 10 key positions for this sequence. The sequence is 100 frames long.

(Remember to have a go at 'slugging out' the x-sheet. That is, fill out a description of all the key positions in the action column of the x-sheet.)

The first key position is at frame 1. Begin with your character standing over the ball. Make sure the ball isn't too far away; otherwise as the character bends, they will end up having to reach too far forward.

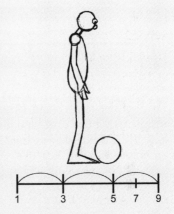

The second key position is at frame 9. Move your character up slightly. This is the anticipatory move (more about anticipation in the next chapter).

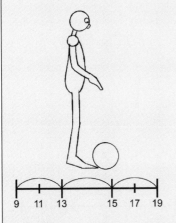

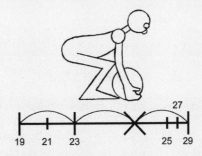

The third key position is a frame 19. This is where our character is grabbing hold of the ball. The hands should be placed at the lower part of the ball.

The fourth key position is at frame 29. As the character starts to pick up the ball, his body will lean back and his bottom will go down. The weight of the ball causes the arms to become straight and even stretch a bit.

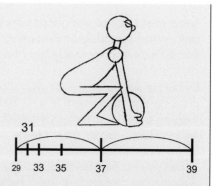

31
29 33 35 37 39

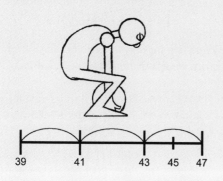

39 41 43 45 47

The fifth key position is at frame 39. As the weight of the body is moved backwards, the arms straighten and the ball leaves the ground. The ball swings between the character's legs.

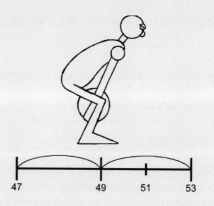

47 49 51 53

Think of the arms being straightened by the weight of the ball and swinging like a pendulum. As the ball travels between the legs, it crosses the plumb line and causes the character to lean forward.

The sixth key position is at frame 47. As the body is raised further, the ball will swing further between the legs of the character, causing the body to lean backwards.

The seventh key position is at frame 53. The character slows down as he goes onto his tiptoes. This is the overshoot position (more about overshoot in the next chapter).

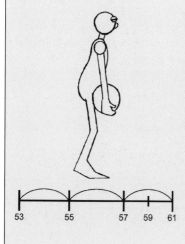

53 55 57 59 61

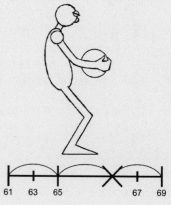

61 63 65 67 69

The eighth key position is at frame 61. As the character starts descending towards the resting position the ball keeps moving upwards. This is because the ball contains momentum from being picked up and wants to keep going.

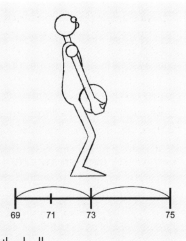

The ninth key position is at frame 69. Our character has moved up slightly from the last key position and the ball has fallen down against its legs.

The tenth key position is at frame 75. Here the character has dropped down slightly and is leaning back and bending the legs to take account of the weight of the ball.

When you've drawn these key positions, shoot them on your line tester (see lift_2D_keys.avi in chapter003 of the CD-ROM to see how the animation should look).

in-betweening the key positions

When we were animating the bouncing balls we could stick quite closely to the timing charts. With a human being it's not that simple. The timing charts should be regarded as a rough guide or reminder to you of where the in-betweens should go. You may find that you will have to make some parts of the character's body move faster than others or leave other bits behind in order to make the movement more believable.

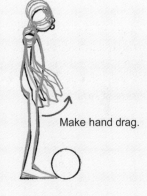

Make hand drag.

Between key position one and key position two (frame 1 and frame 9), make the hands 'drag' a bit to make the wrist movement seem more fluid.

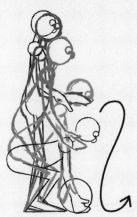

Between the second and third key positions (frame 9 and frame 19), make the hands flail upwards as it moves out of the second key position. As the hand goes downwards towards the ball make it move outwards towards us to give the idea that it is going to grasp the ball.

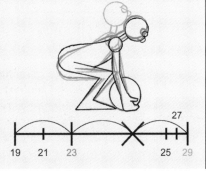

Between the key positions three and four (frame 19 and frame 29), the first bit of the movement is quite slow (19, 21 and 23 are close together) then there is a sudden movement as the arms become taught (a big gap between 23 and 25). At the very end of the movement there are three drawings very close to key position four to decelerate quickly (drawings 25, 27 and 29 are very close together).

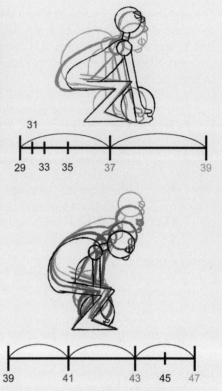

Between key positions four and five (frames 29 and 39) there is a slow movement until the halfway point (29 to 37) and then a sudden movement as the heavy ball 'gives' (between the drawings 37 to 39). At frame 37 the body is positioned half way between 29 and 39 but the ball is positioned about a third of the way between 29 and 39. This will give the impression of the ball being heavy.

Between key positions five and six (frame 39 and 47) the ball swings between the character's legs and slows as it reaches the end of its swing

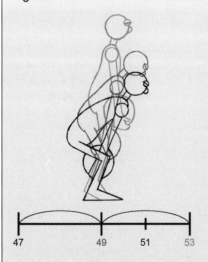

to the left (43, 45 and 47). The arms stay straight and they swing like a pendulum.

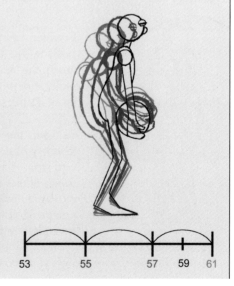

Between keys six and seven (frames 47 and 53) the character reaches the highest position and the ball swings slightly to the right as it is picked up. The arms stay straight and the character goes up onto its toes. The character slows down as this position is reached (49, 51 and 53).

Between keys seven and eight (frames 53 and 61) the character comes back down to earth but the ball continues moving upwards, slowing at its apex (57 and 59).

Between keys eight and nine (frame 61 and 69) the ball falls to a resting point against the character's tummy with the arms at full stretch. The ball comes out of its apex slowly (drawings 63 and 65) then falls quickly (gap between 65 and 67) and then slows into the next key (69). This slowing down is caused by the body moving upwards and the arms stretching slightly, the body slowing to its highest point at key nine (69).

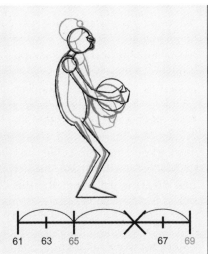

Between keys nine and ten (69 and 75) the character comes down to its final resting position, slower out of key nine (the drawings between 69 to 73 are closer together).

Have a look at lift_2D.avi, chapter003 of the CD-ROM.

the lift in 3D

This scene is 100 frames long.

OK! Lets get animating in 3D. Take all your 'lift' animation drawings and arrange them in a nice pile next to your computer, so you have a reference for each of the key positions. Pin your x-sheet where you can see it so you know the frame number that corresponds with each of your key positions.

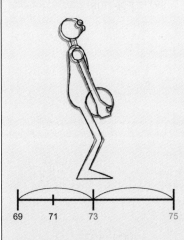

Open up the simple character model that I've built that is appropriate to the program you are animating with. So that's mayaman.mb for Maya, maxman.max for 3D Studio Max; xsiman.scn for SoftImage XSI and lightwave-man.lws for LightWave. You'll find them in the man_model folder in, chapter003 of the CD-ROM. (There are also .pdf files on how to build a basic character in each of the four programs. These are in a folder called 'making man' and are called 'building a man in 3DSMax.pdf',

'building a man in LightWave.pdf', 'building a man in Maya.pdf' and 'building a man in XSI.pdf'. Have a go at animating with the model I've provided first, then if you are interested have a go at building your own character.)

This character consists of a 'skin' made of primitive objects and a set of bones inside that are connected to the skin. The majority of the movement that we are going to do involves selecting these bones at various points and rotating them into the desired position.

The legs and the arms of the character have been set up with inverse kinematics (IK). This means that you can grab the lower part of the leg (or a 'handle' that is connected to it) and move the entire leg. This can make walking and positioning the feet on the ground easier (but sometimes it causes more problems than it solves).

The feet have three 'handles' attached. One square and two diamonds. The square (called LfootControl or RfootControl depending whether it is the left or right one) controls the movement and rotation of the foot. The outer of the two diamonds (called RheelControl or LheelControl) controls the rotation of the heel. The inner of the two diamonds (called RtoeControl or LtoeControl) controls the rotation of the toe.

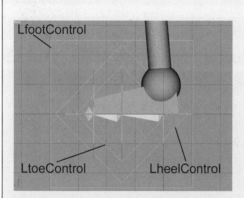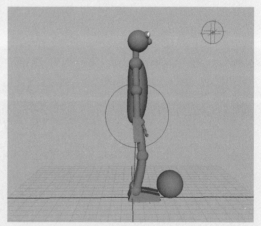

Create a sphere 1.3 units in diameter (13 units for 3D Studio Max) and place it at the feet of your character in the same position as key 1 of the drawn animation (about 3.5 (35 in Max) in X and 1.3 (13 in Max) in Y).

(We also need to make a second ball to attach to the hand of the character. The reason for this is that if you try to get your character to pick up a loose ball, it slops all over the place in its hands. The first ball will stay on the ground all the way through the scene. At the point that the character grabs the ball it will become invisible. The ball attached to its hand has been invisible up to that point and will then become visible. This all happens at frame 29.)

Then you need to move your character into each of the major key positions at the appropriate frame numbers and tweak the way the computer does the in-betweens. This is done either by adding extra key frames (breakdowns) or by manipulating the animation curves appropriate to your program.

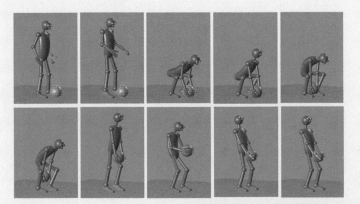

As with the drawn animation, you will need to add some extra key positions to improve the animation. Set these extra key positions at the equivalent of the breakdown positions of the drawn animation.

Between key position one and key position two, make the hands drag a bit to make the wrist movement seem more fluid.

Between the second and third key positions, make the hand flail upwards as it moves out of the second key position. As the hand goes downwards towards the ball make it move outwards towards us to give the idea that it is going to grasp the ball.

Draw on the screen with a chinagraph pencil to mark previous key positions as a guide to your animation.

Have a look at lift_3D.avi, in chapter003 of the CD-ROM.

In chapter003 of the CD-ROM, you will find .pdf files that go into more detail about how to do the lift animation exercise in each of the four animation programs. These are called 3DSMax_lift.pdf, lightWave_lift.pdf, Maya_lift.pdf and XSI_lift.pdf.

the push in 2D

In this exercise we will get our character to push a heavy object. In this case it is a heavy block.

To get a feeling for this, try pushing something heavy. If you cant find anything, then try leaning against a wall facing it and pushing. This will give you an idea of how to approach this exercise. As your character leans against the block you will find that the plumb line will be forward of the legs. The further forward your character leans, the heavier the block will look.

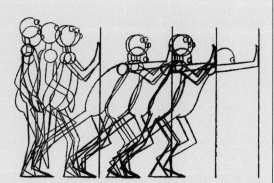

Imagine that the block is pushed along when our character has both feet on the ground. The block moves a little, then stops. The character takes a step, then when both feet are on the ground the block is pushed again. It moves a little and stops, the character then takes another step and so on.

working out the key positions

The sequence is 130 frames long.

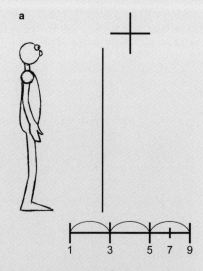

a

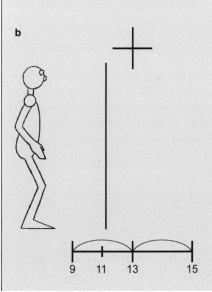

b

1 3 5 7 9

9 11 13 15

The first key position is at frame 1. This is our starting point. Our character is looking at the block apprehensively!

The second key position is at frame 9. This is where our character bobs down in anticipation of stepping towards the block.

The third key position is at frame 15. At this point the character is halfway through the step towards the block.

c

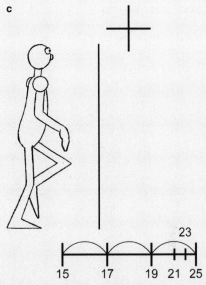

d

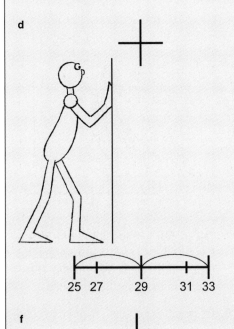

The fourth key position is at frame 25. Our character places his hands on the block.

e

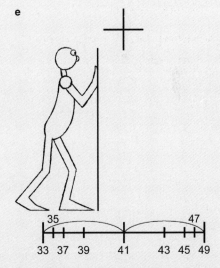

f

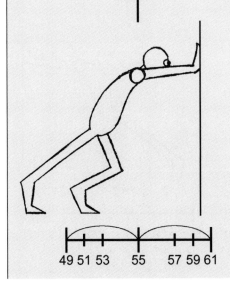

The fifth key position is at frame 33. The body moves slightly forward but because the block will not move immediately, the hands stay in the same place and the elbows bend, closing the gap between the hands and the shoulders.

The sixth key position is at frame 49. The block starts to move as the arms straighten and the body angles forward and the legs unbend. The body is now at full stretch and the block stops moving.

The seventh key position is at frame 61. With the block now stationary, the character takes a step towards it. This key position is very much like the fourth key position but one step ahead.

g

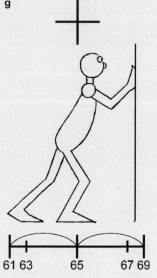

61 63 65 67 69

h

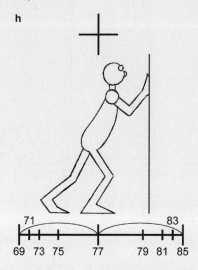

71 83
69 73 75 77 79 81 85

The eighth key position is on frame 69. The body starts moving but the block and hands stay in the same place so the arms bend a little.

The ninth key position is at frame 85. The body is now at full stretch and the block has moved.

i

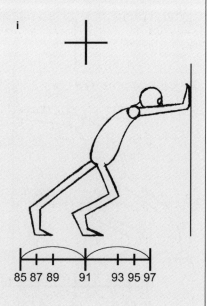

85 87 89 91 93 95 97

j

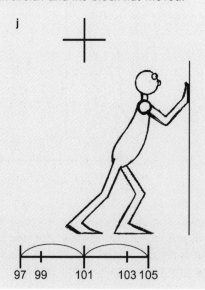

97 99 101 103 105

The tenth key position is at frame 97. The character has taken a step towards the block.

The eleventh key position is at frame 105. The arms bend as it starts pushing.

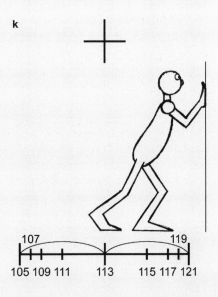

The twelfth key position is at frame 121. The final key position has the character at full stretch having pushed the block.

Shoot the keys on your line tester. Once you are happy with the timing, mark up the key positions on an x-sheet and re-number them by the frame (see push_keys.avi in chapter003 on the CD-ROM).

in-betweening the key positions

The in-betweens between the first, second and third key positions are fairly straightforward and follow the timing charts. Drag the head slightly on the way down (between frames 1 and 9) and drag the hand slightly on the way up (between frames 9 and 15).

With the in-betweens between the third key position (frame 15) and the fourth key position (frame 25), have the hand describe an arc through the wrist before it is placed on the block.

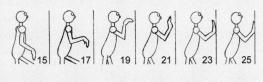

The in-betweens between the fourth key position (frame 25) and the fifth key position (frame 33) are where the character moves slightly forward but the block won't give. These are fairly straightforward, so just follow the timing charts.

With the in-betweens between the fifth key position (frame 33) and the sixth key position (frame 49) have the back arch up to the shoulders as the block is pushed. The arms lock straight at the breakdown position (frame 41) and stay straight until the sixth key position (frame 49).

The in-betweens between the sixth key position (frame 49) and the seventh key position (frame 61) are where the character takes a step towards the block, so the breakdown (the major in-between at frame 55) will be a 'cross over' position. This is where one leg is picked up and crosses over to be placed down ahead of the other.

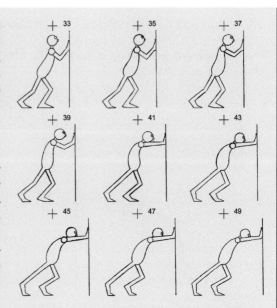

The rest of the in-betweens in the sequence repeat the pattern set above. Between keys seven and eight (frames 61 and 69) the in-betweens are a repeat of those between keys four and five (frames 25 and 33), where the character does the initial move before the block starts to move. Between keys eight and nine (frames 69 and 85) the in-betweens are a repeat of those between keys five and six (frames 33 and 49) where the block is pushed. Between keys nine and ten (frames 85 and 97) the in-betweens are a repeat of those between keys six and seven (frames 49 and 61) where the character takes a step towards the block, only the other leg does the cross over. Keys ten and eleven (frames 97 and 105) are in-betweened like those between keys four and five (frames 25 and 33). Finally the in-betweens between keys eleven and twelve (frames 105 and 121) are a repeat of those between keys five and six (frames 33 and 49)!

Take a look at push_2D.avi in chapter003 of the CD-ROM to see the completed sequence.

the push in 3D

Load your character into the scene and save the scene as 'push'. Create a block for your character to push which will be 15 units by 15 units by 15 units (or in 3DS Max

150 units by 150 units by 150 units). Place this block about 5 units (or in 3DS Max, 50 units) in front of your character.

Set keys at each of the appropriate key positions, just like your drawn animation, and slide the block along at each of the pushes. Hopefully you'll have something that looks like push_3D_loose.avi in chapter003 of the CD-ROM.

Open up the animation curves in your program, select all of the key positions and convert the curves to stepped (Maya), constant (XSI), etc. You should then have something that looks like push_3D_keys.avi in chapter003 of the CD-ROM.

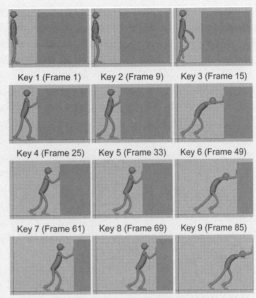

Key 1 (Frame 1) Key 2 (Frame 9) Key 3 (Frame 15)

Key 4 (Frame 25) Key 5 (Frame 33) Key 6 (Frame 49)

Key 7 (Frame 61) Key 8 (Frame 69) Key 9 (Frame 85)

Key 10 (Frame 97) Key 11 (Frame 105) Key 12 (Frame 121)

Take out the first two key positions (drawings 1 and 9) of your drawn animation and the in-between drawings (or have a look at the illustrations **a** and **b** on p. 68). The two breakdowns are at frames 3 and 5. On the computer go to frame 3 of your animation and 'ghost' it so that you can see the key positions at 1 and 9 (or better still draw these two positions on the screen with a chinagraph pencil). Go to frame 3. Translate and rotate your character so that it is in the same position as drawing 3 (about a third of the way between drawings 1 and 9). When you are happy with this, select everything and set a key. Repeat for frame 5, which is one third closer to frame 9. Frame 7 (the other drawn in-between) should be OK for the computer to do!

Between the second and third key positions (frames 9 and 15) the breakdown is at frame 13 and is halfway between the two keys. Select frame 13 on the time slider and position your character halfway between the key positions at frames 9 and 15 (see the illustrations **b** on p. 68, and **c** on p. 69). One thing that is quite nice to do is to make one of the arms slightly later than the other. This just makes the movement look a bit more natural rather than mechanical.

Between the third and fourth key positions (frames 15 and 25) have the hands follow an arc through the air before they make contact with the block (see the illustrations **c** and **d** on p. 69).

Between the fourth and fifth key positions (frames 25 and 33) we can let the computer do the work for us, so specify that the animation curves between these two key points should be spline (see the illustrations **d** and **e** on p. 69).

Between the fifth and sixth key positions (frames 33 and 49) the character is pushing the block. In order to get the impression of it putting in a lot of effort we need to arch its back at the breakdown position (frame 41). So do this breakdown first and then do the in-betweens either side of it (frames 39 and 43) (see the illustrations **e** and **f** on p. 69).

Between the sixth and seventh key positions (frames 49 and 61) the character takes a step towards the block. The breakdown is the cross over position, which is at frame 55 (see illustrations **f** on p. 69 and **g** on p. 70), half way between frames 49 and 61. Put the time slider to frame 55 and arrange your character into this position and set a key. Then go to frame 53 and position the character halfway between the character's positions at frames 49 and 55. Then go to frame 57 and position the character halfway between the character's positions at frames 55 and 61 (see illustration **f** on p. 69 for the timing chart).

The rest of the in-betweens in the sequence repeat the pattern set above. Between keys seven and eight (frames 61 and 69) the in-betweens are a repeat of those between keys four and five (frames 25 and 33), where the character does the initial move before the block starts to move. Between keys eight and nine (frames 69 and 85) the in-betweens are a repeat of those between keys five and six (frames 33 and 49) where the block is pushed. Between keys nine and ten (frames 85 and 97) the in-betweens are a repeat of those between keys six and seven (frames 49 and 61) where the character takes a step towards the block, only the other leg does the cross over. Keys ten and eleven (frames 97 and 105) are in-betweened like those between keys four and five (frames 25 and 33). Finally the in-betweens between keys eleven and twelve (frames 105 and 121) are a repeat of those between keys five and six (frames 33 and 49)!

Take a look at push_3D.avi.

In chapter003, of the CD-ROM you will find .pdf files that go into more detail about how to do the push animation exercise in each of the four animation programs. These are called 3DSMax_push.pdf, lightWave_push.pdf, Maya_push.pdf and XSI_push.pdf.

the pull in 2D

This last exercise follows a character pulling an object.

Imagine a large block with a rope attached to it. Our character hauls on the rope to pull the block along. The further the character leans away from the block, the heavier it will appear.

As with the other exercises, acting the sequence will help you to get a clear

understanding of the movement. You could sit a friend on a chair and try pulling them along.

Remember that you may find a different way of doing this movement from the way I've animated it. If so, do it your way. This sequence is 100 frames long.

The first key position is at frame 1. The character is stood in front of the block with the rope hanging loose from their shoulder.

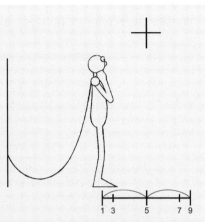

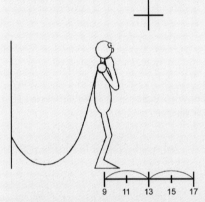

The second key position is at frame 9. This is where the character bobs down in anticipation of the first step.

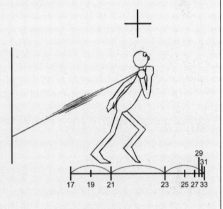

The third key position is at frame 17. At this point the character has taken the first stride and the rope has gone tight.

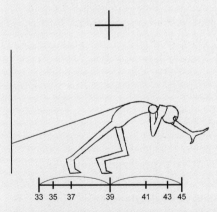

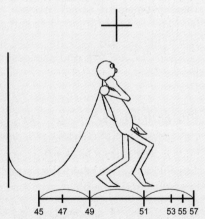

The fourth key position is at frame 33. Both feet are on the ground and our character has leant forward to pull the block.

The fifth key position is at frame 45. The character has taken a step forward while leaning the body back allowing the rope to fall loose.

The sixth key position is at frame 57. The character leans forward and the rope tightens.

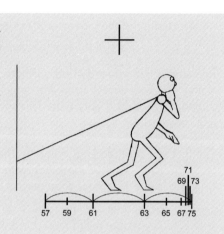

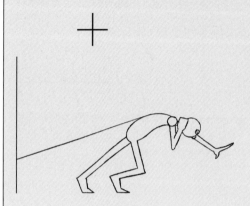

The seventh and final key position is at frame 75. Both feet are on the ground and our character has leant forward to pull the block.

Shoot these keys on the line tester to see how they work. See pull_2D.avi in chapter003 of the CD-ROM.

in-betweening the key positions

The in-between drawings follow the timing charts on the whole. Just remember to arch the characters back as it leans against the rope and pulls the block.

These in-betweens occur between the third key position (frame 17) and the fourth (frame 33) and the sixth key position (frame 57) and the seventh (frame 75).

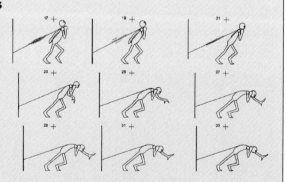

the pull in 3D

This is the most difficult exercise we've tried so far in 3D. It is particularly fiddly and you have to think about three things at once. The character, the rope and the block and how they relate to each other. The character is always going to be the most important of these three elements. The block and rope react to what it does and give it resistance.

Build a block 15 units by 15 units by 15 units (in 3DS Max, 150 by 150 by 150), just like in the last exercise but place it behind your character by about 11 units (110 in 3DS

Max). You then need to make a rope. This consists of a very long thin cylinder with lots of bones running down the length of it. Make it 25 units in length (250 in 3DS Max) and have a bone for every unit. It should then be attached to the block at one end and the character at the next. The bones then need to have IK attached, to help control the rope.

Work through your drawings (or the illustrations shown in the pull in 2D exercise), manipulating the character into each of the key positions at the

corresponding frames and setting a key on everything!

Take a look at pull_keys_3D.avi.

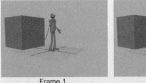
Frame 1

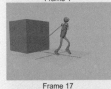
Frame 9

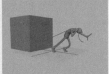
Frame 17

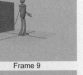
Frame 33

Frame 45

Frame 57

Frame 75

Frame 100

Once the keys are done go back over the animation sorting out the breakdowns, the foot slip and anything else that looks a bit untoward.

Take a look at pull_3D.avi.

Getting the rope to work correctly is a real pain, and all the programs have a slightly different way of dealing with it!

On the CD-ROM in chapter003, you will find .pdf files that go into more detail about how to do the pull animation exercise in each of the four animation programs. These are called 3DSMax_pull.pdf, lightWave_pull.pdf, Maya_pull.pdf and XSI_pull.pdf.

chapter 4

timing, anticipation, over-shoot, follow-through and overlapping action with an animated character

timing

This is probably the most difficult thing to teach and learn about in animation. Timing makes a movement witty or touching or relevant. It is central to any form of film making, whether live action or animation. It runs through all elements of visual moving imagery. Every chapter in this book is about timing.

Timing is about conveying information to your audience so they can follow the action. I always think that good timing is the minimum period you give your audience to understand what is happening. If you make a move or a pose too quick, they won't follow what's going on, make a move or a pose too slow and the audience will be bored. Timing will control how your audience reacts to what they see. Sometimes you will make your audience wait for the action, or you can lead your audience to expect one thing to happen and then another thing happens (surprise is the basis of a lot of humour). You can lull your audience into a state of complacency through repetition and then make your character do something different. These are only a few examples of the use of timing but you can see what I mean about it being difficult to teach.

I touched on timing in Chapter 1 and I have been through the basic stages of working out timing during the exercises. To recap, these are as follows. First, draw the key positions (making sure they are as clear as possible) and shoot them on a line tester for the required amount of time (see Chapter 1). Then vary the number of frames each drawing is held for, until you have a series of stills that express all the information needed for the scene. You then show this to as many people as possible and ask them if they can understand the scene. If all or some of the drawings flash past and no one understands the action, give the offending drawings more frames. If your audience does understand what's going on, well done, but make all the drawings play back for a shorter amount of time. Show this to your audience and see if they still understand it. Keep everything as tight as possible. Never be happy with something that will just do. Always keep pushing your audience, keep experimenting with what you can get away with. Having said this, you must allow for movement between your key positions. Err on the side of being slightly too slow. You can always take out the in-betweens later.

Once you have a sequence of key positions that you are happy with, you can then work out how many drawings to do as in-betweens and where they should be placed (mark these up with timing charts at the bottom of every key).

The best way to work out the position of the keys is to act out the movement of your character in front of a mirror. Using a stopwatch to time this is very helpful. If you don't have a stopwatch try saying 'one little monkey, two little monkeys, three little monkeys' ('one little monkey' takes about a second to say,

'one little' takes about a half second, so does 'monkey'. 'One', 'little', 'mon' and 'key' take about a quarter of a second each to say). Of course acting out a scene in front of a mirror while saying 'one little monkey, two little monkeys' will make you seriously question your sanity. Don't worry! This is the first part of the process in becoming an animator. Get used to working things out this way. Keep thinking of the minimum that the character needs to physically do in a scene. Never try to fit too much information into too short a period of time. Keep things simple.

As you watch yourself, make thumbnail sketches showing the progression of the movement. This way you don't forget the sequence when you get back to your desk. Act out the scene

until the movement becomes second nature and you can feel what's happening at all points as you draw or move the scene on your computer.

Observing other people acting out a scene, or going about their daily lives will also help with your understanding of timing. Watch people and become familiar with how they're moving and how long it takes them to do certain actions. When you're sat at a table outside a coffee bar or pub, watch the people walking by. When watching them use a stopwatch to time how long an action takes. You could say 'one little monkey, two little monkeys ...' (although not too loud). Also think about what's going through their mind. Are they moving slower because they're depressed or they're contemplative? Are they moving faster in order to get somewhere quickly, or do they need to get away from something?

Timing comes with experience. Experience comes by doing lots of animation and getting it shown to as many people as possible. Don't be afraid of asking for advice, be big enough to take criticism and always think of your audience.

anticipation

Every action initiated by a living creature (humans, animals or inanimate objects that have a character) will look better if you use an anticipatory move prior to the main move. An anticipatory move is one that precedes the main movement your character will make, and follows a path that is in the opposite direction to that main movement.

Anticipation serves two purposes.

It communicates to the audience that the character is initiating a major movement. It's as if the character is winding itself up prior to making the move.

It alerts the audience to the fact that something is going to happen and makes sure they are looking at the right place on the screen to see that move (it's all very well doing a move that will surprise an audience, but if they are not looking at it they won't see it and consequently won't be surprised).

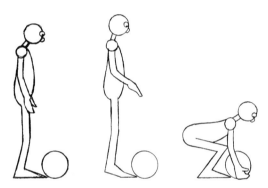

A few examples of anticipatory moves follow.

If somebody is going to bend down to pick something up, they will make a slight move upwards (in the opposite direction to the main downward movement), before bending over.

Before walking in one direction, they will pull themselves back (in the opposite direction), before taking the first step.

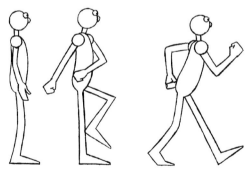

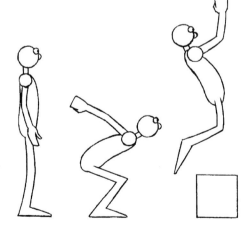

If somebody is going to jump up over something, they will bend their knees and body down into a crouch (bending their arms upwards and backwards) before they jump.

Before throwing something, they will pull their arm back (and lean their body back) in order to put as much energy into the throw as possible.

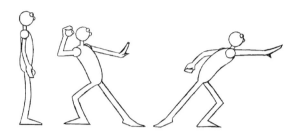

If someone is about to faint and fall to the ground they will straighten up before falling.

If a character is flying through the air and they suddenly fall (Icarus, losing the ability to fly, for example), they will flinch upwards before falling out of screen.

The main occasion that you wouldn't use anticipation is when animating an inanimate object affected by gravity and you don't want to give the impression of the object being alive.

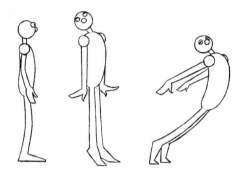

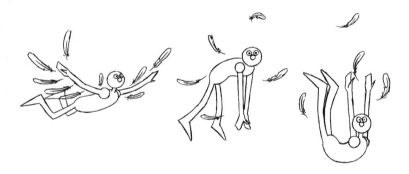

how much anticipation

This depends on a number of factors.

- How much *force* is being put into the move.
- How *fast* the move is.
- How much you want to *surprise* the audience.
- Whether the anticipation is taking place *during a move* or is initiating a *change of direction* during a move.
- It also depends on whether part of the character's body is anticipating the move or the whole body.

force

These are examples showing how force affects anticipation.

If somebody wants to throw a relatively light ball a long distance, they will lean right back in anticipation of the throw. They will pull back with the ball into the extreme position relatively slowly and accelerate out of the extreme position quickly.

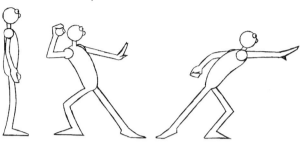

If they were throwing the same ball a short distance, and trying to hit a target with accuracy, the extreme position will not be as far back. They will move slowly backwards into the extreme position and accelerate slowly out of it, making a quick movement at the end of the throw with a flick of the wrist.

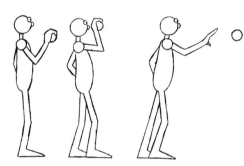

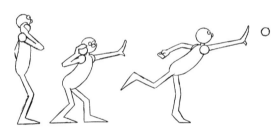

If somebody is trying to throw a heavy ball, they may not be able to lean back very far without unbalancing themselves. In this case the ball would be kept fairly close to the body. The body would be used more in the throw, bending down at the knees and swinging the arms (if they are both holding the ball), just far enough backwards to prevent themselves from overbalancing. They could perhaps take a step back or part their legs further in order to keep the centre of balance above and between the legs.

When jumping, the weight that the character is trying to move is themselves. A heavier character will need to anticipate more than a lighter character in order to jump in the air!

When jumping upwards the direction of the anticipation is straight down. The higher somebody wants to jump the further down a body will have to crouch in anticipation.

If somebody wants to jump a long distance they will pull themselves backwards and downwards in anticipation. The amount backwards and the

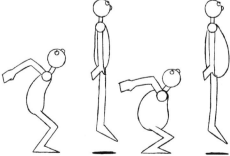

amount downwards depends on the angle at which the character will jump. Anticipating downwards for height and backwards for distance. Rather than keeping the two feet together the legs will take a stride.

acting and anticipation

When it comes to acting, the way a character moves when changing position will influence how extreme the anticipation is. A slow movement could have a small anticipation. A fast violent move would need a larger anticipation. A sudden movement would barely have any anticipation at all. Added to this is the frame of mind the character is in together with their surrounding environment. Usually there will be an anticipatory position, before or during any move.

One way to carry out this is to have a small anticipatory move of the head in the opposite direction of the major move. Make the eyes move in the direction of the major move first. If a character is going to look screen right, the eyes will look screen right first, while the head

does a small anticipatory move to the left. It will then turn to face screen right following an arc.

Sometimes anticipation in acting can be as small as a slight roll of the eyes; sometimes it can be as huge as a full-blown double take.

double takes!

The classic example of anticipation is a double take (called this because it involves a character looking at something twice – taking something in twice). This is when a character catches sight of something (perhaps out of the corner of its eye) but does not take in the significance of what it has seen. This first look would be followed by an anticipatory move. This could lead to the character almost screwing themselves up (in the opposite direction to the major or 'take' move). This anticipatory move is followed by the second look. The second

look can be as extreme as the eyes popping out of their sockets and a huge mouth with a large wagging tongue. Watch any Tex Avery film if you want to know how to do an over the top double take correctly.

Double takes don't have to be as extreme as this. They can be as subtle as a small nod of the head from the first look to the next. This gives the suggestion that the character has seen something, is slightly surprised by what they've seen and needs to see it again to make sure their eyes are not deceiving them.

speed and surprise

If a movement is quick or is made suddenly, it's best to use a small anticipatory move. Having said that, much depends on the force and the speed of the move. Somebody running fast will start with a big anticipatory move.

To shock your audience with an unexpected action, you may think there would be no anticipatory move. If this was left out the audience could miss the action because they may not be looking at the right place. Have a small and very quick anticipatory move (just enough to catch your audience's eye) and then do your sudden move.

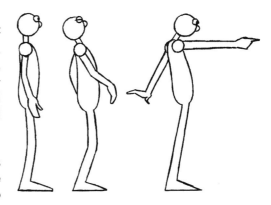

Another way of giving a hint that something is going to happen is to make another part of the body do the anticipatory move. In this example the character is pointing with his right arm. Make its arm move suddenly away from the body. The rest of the body would be thrown back first and then be dragged forward by the arm.

This relative flinging of the body backwards acts as an anticipatory move and gives the audience something to latch onto prior to and during the major move.

anticipation during a move

Anticipatory moves, as with the sudden movement we discussed above, don't have to happen before a move, they can happen during a move as well.

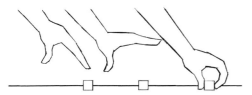

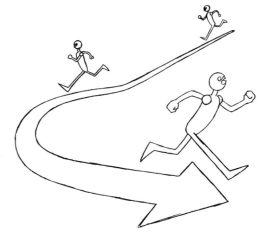

If somebody is moving their arm to pick something up, as the hand approaches the object it may pause and pull back slightly, opening its fingers just before it grabs the object. The arm as a whole is moving all the time, but the hand relative to the arm is moving backwards (anticipatory move) and then forward (major move).

If a character is running and wants to change direction, they could twist away, still running, before executing the main turn. I always think of this in relation to driving a car and making a tight turn. In order to do this you have to initially steer outwards in order to increase your turning circle. The same is true of a four-legged character like a horse or a dog.

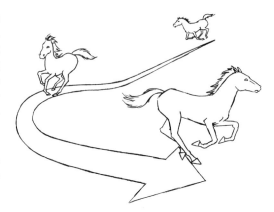

When walking or running around a corner the head will always turn into the corner first followed by the body.

This all helps with creating momentum and it alerts the audience to the fact that the character or animal is going to make a turn.

If a character is tripping up you can always make it look better by having a very slight pause at the first point of the trip (to get the audience wondering whether the tripper will fall over or not). Use a few frames (six to eight), then as gravity takes hold, part of the body (led by the stomach (centre of gravity)) starts to fall toward the ground. Have the arms, the head and the legs thrown back slightly in the opposite direction to the fall before following the rest of the body.

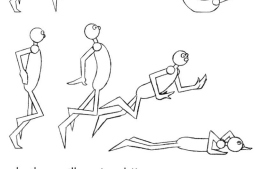

This is a very cartoon like trip and, hopefully, will make an audience laugh. A more naturalistic trip will look something like the illustration. An audience seeing this trip will not laugh, they will go 'ouch'!

varying the amount of anticipation

This is to do with the amount that the body anticipates a given move over its entirety. If a character is going to point with its arm, the arm is going to pull back in anticipation by a large amount. The body will pull back by only a small amount, the head (especially if the character is looking at something intently) may move by an even smaller amount.

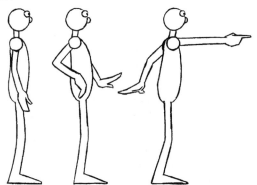

If a character is going to make a move which uses the entire body, then the whole body

will do an anticipatory move. Any variation across the body will be relatively less.

When animating a scene where there will be several anticipations, try to think of different ways of doing each anticipatory movement. If they are all done in the same way your animation will look very mechanical and repetitive.

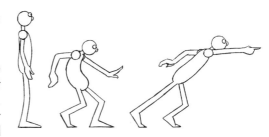

other ways of using anticipation

Anticipation can also be used with special effects animation. When something is struck by lightning, the clouds that generate the flash should light up at different patches. This will let the audience know that something is about to happen. Just before the bolt of lightning appears have a white flash frame.

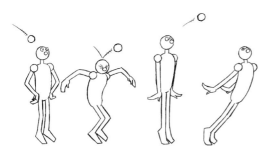

Otherwise the audience misses the bolt of lightning.

Somebody hit on the head by a rock will bounce up straight into the air before falling over, anticipating the fall.

follow-through

When a character initiates a move, follow-through is the movement by additional matter, which follows the major anticipation and overshoot movement. This follow-through movement is made by the extremities of the body, such as hair, ears, tails, etc. and also ancillary items such as clothing and general drapery.

follow-through of inanimate objects

This is the animation of hair, manes, coat tails, ties, sleeves, strings, general drapery, etc.

Generally inanimate objects connected to your character will follow a path similar to the part of the character they are attached to. Depending on the size and flexibility of the object it will flail out from the end of this path to varying degrees.

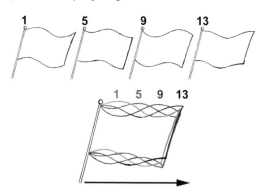

Depending on the stiffness of the object, you will get a slightly different type of follow-through. Generally a piece of drapery will demonstrate a wave running along its length as it is pulled through the air. At its most simple this is like a flag cycle. See flag_cycle.avi chapter004 of the CD-ROM.

A flag cycle consists of a piece of cloth that has a wave running though it. Each crest of the waves on one drawing becomes the crest of wave on the next drawing. The first key drawing (number 5) is the mirror image of the first key position (number 1) and the fourth key drawing (number 13) is the mirror image of the second key drawing. They will then need in-betweening. You should shoot these drawings: 1, 3, 5, 7, 9, 11, 13, 15, 1, 3, 5, 7, 9, 11, 13, 15, etc.

Imagine a piece of cloth being pulled through the air. The cloth will drag behind the point where it is being held by the hand, flailing outwards at the end. If the hand

slows down or stops, the cloth will catch up with the hand and start to move ahead.

A piece of string or rope will act in a similar way but because they have a greater flexibility

than a piece of cloth they will flail out of the path set by the character to a larger degree.

A steel chain will do something similar but will always be affected by its weight falling faster, but not swinging as far.

If the object holding the cloth speeds up, the cloth straightens as it is left behind. Just give it a very tight wave running along its length.

follow-through of animate (living) objects

This is the animation of ears, tails, breasts, beer bellies and to a lesser extent, arms, legs, the neck and head. Anything that at certain times moves loosely on the body.

Rather than following the path of the character, these body parts have a life of their own. They follow the pattern of cloth or string but can be more exaggerated.

Tails are extensions of the backbone and as such have a particular movement. Always think of them as part of the backbone and think of them as resembling a chain of joints.

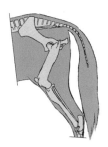

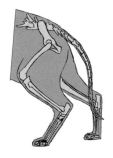

It's worth knowing how much of the tail is backbone as it varies from animal to animal and will affect how the tail moves. A horse's tail is a relatively short stump of bone with a large amount of long hair attached to it. A cat's tail is backbone along its entire length.

In the same way that a piece of string will, to a certain extent, follow a path led by the part of the body that initiates the movement, the same will happen with the tail. This time the movement is led by the animal's bottom.

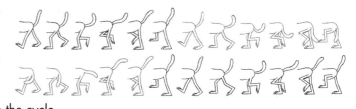

Occasionally the animal will initiate a slight movement through the tail itself. So for most of the time the tail will follow a cycle but occasionally it will give a twitch and do something slightly different. The tail will then return to the cycle.

Think about how much of the tail will be following through and how much is initiated from within. Some of the movement is as a result of the animal's bottom moving and some of the movement is as a result of the animal moving the tail.

Ears move slightly differently. As with the tails, the make-up of the ear will vary from animal to animal. This affects the movement during follow-through. With dogs ears for example, a spaniel's ears will move in a much more floppy way than a terrier's ears. This is because a spaniel's ears are larger and softer and a terrier's ears are shorter and stiffer.

Any sort of hair will move more like an inanimate object, because hair consists of a huge amount of individual strands. On their own they would move like a piece of light string, but collectively they have a firmer quality. It is always a good idea to simplify a clump of hair to an outline with a few individual strands highlighted. To draw every single

hair would take a very long time. In 3D whole sections of the animation program are dedicated to the animation of hair and to a certain extent will do a lot of the work for you. It is always a good idea to have some understanding of how hair works.

As with the previous examples, the level of follow-through depends on how extreme the movement is. If we take as an example a head moving from side to side; as the head moves from one side, the hair fans out close to the scalp. It then starts to taper towards the tips before pinching up thinner at the extreme of the movement.

With 3D-computer animation it depends how naturalistic you want to be. Keep in mind that the more realistic your design, the more realistic the audience expects it to move.

The limbs of a character will demonstrate follow-through during a movement. The amount of follow-through is dictated by the nature of the action.

An animated arm that accurately follows the true movement of the limb may look ungainly to the audience. When you animate a sequence like this it can look jerky and not flow nicely.

The arm should be re-drawn so that the arm flows with the movement.

To achieve a graceful movement as an arm moves into a resting position may require the bending of

joints into impossible positions. This way of achieving fluidity by cheating is often called the 'breaking of joints'.

Imagine that the arm is a length of rubber hose and will follow-through the movement initiated by the hand. This will look fluid but will also look odd, as

though it has lost the elbow and the wrist joint. To make it more convincing, take this piece of animation but add the elbow and the wrist joint to it. Bend the elbow or wrist joint in such a way that it follows the general bend of our rubbery arm. Don't worry that the joints do something impossible. As long as it moves nicely it doesn't matter!

You can take this idea further when any of the limbs are moving at a very fast speed. The arms can lose their joints altogether and even be distorted along the length of the movement to suggest speed. This is referred to as 'smearing'.

What is happening is that the movement is so fast that each individual shot frame is not fast enough to catch a sharp image of a particular bit of the movement.

A similar thing happens in live action film-making. If you look at the individual frames of a live action

sequence which shows a fast movement, the image will be distorted.

The leading part of the moving limb will be fairly sharp but the trailing part will be blurred. You can replicate this in your animation in a number of ways. These include smearing, adding whiz lines or (in 3D) motion blur.

Smearing and whiz lines tend to be more cartoon like, motion blur tends to be more realistic. With all of these techniques they should only be used at the appropriate time. If you use these tricks to slow a movement you end up with a mutant limb. You should never actually see any of these distortions but you should miss them if they are not there. Only ever use them with a fast move.

If a character is moving so fast that they cannot control their limbs, we will get the most distorted follow-through. This will happen, for example, when a character is falling through the air or is being pulled out of screen.

Generally it's always a good idea to animate the follow-through of these parts of a character after you've done the main animation. Follow-through always works better if you animate straight ahead, so take your completed rough animation and put the additional followed-through bits on afterwards.

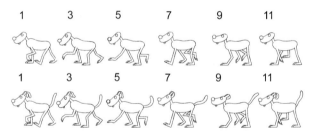

overlapping action or overshoot

When a character makes a move and then comes to a stop it's always a good idea to make individual parts of that character come to a stop at different times. This gives the impression of a character that is alive. Having a character come to a dead stop makes a character look just that, dead! A good way of doing this is

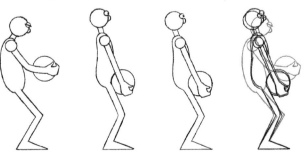

to give your character overlapping action. This means making your character go slightly

beyond the position it will come to a stop in and then going back to this position. It over-shoots its final position. A good example of this is at the end of the lift sequence in the last chap-ter. The character moves upwards after the ball is picked up and then settles down at the end.

For example, when a character lands on the ground after jumping, the legs will bend as the knees take the weight. The arms will 'flow' for-ward in an arc and be pulled back as the body unbends. The head will be tilted backwards as the body falls and be dragged back up as the

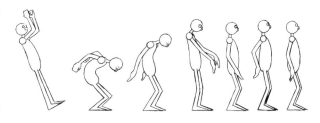

body straightens. When the body comes to a stop the head will go slightly beyond its final resting-place and then come back to a stop. This is what overshoot is. Extremities of the body go beyond the body's final resting place and then come back to rest.

When somebody points, the finger doing the pointing will go slightly beyond its final rest-ing position. You could even lose the joint and make the arm perfectly straight at the most extreme position and try stretching the arm as well.

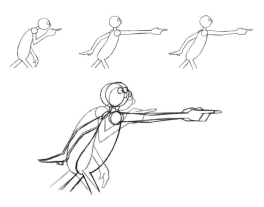

When a head moves from one side to another, it will go slightly beyond its final rest-ing position and then move back to a stop. The hair continues to move, as will the jowls, ear-rings and any other loose items. The hair, being lighter, will go further beyond the stopping position; the ear-rings, being heavier and more solid, will not go as far. The jowls will only go beyond their resting position a small amount before coming to a stop. Both the hair and the jowls will come back to a final resting position but at slightly different times; the hair will come to a stop last.

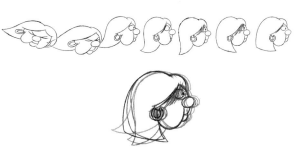

Drapery will move beyond the character's final resting position and then flow back to a graceful stop.

Making parts of you character come to a stop at different times always improves your animation.

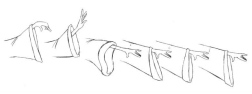

vibration

When we have a stiff object that can show a small amount of flexibility, like an arrow, a plank of wood or a fishing rod, we will get a certain amount of vibration with its follow-through and overlapping action.

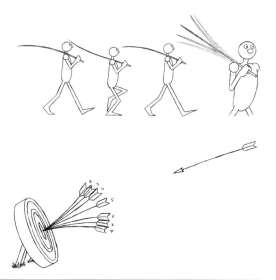

When an object like this comes to a sudden stop or is bent and then released we get a vibrating movement.

To put these drawings on an x-sheet put drawing 1 at frame 1 then drawing 5 at frame 2, drawing 2 at frame 3, drawing 8 at frame 4, drawing 3 at frame 5, drawing 7 at frame 6, drawing 4 at frame 7, drawing 6 at frame 8 and finally drawing 5 at frame 9.

exercises

the string and stick in 2D

For this exercise we will animate follow-through using a piece of string attached to a stick. Imagine the stick being waved through the air by someone's hand and the string trailing after it. The stick will move forward in an arc, stop and then move back again dragging the string behind it. When the stick reaches the end of its arc, the string overlaps. The stick is then moved through an arc back to the first position, the string being dragged and then overlapping. This action is repeated a second time and then the stick comes to a stop at the same position as frame 1. The piece of string overlaps and comes to a rest. This scene is 100 frames long.

First animate the stick, without the string. For the first key position draw your stick at a jaunty angle.

The stick is going to move forward in an arc to an angle that is a mirror image of the first position. This is key 2. This is at frame 17.

Bring the stick back to the same position as key 1. This is the third key position. This is at frame 33. Draw the stick at the same position as key 2 for the fourth key position. This is at frame 49. Finally

draw the stick at the same position as key 1 for key position 5. This is at frame 65. Have a look at stick_2D_keys.avi in chapter004 of the CD-ROM to get the idea.

In-between the key positions by accelerating out of one key position and decelerating into the next.

Have a look at stick_2D.avi in chapter004 of the CD-ROM. This is the stick waving backwards and forwards.

Now animate the string as 'straight-ahead' animation, drawing on top of your stick drawings. Start with the string hanging down from the end of the stick on frame 1. As the stick moves forward to the next drawing, the string will be pulled forward through the air and will follow-through the shape of the previous drawing.

When the string reaches the second key position (the point where the stick comes to the end of its arc) the string will keep going forward and will be pulled in the opposite direction as the stick moves back through its arc.

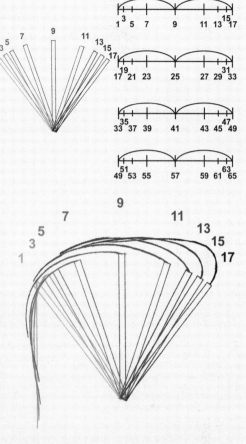

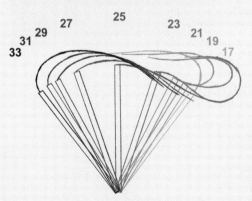

When the stick reaches the end of the second arc (key position 3) the string will keep

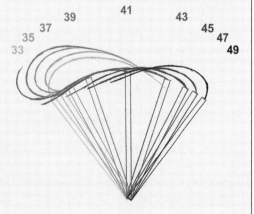

going forward and then be pulled in the opposite direction as the stick moves back through its arc.

When the stick reaches the end of the third arc (key position 4) the string will keep going forward and then be pulled in the opposite direction as the stick moves back through its arc.

When the stick reaches the end of the fourth arc (key position 5) the string will keep going forward and then be pulled in the opposite direction as the stick moves back through its arc.

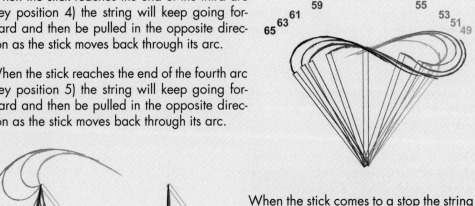

When the stick comes to a stop the string will swing over and sway to a stop.

Take a look at stick_string_2D.avi in chapter004 of the CD-ROM.

the string and stick in 3D

First we need to build our stick and string. Create two cylinders, arrange them in a position that resembles the first position of the drawn animation and put bones into them.

This is described in greater detail in the .pdf files; 3DSMAX_stick_string.pdf, LightWave_stick_string.pdf, Maya_stick_string.pdf and XSI_stick_string.pdf in chapter004 of the CD-ROM.

Animate the stick rocking backwards and forwards, then animate the string every other fame at a time, copying the drawn animation (final five illustrations in the 2D exercise).

the dive in 2D

We will animate a character diving off a cliff, then bouncing off a diving board and finally splashing into the sea. This scene is 70 frames long.

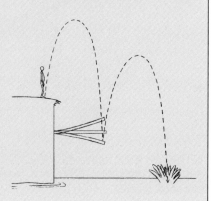

During this scene the diver is distorted on certain frames to emphasize the movement. The diver

should never be distorted for more than one frame at a time and only at the fastest point of any move.

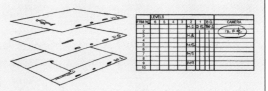

First draw your background on a piece of paper. Use the one above for reference. On a separate piece of paper draw the diving board. This will animate when the diver hits it, but will remain still at the start of the scene. Drawing it on a separate sheet will save you having to draw it on every diver drawing.

When it comes to putting this information on an x-sheet. The background will be on the lowest layer (call it BG1), the diving board is on the middle layer (these will be called drawings D1 to D9) and the diver is on the top layer (call these drawings M1 to M59).

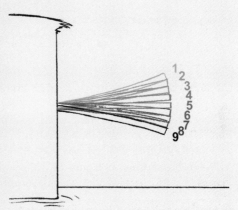

Draw and number the diving board as in the next illustration. The drawings are numbered by the drawing instead of the frame. Have diving board number D5 at the start of the scene (the straight diving board).

Start by drawing the key frames first. In the following illustrations I've included the breakdown positions (the major in-betweens) as well. Do these after you've drawn all the key positions.

Have your diver stand at the top of the cliff and anticipate into the jump. The character

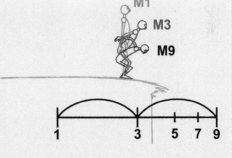

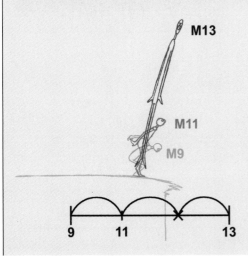

bends down and throws their arms out the back. These are key positions one and two that are at frames 1 and 9 with the breakdown (the major in-between) at frame 3.

When our diver takes off, distort the character as far as you possibly can up to the apex

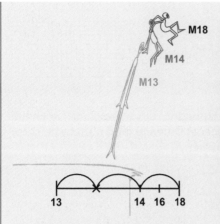

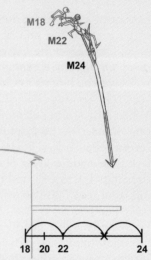

of the jump. At the apex have our character regain his original shape. These are the second and third key positions at frames 9 and 13 with the breakdown on frame 11.

The diver follows an arc through the air similar to the balls we animated in Chapter 2. These are the third and fourth key positions at frames 13 and 18, the breakdown being at frame 14.

As our diver falls, make the character distort again in the direction of the fall before the diving board is hit. These are the fourth and fifth key positions at frames 18 and 24 with the breakdown at frame 22.

The diving board will bend as it is hit. At this point the diving board will move with the diver. These are the sixth and seventh key positions at frames 25 and 31. The breakdown position is at frame 27. Diving board D5 goes with diver

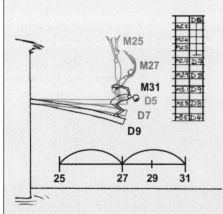

M22	D5
M24	
M25	
M27	D7
M29	D8
M31	D9
M33	D8
M35	D4

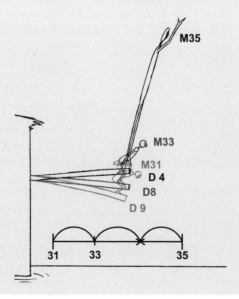

M25, D7 goes with M27, D8 goes with M29 and D9 goes with M31.

After the diving board bends down, the diver will bounce up from the board and be stretched along the second arc of his dive. These are the seventh and eighth key positions and are at frames 31 and 35. The

breakdown position is at 33. Diving board D9 goes with diver M31, D8 goes with M33 and D4 goes with M35.

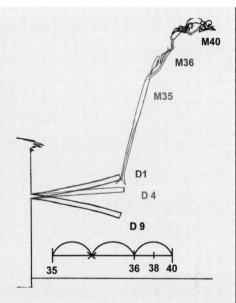

At the apex of this arc the character will slow down and regain his shape. These are the eighth and ninth key positions at frames 35 and 40, the breakdown position being at frame 36. D4 goes with M35, D1 goes with M36 and D1 goes with M40.

The diver will then fall into the water distorting at the fastest point. These are the ninth and tenth key positions and are at frames 40 and 46, the breakdown position is at frame 44. D9 goes with M40, D3 goes with M44 and D3 goes with M46.

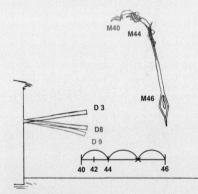

Then there will be a splash as the diver falls into the water.

The diving board will then vibrate to a stop. Draw the following positions and then shoot them in the order shown.

This will produce the effect of the diving board vibrating and gradually coming to a stop.

When you've completed all of these key positions, try shooting them with your line tester. I've included the rough timing and the timing charts with this exercise.

Take a look at dive_2D_keys.avi in chapter004 of the CD-ROM.

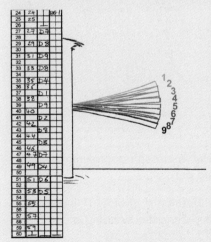

You could also take a look at my rough x-sheet called dive_x-sheet_1.pdf or dive_x-sheet_1.jpg and dive_x-sheet_2.pdf or dive_x-sheet_2.jpg in chapter004 of the CD-ROM.

Once the key animation looks OK, in-between the keys, following the timing charts. Do the breakdowns first and then the in-betweens. Make sure that the character's body returns to its proper shape immediately before and after the points at which it's distorted.

Take a look at dive_2D.avi in chapter004 of the CD-ROM.

When you're happy with your drawn version have a go in 3D!

the dive in 3D

For this follow the sequence below.

- We need to build a cliff, a diving board and the sea.
- We then place our character at the top of the cliff.
- Animate the character through the key positions.
- Get the diving board to vibrate.
- Finally distort the character at the necessary frames.

As a guide it helps to put in some nulls (or any other non-rendering objects) at the apex of each bounce and at the point where the character hits the water. When you are zooming in and out of the scene and animating at the same time you can refer to these objects.

For the key positions follow your drawn animation (illustrations for key 2 to key 9 following), but when sorting out the keys don't put in any distortion of the body at frames 18, 24, 35 and 46. Just move the

character to a rough approximation of the distorted position.

At key position 1 (frame 1) we need to have our character standing at the top of the cliff in a relaxed pose.

At key 2 (frame 9), the character bends down into the anticipation position of the jump.

Key 3 (frame 13) is the position where the character is distorted on the way up to the apex of the first bounce. When just putting in the key positions we want to move the body to a point halfway between the character's anticipation position at frame 9 and the apex of the first bounce, without any distortion.

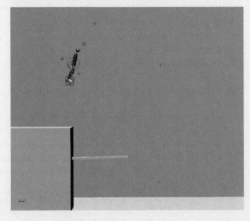

At key 4 (frame 18) the character is at the apex of the bounce. Move him into the same position as the fourth drawn key position (drawing number 18).

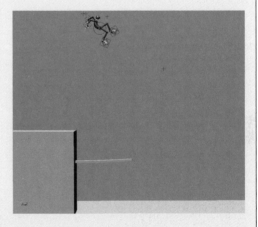

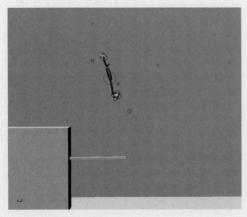

At key 5 (frame 24) the key position should be distorted but, as for key 3, just move the character to a rough approximation of the correct position.

At key 6 (frame 25) the character first comes into contact with the diving board. Move the character down to a point where his heels are just touching the board.

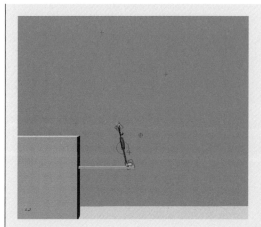

Select all the bones in the diving board and set a rotation key.

At key 7 (frame 31) bend the diving board by rotating each of the bones in the hierarchy progressively more so that you get something that looks like the drawn animation. Then move our character down into an anticipation position.

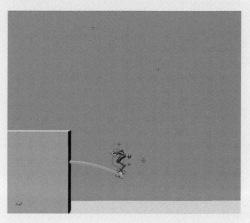

At key 8 (frame 35) the character should be distorted on his way up to the apex of the second bounce. At the moment put the

character in a position that approximates this position undistorted.

Key 9 (frame 40) is the apex of the second bounce so position the character curled up with its arms in a diving position.

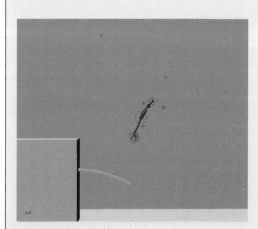

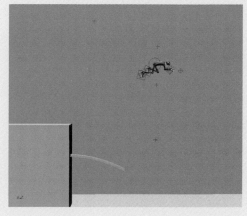

Key 10 (frame 46) is where the character distorts as he falls towards the water. Position our character undistorted into this position.

Key 11 (frame 47) is where the character has hit the water.

Once the key positions are done it's time to sort out the details like putting in the breakdown positions, distorting the character at

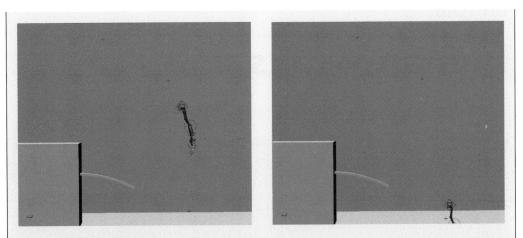

frames 18, 24, 35 and 46 and making the diving board vibrate. All the four programs do this in a slightly different way.

This is described in greater detail in the .pdf files 3DSMAX_dive.pdf, LightWave_dive.pdf, Maya_ dive.pdf and XSI_dive.pdf in chapter004 of the CD-ROM.

chapter 5

human walks and runs

A human walk can be a difficult sequence to animate believably. This is because your audience are walking experts! They have been walking since they were about a year old and see people walking around them all the time. Consequently they can judge whether your walk is convincing. If it's not so good they stop believing in your character.

walk cycles!

A walk cycle is a piece of animation where a character walks on the spot (similar to walking on a treadmill) and the background pans past them. It consists of two strides that are repeated.

The one thing to remember about walk cycles is that they are by nature repetitive. When we see someone walking along, we are observing a living, breathing person, who is taking in the world around him or her. What we see when watching a walk cycle are the thoughts and actions of the character during those two strides, repeated continually. Consequently, when you animate a walk cycle of somebody in a certain mood, it can seem false, over the top or repetitive.

I've found that walk cycles tend to work better if you make them slightly stylized. I think this is because if you deliberately make the design more artificial, your audience will forgive the artificial movement. The more realistic you make an animated character, the more the audience expects it to move in a realistic way.

Take a look at stylised_walk.avi in chapter005 of the CD-ROM.

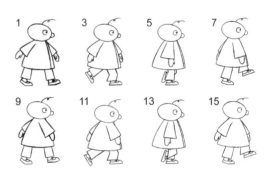

Walk cycles tend to be used in TV series and computer games. The reason for this is that a walk cycle produces a lot of screen time for a small amount of work (and money).

You rarely see walk cycles in feature films. In a feature film an animator will usually animate a character walking from A to B in its entirety. This will produce a walk that is more believable. Only background characters will be doing any form of cycle in a feature film.

walking

When animating a character walking from A to B we have to take the following into account.

pace

Everybody has a natural pace they are comfortable walking at. Think of the pace of your character's walk as the amount of frames it takes for that character to take one stride.

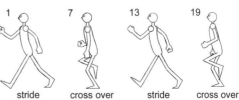

stride cross over stride cross over

A walk cycle will consist of two major key positions. These are referred to as the stride positions, each with a different leg leading. The breakdown (major in-between) positions between these keys are referred to as the cross over positions. This is where the trailing leg is picked up and crosses over to be placed in front of the (previously) leading leg. Most people take a stride about every half a second. So at 25 frames per second, that's a stride every 10 to 16 frames.

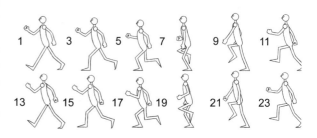

The pace of each stride varies depending on many outside influences. As they are strolling along someone's walking speed will change. It can be affected by the things they see and obstacles they have to negotiate or whether they are on their own or are in company. Frame of mind will also contribute – if they are feeling happy or sad or one of a million other moods.

Remember that all the joints of your character will move in arcs in relation to each other.

Take a look at basic_walk_2D.avi in chapter005 of the CD-ROM.

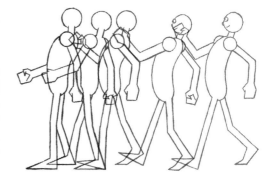

When a character slows down or speeds up during a walk the same pace, of around half a second a stride, will be maintained. A character slows down by making the stride shorter and speeds up by making the stride longer. They will still be making each stride roughly every half a second.

walking mechanics
the four basic positions of a walk
These are the two stride positions and the two cross over positions.

the stride positions
The two basic keys of a walk are at the extremes of each stride. To complete a walk cycle you need two strides. The exact arm and leg positions will be dependent on the emotions of your character and the external influences being forced on them. However, one thing that is generally true of these 'stride' keys is that the shoulder of the leading arm will be twisted forward of the shoulder of the trailing arm. The hip joint of the leading leg will be twisted

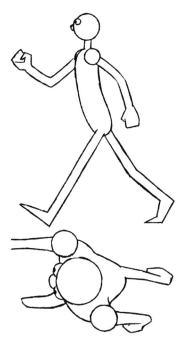

forward of the hip joint of the trailing leg. Opposite shoulders and hips lead.

A large amount of the twisting that is happening in the body is occurring at the base of the spine. This is the most flexible part of the spinal column.

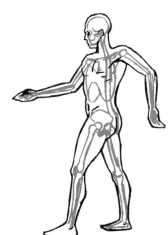

The twisting of the shoulders is dealt with by the movement of the shoulder blade and the collar-bone. This will push the shoulder joint of the arm forward or backward in order to balance the top part of the body.

The hips twist in the opposite direction to the shoul-

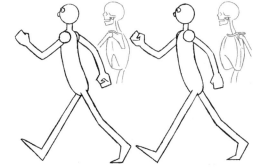

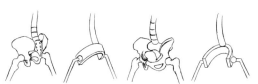

ders, the leading hip being attached to the leg that is forward.

The angle of the hip at this stride position can help put over an idea of the mood of your character.

If the hip is angled with the leading hip higher than the trailing hip, this throws the backbone back and increases the curve in the small of the back. This gives a positive feel to the way your character holds itself. Moods such as happy, determined and laid back will have a hip positioned like this at the stride position.

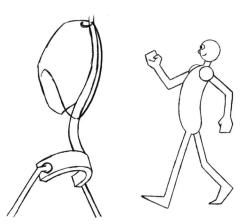

If the angle of the hip has the trailing hip higher and the leading hip lower, you get a curving of the spine forward which gives a negative angle to the body. Depression, misery, goofiness and tiredness are suggested by this hip angle.

Of course there are lots of other things that will suggest the mood of your character (which we'll go into later), but the angle of the hips and the body give the basics of emotion in a walk.

the cross over positions

The breakdowns to sort out are the cross over positions. These are the drawings where the

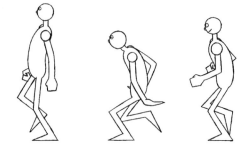

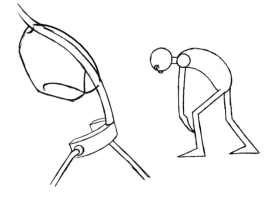

raised leg crosses over in front of or behind the leg that is still in contact with the ground.

A leg that is picked up high during the cross over looks light. The hip of the raised leg will be higher than the other hip.

These are the key drawings that give the audience a clue to the character and mood of your animation. A leg that drags along the ground when crossing over looks heavy. The hip connected to the raised leg would be lower than the hip of the leg touching the ground.

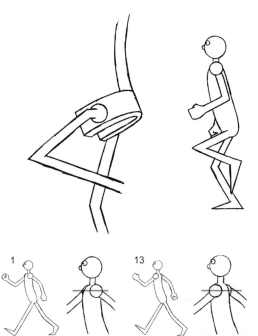

shoulder movement

With the stride key drawings, the shoulder opposite to the leading leg will be forward. The other shoulder will be trailing. Because the shoulders can move independently of each other, the leading shoulder can be higher, lower or level with the trailing shoulder.

If the leading shoulder is angled higher than the trailing shoulder, this makes the top part of the body look as if it is pulled back. This gives an upbeat, positive feel.

If the leading shoulder is lower than the trailing shoulder, you give more direction to the top of the body. It gives determination to the character. The character is leaning towards what it's walking to.

How you draw the cross over key positions for the shoulders will also give a guide to character.

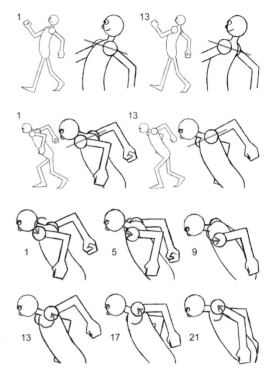

The shoulder of the arm coming forward moves up (in an arc) and the shoulder of the arm travelling back moves down (also in an arc) (creating a rolling of the shoulders towards the front of the body). This gives the impression of someone who is pushy, determined and knows what they want. A bit of a gangster's walk. The effort is being put into pushing the arms forward.

The shoulder of the arm that is moving forward dips down (in an arc) and the shoulder of the arm that is travelling back moves up (in an arc) (creating a rolling of the shoulders towards the back of the body). It gives the impression of someone who's happy and positive. The effort is being put into pulling the arms back.

If both shoulders dip down when moving forwards and backwards, it gives the appearance of lethargy and depression.

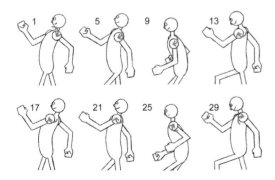

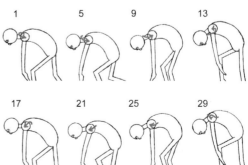

arm movement

At their most basic the arms will swing like a pendulum. They will accelerate out of the

extreme positions at the strides, moving fastest when they are near to the body. They will then decelerate as they reach the next extreme key position, at the next stride.

The movement of the arms is affected by which joint in the arm is initiating the movement. If the shoulders initiate the movement, the arms will flail out from the shoulders down, following through the movement of the shoulders.

If the elbows initiate the movement, the arms will flail out from the elbows down, following through the movement of the elbows.

If the wrists initiate the movement, the hands will flail out from the wrists down, following through the movement of the wrists.

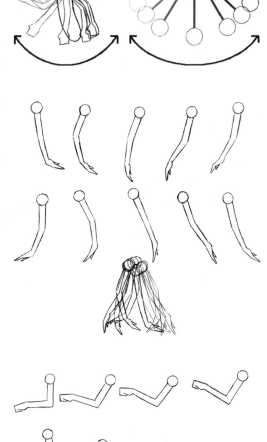

up and down movement of the body

As a person walks, their body bobs up and down. Depending on the mood of your character, this will happen at different places.

During a basic walk the body will bob down at the point when all the weight goes on to the one foot. It will lift up at the point where the foot is brought over, between the cross over position and the stride position.

Making the highest point of the walk at the cross over will give a resentful depressed negative feeling. Animating the cross over at the lowest point of a walk will make the body bounce up and down further and give a more positive feel.

walk cycles displaying different moods

It has to be emphasized that all the following examples of walks are stereotypes and as such are at the extreme cartoon end of the animation spectrum. The reason why I give these examples is that it is usually better to exaggerate real life, in order for your animation to look more convincing. If you try and make the animation look naturalistic (especially when you are learning to animate) it always ends up looking stiff and wooden. It's better to think of all your animation as having more in common with theatrical stage acting than with real life. When animating I've often found that it's better to 'ham up' a scene at first and then go back and tone the animation down if it's too over the top (it rarely is too over the top).

The mood or character of a person will affect the way they walk. If a person is depressed they will drag their feet and slouch forward with droopy shoulders. Their inner turmoil will result in them putting as little effort into their forward progression as possible so they can concentrate on being depressed. Every move is an effort. A good depressed face and a head hung low will be the main sign to an audience of what is going on in the head of your character. The shoulders follow up and down arcs (the shoulder is at its highest point at each stride). Have a look at depressed_walk_2D.avi in chapter005 of the CD-ROM.

A not so clever person will move in a similar way, but this time the reason why the person finds movement such an effort is that they find walking intellectually difficult! If this dragging of the

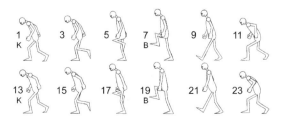

feet with droopy shoulder movement is topped with an erect head with a stupid grin and half-open eyes (too much effort to open the eyes fully), your character has a goofy look. Have a look at not_so_clever_walk_2D.avi in chapter005 of the CD-ROM.

An angry person has something they are angry at, focusing their attention/gaze on the object of their anger. They will stamp their feet and clench their fists, holding their body at a stiff angle forward, maybe fixing their gaze toward the thing they are angry at. Shoulders rolling over the top as they move forward. Have a look at angry_walk_2D.avi in chapter-005 of the CD-ROM.

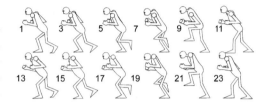

A determined person will move in a similar, smaller way but with the emphasis on the body angle. Everything about this person is pointing toward the goal that they want to achieve. Head down like a bull that is about to charge, keeping the leg and arm movements small so that nothing gets in their way.

A happy person will walk with a spring in their step, perhaps putting a double bounce into their stride at the point where all the weight is on one foot. The strides will be light and the arms will swing with a snap (much slower at the extremes). It's as if they are full of energy and they are putting the excess into their walk. Shoulders rolling underneath as they move forward. Have a look at happy_walk_2D.avi in chapter005 of the CD-ROM.

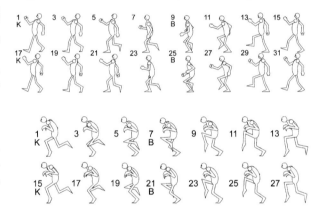

If somebody wants to be quiet when walking they could tip toe. This involves talking little steps on the tips of the toes. See tip_toe_2D.avi in chapter005 of the CD-ROM.

If someone wants to be really quiet (or is walking over a pond of ice and testing the surface) they could sneak. This involves placing the feet slowly onto the ground to test the surface (to see if it will make a noise or break). When the character knows the surface is OK, they will move forward and take the next step. See sneak_2D.avi in chapter005 of the CD-ROM.

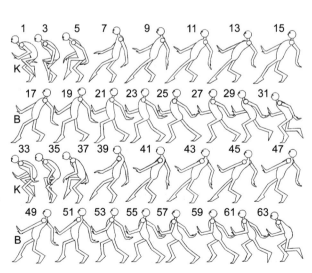

If somebody is cool and laid back, they are going to adopt a laid back position when they walk. The whole point of this type of walk is to give

the impression that as little effort as possible is being put into it. The body is angled back and the legs are bent to help with balance. As the legs are picked up the body will slowly lower and then rise as the legs are kicked forward. See cool_walk_2D.avi in chapter005 of the CD-ROM.

A dreamy person will float along, giving the impression of being very light. It's as if they are being carried along by their thoughts. The movement being like a leaf falling off a tree. Make them cushion themselves with their extended toe at the start of each stride. See

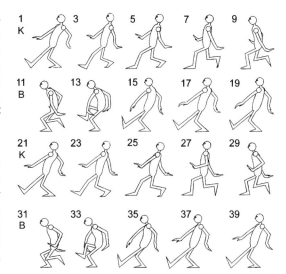

dreamy_walk_2D.avi in chapter005 of the CD-ROM.

The double bounce walk is a type of walk used by a lot of cartoon characters. It involves having a dip of the body at the point where the front foot contacts the ground and a second dip of the body as the rear foot leaves the ground. See double_bounce_walk_2D.avi in chapter005 of the CD-ROM.

A walk can emphasize the sexuality of the walker. With a male this will involve a laid back top part of the body combined with a pelvic thrust at the lower part of the body with every stride. See macho_walk_2D.avi in chapter005 of the CD-ROM.

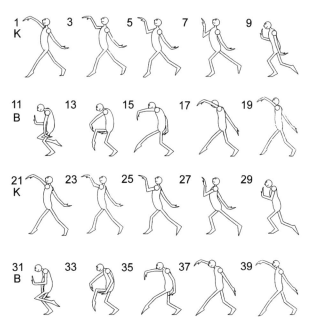

A female catwalk model's walk involves pushing out the hips sideways at each stride position. The small of the back is very curved and this pushes out the breasts and the bottom. The walk is on tiptoe (or high-heeled shoes). Because of this, during a walk it is difficult to bend

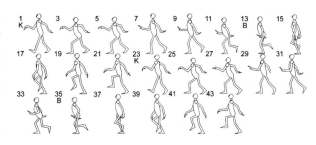

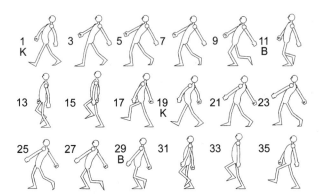

the knee while all the weight of the body is moved over the leading leg. This results in the leg locking straight and the hip being pushed out to take this weight. The feet being placed in a central line in front of each other accentuate this. See model_walk_2D.avi in chapter005 of the CD-ROM.

external influences

When somebody is walking along not only will they have these internal influences; they have to contend with external ones too. Is the person carrying or pulling something? If so they will be straining to hold, pull or carry the object they are interacting with.

Are they walking up or down something (a ramp, a hill, stairs, etc.). What's the temperature (somebody

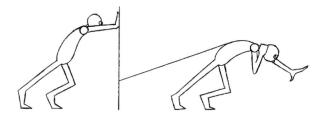

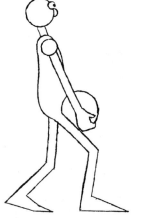

who's hot will seem exhausted) or is the wind blowing (they have to push against the wind). Is the surface they are walking over smooth or rough? Somebody picking there way over a rocky landscape will be watching their feet, making sure they don't trip up).

Do they have to step over something (again they will have to look down in order to see where their feet are stepping) or is their attention taken by something that they are looking at (for example, a poster or cars, when they are crossing the road). Are they eating chips or talking on a phone.

two people walking together

When two people interact they do something called 'mirroring'. If you watch two people sitting in a pub together, they will often sit in a similar position to each other. They will take drags from a cigarette or sips from a drink at roughly the same times. Also scratch their heads or fold their arms in approximate unison. The amount of mirroring will vary depending on how well people know each other. Those who are good friends mirror more. Married couples who are used to each other's company (perhaps they are even bored with each other) tend to mirror less, depending on how much they want to emphasize their personality, but will return to mirroring at certain points during their interaction. The same can be said of two people walking together. They will often speed up or slow down their walk (or shorten or lengthen their strides) so they take steps at roughly the same time, especially if they are talking together. If their attention is taken by something else (a poster for example) they will revert to their natural walking pace (as they look at the poster), regaining their unison walk when they have each other's attention.

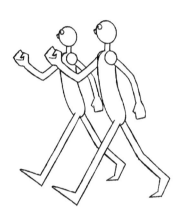

running

The main point of a human running is to get from A to B as fast as possible. This is achieved, not by making the strides quicker (this results in a fast walk) but by making the strides longer.

Each stride is basically a jump, with both feet off the ground. Each cross over point is the squash down following the jump, combined with the anticipation for the next jump. The twists in the body will be an exaggerated version of a walk cycle. The line of balance is pushed forward as if our character is falling forward – this gives more momentum.

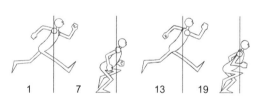

There are four basic key drawings to a run cycle:

1. Near side leg leading a stride and the far side leg trailing.
2. Near side leg impacting the ground and bending as the far side leg crosses over.
3. Far side leg leading the stride, near side trailing.
4. Far side leg impacting ground and bending as the near side leg crosses over and so on.

When in-betweening these key positions remember to bring the foot up and over from the stride position to the cross over position. Have a look at run_2D.avi and run_3D.avi in chapter005 of the CD-ROM.

Of course, because the stride is a jump, the squash is much bigger than during a walk cycle. The difficult bit is putting some character into your run.

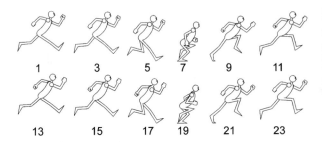

If your character is running away from something it's as if the legs are running away with them. The legs could drag the body. See run_away_2D.avi in chapter005 of the CD-ROM.

If somebody is running towards something, they will lean towards what they are chasing (be it something that is moving or the finishing line). See run_toward_2D.avi in chapter005 of the CD-ROM.

One good way of helping a run cycle work is to add whiz lines or to smear the arms and legs and if it's on singles also offset the

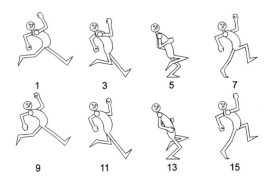

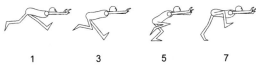

legs slightly so that the legs don't strobe. See fast_run_2D.avi in chapter005 of the CD-ROM.

A skip is a kind of run that involves a floating stride position and landing on the rear foot. See skip_2D.avi in chapter005 of the CD-ROM.

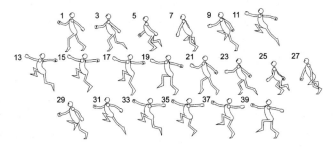

Take a look at humanlocomotion.pdf on the CD-ROM for larger versions of these illustrations.

exercises

walk or run cycle in 2D

Take any of the illustrated examples of walk cycles or run cycles and have a go at a character walking or running on the spot.

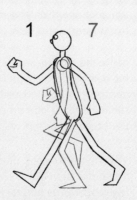

In order to do this you have to think of your character walking on a treadmill (the kind of device that you get in a gym).

Think of the body staying in the same position on the piece of paper, it can go up and down but not backwards and forwards.

Start with the two stride positions. They are basically mirror images of each other. Make sure that you take into account perspective when you draw each of these. This will prevent the character from 'strobing' (this is when the stride positions you've drawn look so similar that your audience can't tell the difference between them when the sequence is played).

Take a look at any of the ... walk_2D.avi's in chapter005 of the CD-ROM.

Have a go at animating several of the different walk cycles.

walk or run cycle in 3D

Because there is nothing new to learn in each of the 3D computer programs covered in this book I will only give a very general guide as to how to animate a walk cycle in 3D rather than doing each of the specific programs.

Take out your animation drawings for the walk or run cycle (or refer to the relevant illustrations).

We are only going to animate two strides (one complete cycle) and then loop the animation on playback. Our character will be walking on the spot, sliding its feet backwards along the ground and then picking them up to cross over and bring them forward.

In order for this to work correctly we need to set the length of the scene to one frame longer than the drawn walk or run cycle. For example if we are animating the basic_walk, which is 24 frames long we need to set the length of the animation on your chosen computer program to 25 frames (this is fine for XSI and Maya; in LightWave and 3DS Max the first frame of a scene is 0 (zero) so set the scene length to 24).

Load your character model and move it into the first key position at the first frame of your animation. This will be a stride. Set a key for this position. Go to

Frame 1.

the last frame and, without moving any-thing, select your model (or the individ-ual sections that you moved at the first frame) and set a key.

Move the time/frame slider to the frame of the next stride key position and move your character into the position of this stride, setting keys as you do so. For example in the basic_walk this will be at frame 13.

When you play the animation it will give the impression of the character sliding its feet backwards and forwards on the floor.

At each of the frames where the cross over breakdown positions occur move your character into a cross over position and set a key. For example in the basic_walk these will be at frames 7 and 19 (6 and 18 in LightWave and 3DS Max).

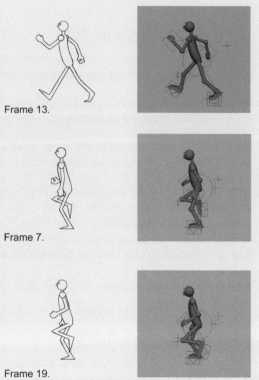

Frame 13.

Frame 7.

Frame 19.

Add extra key positions or manipulate the animation/function curves in order to stop the feet sinking and sliding in the wrong places.

If you want to add whiz lines make a sphere, distort it so it looks roughly like the shape of your drawn whiz line and place it behind one of the legs. Change the shape of the distortion for each frame, matching your drawn animation and render it as semi-transparent. Do the same for the other leg.

When it comes to rendering your ani-mation, don't render the last frame. For example in the basic_walk the piece of animation you have been animating is 25 frames long but only render 24 frames. This will prevent a pause at the point where the animation loops.

changing the pace and mood in a walk in 2D

The background for the exercise we are going to do is like this one on the right.

The idea is to have a character that walks into the scene from screen right, slows down to look at the sign (by taking shorter strides) and then, as a result of reading the sign, walks out screen left displaying a different emotion.

Our character will be walking along the floor this time, rather than sliding the legs back as in the walk cycle exercise.

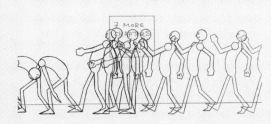

The illustration shows the key positions for a character walking into the scene happy, slowing to see the sign and walking out unhappy as a result of seeing what is written on the sign.

First work out the stride positions all the way through the scene. Once these are done and you are happy with the pace put in the breakdowns. These are the cross over positions.

Take a look at walk_by_2D.avi chapter005 of the CD-ROM.

You don't have to follow this scenario. You may want to have a sad person become happy, or a miserable person become dreamy or a stupid person acquiring some intelligence, just make sure your audience understands it.

changing the pace and mood in a walk in 3D

Start by building a floor for the character to walk on. Make it out of a grid, plane, box or cube. It should be about 100 units wide (1000 units for 3DS Max) and 30 units deep (300 in 3DS Max).

Don't make it any taller than 1 unit. Position it so that the majority of its length is in front of our character.

Make a sign for our character to read by creating a post out of a box or cube and make it 15 units high (150 in 3DS Max) and one unit wide and deep (10 units in 3DS Max). Position it 30 units in front of our character and 15 units to the side. Make the notice board attach to the post by creating a box or cube 10 units tall and wide (100 units in 3DS Max) and 1 unit deep (10 units in 3DS Max), and position it at the top of the post.

Using your animation drawings (or copy the first illustration in the walk and run cycle in 3D exercise), work out the basic stride key positions of the entire sequence.

This time the character will be walking along, rather than having the feet slide back, like during the walk cycle exercise.

One thing that can help is to put a block/cube/box at each of the points where the heel of the character touches the ground. This can act as a permanent marker for where the character is going to put his heel at each stride. Each stride during the happy part of the walk is 8 units long so place the blocks 8 units apart. At the point where the character is looking at the sign the strides are about 5 units apart so place the blocks 5 units apart. During the depressed walk part of the scene the strides are about 7 units apart so put the blocks 7 units apart. When your animation is done just delete the blocks!

Once the key positions are done, go back and sort out the cross over breakdown positions.

To stop the feet slipping and sinking into the ground make sure that the rotation and translation animation curves that relate to the foot controls are flat at the points where the feet touch the ground.

Tweak your animation as needed and hopefully you will end up with something like walk_by_3D.avi in chapter005 of the CD-ROM.

chapter 6
animal walks and runs

the four types of animal locomotion

There are four kinds of gaits (types of locomotion) adopted by animals. These are walking, trotting, cantering and galloping. Before covering these we have to understand how different styles of animals used in animation are put together.

construction of an animal

The best way to get an idea of how a four-legged animal moves is to go out and sketch some. Go to a zoo or a farm or just to the local park and draw animals. Don't worry if your drawings don't seem that good. The whole point of sketching is to make you look at your subject for long periods of time and to assimilate how they are constructed and how they move.

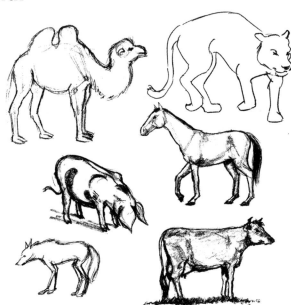

There are three ways to construct a four-legged animal. These are pantomime horse, cartoon four legged and correct four legged.

pantomime horse

This involves constructing your four-legged animal like two actors in a horse suit.

When the two actors walk in unison they will probably do something like that shown in the illustration. Both pairs of legs doing a basic human walk!

The walk consists of the four major key positions. The first key position is at frame 1: Stride at the front, cross over at the back. The second key position is at frame 7: Stride at the back, cross over at the front. The third key position is at frame 13: Stride at the front, cross over at the back (mirror image of the first key position). The fourth key position is at frame 19: Stride at the back, cross over at the front (mirror image of the second key position). This means that there is always at least two legs touching the ground and, in

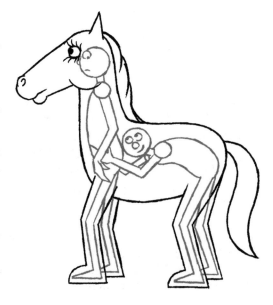

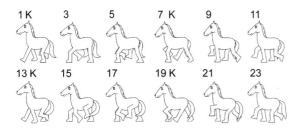

order to maintain a 'tripod' of balance, three legs will remain on the ground for as long as possible.

The stride at the back is the same length as the stride at the front and the foot of the leading leg at the rear will step into the footprint of the trailing leg at the front.

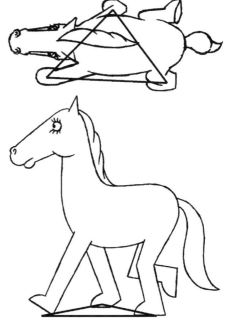

This is a very unrealistic walk for a four-legged character to do. The construction is entirely wrong, but it can be quite effective. It tends to look better when you are animating a toy-like character. Bullseye in *Toy Story 2* walks like this.

I've included a basic panto_horse.avi in chapter006 of the CD-ROM.

cartoon four-legged walks

For this type of character think of a human on all fours.

The rear legs of our character are like the legs of a human. The front legs of our character are like the arms of a human.

This is much closer to the way that a four-legged character is realistically constructed but is still a simplified cartoon version.

The way to animate a walk with this character is to do something similar to the walk made by our two actors in a pantomime horse but to make sure that the legs bend in the correct way. The stride of the back leg will be the same length as that of the front leg. The legs will still maintain the tripod of balance.

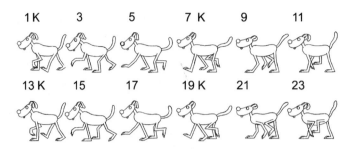

1 K	3	5	7 K	9	11
13 K	15	17	19 K	21	23

The first key position is at frame 1: Stride at the back, cross over at the front. The second key position is at frame 7: Stride at the front, cross over at the back. The third key position is at frame 13: Stride at the back, cross over at the front (mirror image of the first key position). The fourth key position is at frame 19: Stride at the front, cross over at the back (mirror image of the second key position). Also, as the back leg at positions 3 and 5 comes down to touch the ground the rear leg at the back of the stride will be picked up. Again this leaves the three legs in contact with the ground for as long as possible.

As with the pantomime horse walk, the tripod of balance will be maintained for as long as possible and the foot of the rear leading leg will step into the front trailing leg's foot print.

This kind of walk and construction is suited to the types of animal character that jump up and become more human-like. Characters that talk and gesticulate with their front legs. Examples are Tom and Jerry and Bugs Bunny.

I've included a basic cartoon_dog_2D.avi in chapter006 of the CD-ROM.

correct four-legged animal construction

This is a four-legged animal that is constructed like a real quadruped.

Still think of your animal as a human on all fours, but rather than standing with the feet and the hands flat on the ground, the feet are articulated differently depending on the

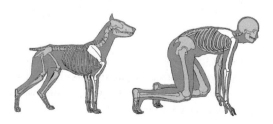

animal. The rib cage on the animal is elongated downwards whereas a human rib cage is flat. The shoulder blades on an animal are on the side of the rib cage. On a human they are on the back.

These animals do not have a collarbone like a human. This allows the shoulder blade to rotate and move up and down more freely. It's as though the shoulder blade of a four-legged animal has a sliding pivot point that can move up and down the side of their rib cage. When all the weight is on one of the front legs the body will drop in relation to the shoulder, making the top of the shoulder blade stick out at the top of the body.

animal leg and foot construction

The construction of the legs and feet of a four-legged animal influence the way in which they walk.

animals with paws

At a stretch, this category could include cats (big cats as well as domestic cats), dogs (all breeds as well as wolves and wild dogs), rodents (although they vary enormously) and some marsupials.

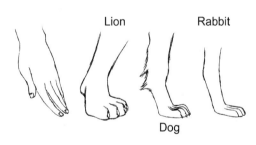

Notice how the length of all four feet has been elongated and how the animal balances on the last two digits of the toes. The animal walks on pads. This gives the animal lightness as it walks on the ground. The legs remain fairly straight. Bend the legs when you want to suggest an animal is crouching in order to jump or sneak along.

Lion Rabbit

The rear leg is similar to the leg of a human, but again the feet and toes are elongated. The rear leg will always have a shape like a straightened S. A dog leg shape!

Dog

Whatever position it's in the foot and the thigh will stay in parallel with each other (with the exception of frames 9 and 21 where the foot drags).

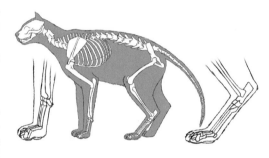

When animating a basic, naturalistic animal walk it's a good idea to think of the same sort of tripod walk that we did with our pantomime horse and our human on all fours.

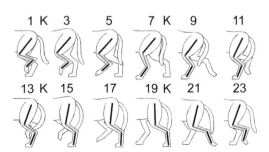

a dog walk

A dog has a very solid, eager walk that displays a lot of weight. Have a look at dog_walk.avi in movies006, chapter006 of the CD-ROM.

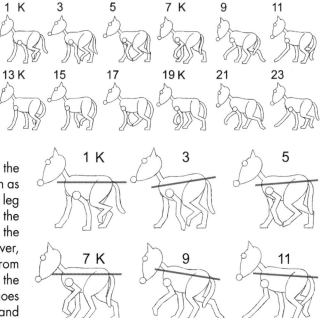

The backbone of the dog will be level at the stride and cross over key positions (frames 1, 7, 13 and 19). Between frames 1 and 7, as the dog moves forward the front part of the body will dip down as the weight goes onto the forward leg of the stride. The back part of the body will rise to accommodate the rear leg being brought up and over, out of the cross over position. From frames 7 and 13 the rear part of the body will dip down as the weight goes onto the leading leg of the stride and the front part of the body will rise to accommodate the front leg being brought up and over. Between frames 13 and 19 the back does the same thing as between frames 1 and 7 and between frames 19 and 1 the back does the same thing as between frames 7 and 13 (the illustration shows the first half of the cycle and in the remaining part of the cycle the back will do the same thing; 13 is the same as 1, 15 is the same as 3, 17 is the same as 5, etc.).

The other thing to take into consideration (especially if animating a rear or three-quarter view) is the twisting of the hips and the shoulders as the animal moves forward. (The illustration shows the first half of the cycle. In the remaining part of the cycle the hips will do the same thing, but as a mirror image. 13 is the mirror image of 1, 15 is the mirror image of 3, 17 is the mirror image of 5, etc.)

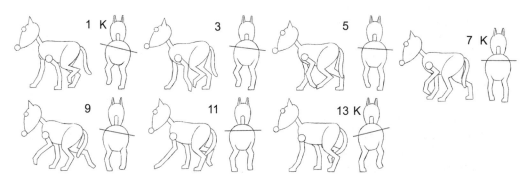

At the stride position, the hips are level. As the animal moves forward more weight is placed on the leading leg. Less weight is placed on the trailing leg and that side of the hip drops as a result. As the trailing leg is picked up and goes into the cross over position, the hip is raised to stop the leg dragging on the ground. Finally this leg reaches the next stride position and the hips are level.

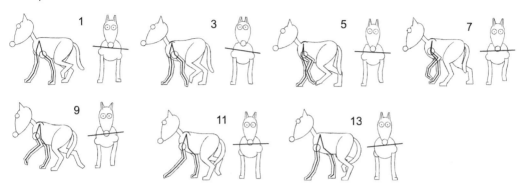

At the front most of the twisting is made by the movement of the shoulder blades, with only a small amount of rotation through the rib cage.

Generally at the stride position the shoulders and rib cage are slightly angled. The shoulder of the leading leg being slightly higher than the shoulder of the trailing leg. The leading leg's shoulder blade is facing forward, the trailing leg's shoulder blade is facing back. (The illustration above shows the first half of the cycle. In the remaining part of the cycle the shoulders will do the same thing, but as a mirror image. 13 is the mirror image of 1, 15 is the mirror image of 3, 17 is the mirror image of 5, etc.)

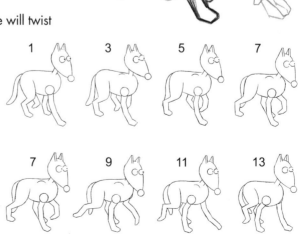

As the dog moves forward the rib cage will twist away and downwards from the leading leg and the shoulder blade of the trailing leg will drop. The shoulder blade of the leading leg (the leg in contact with the ground) will stick up through the top of the body as it takes all the weight. (The illustration shows the first half of the cycle).

As the trailing leg moves to the cross over position, its shoulder blade will be higher than the shoulder blade of the leg in contact with the ground.

Finally we get back to the next stride position. The remaining drawings in the cycle will do the same thing but on the opposite sides. (The previous two illustrations show the first half of the cycle; the remainder of the cycle will do the same thing but as a mirror image. 13 is the mirror image of 1, 15 is the mirror image of 3, 17 is the mirror image of 5, etc.) From the top, the spine will twist from side-to-side in order to accommodate the stride positions.

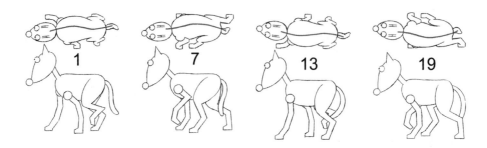

Take a look at dog_walk_2D.avi and dog_walk_3D.avi in animations006, chapter006 of the CD-ROM.

a cat walk

Where dogs are quite solid and resilient in the way they move, cats are rather floppy and nonchalant.

Have a look at cat_walk.avi in movies006, chapter006 of the CD-ROM.

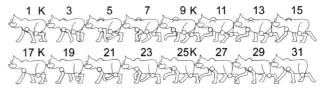

In comparison to a dog, cats tend to have longer back legs but the stride of both front and back legs will be of the same length. They are more likely to hold their bodies lower to the ground and tend to pick up their legs slightly slower than a dog will. A cat's hips will move in a similar way to the hips of a dog. The noticeable difference in movement is at the shoulders.

To give a cat that 'can't be bothered' feel to their walk the rib cage should always be suspended lower between the shoulder blades, than a dog's rib cage is. This makes the shoulder blade of the leg in contact with the ground stick up through the top of the body. The leg that is picked up to cross over will drop, leaving the shoulder blade lower than the outline of the body. The rib cage drops and twists slightly. (The illustration shows half of the cycle. Frame 17 is a mirror image of 1, 19 is a mirror image of 3, 21 is a mirror image of 5, etc.)

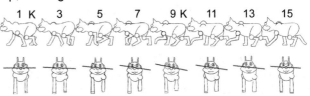

At the cross over position the rib cage remains dropped (although slightly raised, compared with the stride position) and the shoulder blade of the leg in contact with the ground remains visible through the top of the body.

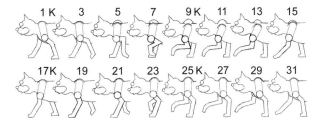

The raised leg then moves to the next stride position. The twisting of the spine (from the top view) will be similar to that of a dog.

Take a look at cat_walk_2D.avi and cat_walk_3D.avi in animations006, chapter006 of the CD-ROM.

animals with cloven feet

This covers animals such as cows, sheep, pigs, goats and deer and relates to the fact that these animals walk on the equivalent of two fingers.

These extended digits are referred to as the fetlock. The lengthening of these digits extends along the length of the leg, allowing for a longer stride, thus enabling these animals to walk and run faster.

Take a look at cow_walk_2D.avi in animations006, chapter 006 of the CD-ROM.

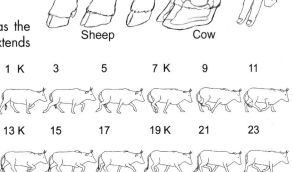

animals with hooves

This covers animals such as horses, ponies, donkeys, zebra and giraffe. The fetlock of a hooved animal consists of a single elongated digit. If you imagine an extended finger, the bone at the end of the finger is the equivalent to the hoof.

Take a look at the live action horse_walk.avi in movies006, chapter006 of the CD-ROM.

This elongation of the fetlock and the leg as a whole make these animals especially good at running.

The rules for the earlier four-legged walks also apply to a hooved walk. There will be a cross over at the back and a stride at the front and a tripod

of balance will be maintained for as long as possible. There will always be at least two legs on the ground.

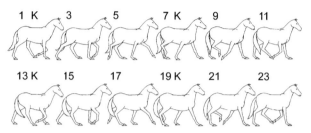

I've included a horse_walk_2D.avi in animations006, chapter006 of the CD-ROM.

The movement of the hips and the shoulders is similar to the earlier four-legged walks, but with an animal with hooves these movements tend to be more pronounced, because the legs are longer.

The head will counteract what the body is doing. The head will be down on the cross over position of the front legs and up on the stride. This head movement tends to be more pronounced on a hooved walk because the legs are much longer than on the other animal walks.

flat feet

Animals such as elephants and rhinos walk on the equivalent of the bones at the very end of our fingers. Imagine the thumb facing backwards and three fingers facing forwards. These digits are very thick and heavy in order to take the large weight of the animal they are supporting. The remaining digits are very short.

There is virtually no movement of these digits because they are firmly wrapped in flesh, which gives additional help to support the great weight of the animal they belong to. The solidity of the foot gives the appearance of it having one less joint than most animals.

Take a look at elephant_walk_2D.avi in animations006, chapter006 of the CD-ROM.

animal runs

We've covered walking, now we need to look at the remaining three gaits: trotting, cantering and galloping. I've illustrated each of these gaits with a horse, but something very similar happens with most other four-legged animals.

In order to speed up, an animal, like a human, must lengthen its stride. To do this it needs to change its gait. That is, it must change the way in which it makes the strides.

trotting

Have a look at horse_trot.avi in movies006, chapter006 of the CD-ROM.

To move faster than a walk, the legs will move as diagonal pairs during a trot. This means that the animal is doing a stride at the back and a stride at the front at the same time and a cross over at the back and a cross over at the front at the same time. Add to this a little jump in the air during the stride position and your horse's stride is lengthened.

When the horse lands after the little jump, the fetlock absorbs most of the weight, by bending. With each of the strides and cross overs the back moves up and down in a parallel movement.

When moving your horse from a walk to a trot, pick up one of the legs (it doesn't matter which leg) slightly earlier as it travels from a stride into the cross over. Move it through the cross over position slightly faster than a walk so that it catches up with the cross over at the other end of the animal. Then have it come down to the next stride at the same time as the stride at the other end of the animal.

Take a look at horse_trot_2D.avi in animations006, chapter006 of the CD-ROM.

A dog trot will be very similar to that of a horse trot.

Take a look at dog_trot_2D.avi in animations006, chapter006 of the CD-ROM.

cantering

Have a look at horse_canter.avi in movies006, chapter006 of the CD-ROM.

Two legs work in unison as a diagonal pair. The other two legs work independently. The fetlocks now compress more because of the greater force placed upon them as a result of the longer stride achieved.

The back is level when the diagonal pair of legs are in contact with the ground. As the two rear legs and the front leg of the diagonal pair lift off the ground, the horse's pelvic region is raised and the spine is tipped forward. When the front leg leaves the ground,

we have all four legs in the air. At this point the backbone becomes level. As the first rear leg touches down on the ground the horse's pelvic region drops and the spine is tipped forward. As the diagonal pair of legs touch down onto the ground the spine becomes level! This gives the back a rocking motion. Take a look at horse_canter_2D.avi in animations006, chapter006 in the CD-ROM.

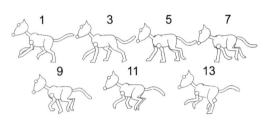

A dog canter will be very similar to that of a horse canter.

Take a look at dog_canter_2D.avi in animations006, chapter006 of the CD-ROM.

galloping

Have a look at horse_gallop.avi in movies006, chapter006 of the CD-ROM.

All four legs touch the ground at different times, but essentially the front two legs work in unison with each other and the rear two legs work in unison with each other. The legs are slightly offset from each other.

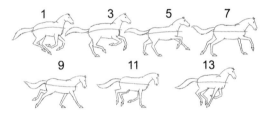

The spine will extend and stretch as long as possible at the point where the rear legs are in a stride position and the front legs are just about to touch down on the ground. At this point the front part of the body is at its highest. As the front legs leave the ground (when the rear legs are in the air and trying to come as far forward as possible) the spine arches and curves over. At this point the horses pelvic region is at its highest. Take a look at horse_gallop_2D.avi in animations006, chapter006 of the CD-ROM.

A dog gallop will be very similar to that of a horse gallop.

Take a look at dog_gallop_2D.avi in animations006, chapter006 of the CD-ROM.

transverse or rotary gallops and canters

During a canter or a gallop, depending on whether front and rear legs on the same side lead or front and rear legs on the opposite sides lead, they can be referred to as a transverse (same side) or a rotary (opposite) gallop or canter.

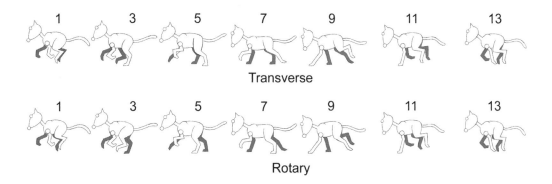

Transverse

Rotary

According to the experts, dogs and deer tend to carry out the rotary kind of canters and gallops whilst most other animals do the transverse form.

Having watched a few animals galloping and cantering in my time I can swear that I have seen horses and dogs doing both transverse and rotary gallops. The same can be said of most animals.

To be quite honest with you the whole visual experience of watching an animal gallop is so complicated that only an expert is going to question whether you have done the correct sort of gallop or canter for an individual animal.

Take a look at 'animal locomotion illustrations.pdf' on the CD-ROM for larger illustrations.

exercises

dog walk cycle in 2D

Take a look at the illustrations of the dog walk cycle and have a go at animating the dog walking or running on the spot (see first illustration in 'a dog walk' section).

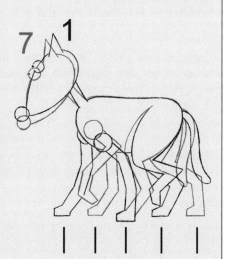

First sort out the first two stride and cross over positions (for the dog walk these are 1 and 7). It can help to mark on the paper the positions where the feet will touch the ground. The stride at the back legs should be the same as the stride at the front legs.

At the front of the dog, from frame 1 to frame 7, the foot in contact with the ground will slide back

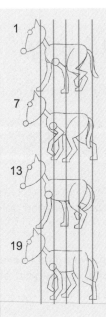

to a point that is half way between the front legs at frame 1. At the back of the dog the leg that is in the air will be put down onto the ground and the leg in contact with the ground will slide back into a stride.

The next two key positions to sort out are on frames 13 and 19. 13 is a mirror image of the drawing at frame 1 and is placed in the same position as 1. 19 is a mirror image of the drawing at frame 7 and is placed in the same position as 7.

Next, sort out the in-betweens. These should have the feet sliding back at a constant rate against the ground. Take a look at dog_walk_2D.avi in chapter006 of the is CD-ROM.

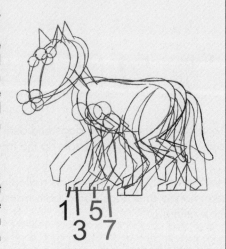

If you were animating your dog walking across the screen the position of the key positions would be as shown in this illustration.

Finally, have a go at animating a dog walking into screen, seeing something, coming to a stop, and galloping out of screen as a result of what they've seen.

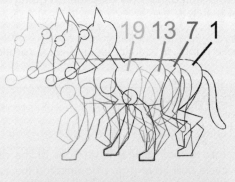

dog walk cycle in 3D

Open up your chosen 3D software and load up either maya_dog, lightwave_dog, xsi_dog or max_dog. These are in the dog_models in chapter006 of the CD-ROM.

The 3D dog is constructed in a similar way to that of the 3D human. There is a circle running through the hips of the dog called BodyControl. This is used to pick up the whole dog or to rotate the hips.

There is a square (FootControl) and two diamonds running through each foot that controls

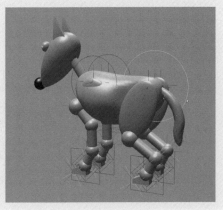

the lifting and rotation of the foot and the rotation of the heel and toe. These are the same as the controls used for the human but there are four of them.

There are also two circles running through the shoulders. These control the rotation of the shoulder blades and are called LShoulderControl (left shoulder control) and RShoulderControl (right shoulder control).

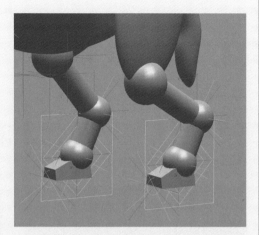

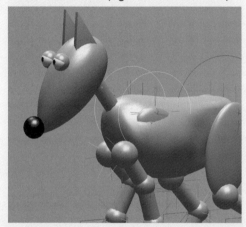

Between the shoulder bone and the back-bone there is a bone called a rib (LribBone or RribBone). This controls the up-and-down

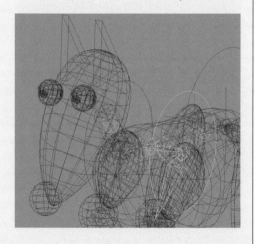

movement of the shoulder bone, in order to replicate the sliding pivot effect that you get with shoulder movement.

There are controls at the knees and elbows (LKneeControl and RKneeControl and LElbowControl and RElbowControl). These control the angle of the legs.

dog walk or run cycle in 3D

Take out your drawings for the 2D dog walk cycle (or have a look at the first illustration in 'a dog walk' section) for reference.

To help with this create some small blocks and position them alongside the dog at 2 unit intervals (20 units for 3DS Max) as marks to guide where the feet will go.

Make the scene 1 frame longer than the drawn walk or run cycle and make the last key position at the last frame identical to the first key position at the first frame (just like the human walk and run cycles).

The dog walk is 24 frames long so the animation needs to be set to 25 frames long in SoftImage XSI and Maya (which start the animation at frame 1) and 24 frames long in LightWave and 3DS Max (which start the animation at frame 0). The first frame (frame 1 or frame 0) and the last frame (frame 25 or frame 24) are the same and have a stride at the front and a cross over at the back.

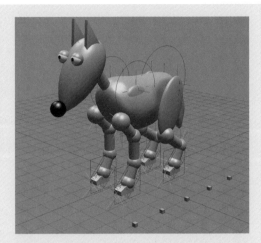

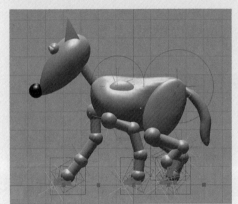

Frame 1 (0)

Move the feet forward or back or up or down by using the FootControls and rotate the ToeControls, HandControls and HeelControls. Remember to set keys on all the key positions.

Next sort out the 'mirror image' key frame at frame 13. There is still a stride at the front and a cross over at the back but the legs are swapped. You can always make a note of the numerical position and rotation of one leg at frame 1 and then paste these numbers onto the opposite leg at frame 13.

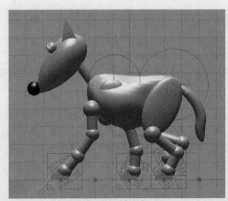

Frame 13 (12)

Once these are done do the other two key positions. These are at frames 7 and 19 (6 and 18 in LightWave and 3DS Max). These have a cross over at the front and a stride at the back and are the mirror image of each other.

The computer will in-between the legs reasonably successfully but the back is left ramrod straight. To alter this the next step is to do the breakdowns (the major

Frame 7 (6)

Frame 19 (18)

in-betweens). Go to frame 3 and select the BodyControl and lift the body up. Save a key. Then rotate the BodyControl to position the front part of the body lower than the back. If you play back your animation you will have a dog that dips at the front as it puts all its weight at the front onto the leading leg. At the back it raises its bottom. Then go to frame 15. At this frame the body will be positioned exactly the same as frame 3. So select, move and rotate the BodyHandle so that the body is in the same position at frame 15 as at frame 3.

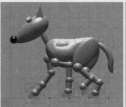

Frame 3 (2) Frame 15 (14)

Next, sort out frames 9 and 21. These are where the front part of the body is higher than the back. Lower and rotate the BodyControl upwards to increase the height at the back.

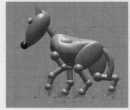 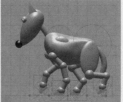

Frame 9 (8) Frame 21 (20)

Once these breakdowns are completed your dog will be walking, although the movement will probably be jerky. Select the BodyControl and go through the piece of animation frame by frame. Draw the position of each key and breakdown on the screen using a chinagraph pencil. Make sure that the body moves smoothly between each of these keys by either opening up the rotation animation curves for the BodyControl and adjusting them or by moving the BodyControl and setting a key on this movement.

If the feet sink into the ground, adjust by opening up the translation (move) animation curves for the FootControls. Make the curves straight between the key positions where the feet are touching the ground. Either move the curves with the bezier spline handles or make the curves linear.

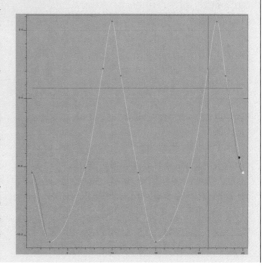

You'll probably need to move the knee and elbow controls outwards to stop the knees and elbows sinking into the dog's body.

When you render a movie of this animation only render frames 1 to 24 and loop the playback. If you include frame 25 the walk will pause at one point because frames 1 and 25 are the same.

The animation will accelerate out of key 1 and slow into frame 24, again causing a pause in the walk. To adjust this select any of the major components of the dog that are animated and open up the animation curves. Make sure that the curves going out of frame 1 and going into frame 25 match each other. Remember the movement at frame 25 continues on to the movement at frame 1 in a cycle.

Adjust the tail by setting a key at frames 1 and 25 where the tail has swung out and then at frame 13 where the tail has swung in between the leg. Go through the animation two frames at a time. Rotate the bones inside the tail to move them into the correct position according to your drawn animation (or refer to the third illustration in the 'a dog walk' section).

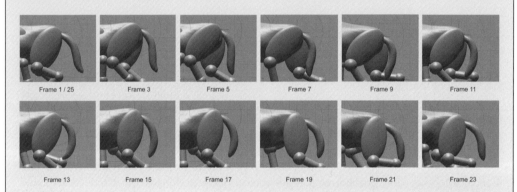

| Frame 1 / 25 | Frame 3 | Frame 5 | Frame 7 | Frame 9 | Frame 11 |

| Frame 13 | Frame 15 | Frame 17 | Frame 19 | Frame 21 | Frame 23 |

Adjust the head by placing it at its lowest point just after the front legs cross over and at its highest point just after the stride. Drag the head into higher or lower positions after each cross over and stride to stop it looking too repetitive.

Take a look at dog_walk_3D.avi in animations006, chapter006 of the CD-ROM.

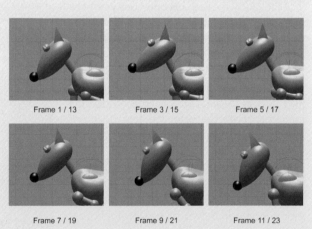

| Frame 1 / 13 | Frame 3 / 15 | Frame 5 / 17 |

| Frame 7 / 19 | Frame 9 / 21 | Frame 11 / 23 |

Have a go at a trot, canter and gallop as well and then take a look at dog_trot_3D.avi, dog_canter_3D.avi and dog_gallop_3D.avi in animations006, chapter006 of the CD-ROM.

If you're feeling very brave, have a go at a dog walking past a sign and changing its form of locomotion as a result of what it sees. Just like in Chapter 5.

chapter 7

animation of fish
and snakes

chapter
summary

- *fish*
 how they swim
 drag
 two swimming types of fish
 schooling (shoaling)
 swimming mammals and flatfish
 rays
 fins

- *snakes*
 basic movement
 concertina movement
 crotaline (sidewinder) movement

- *exercises*
 animation of a fish in 2D
 animation of a fish in 3D
 animation of a snake in 2D
 animation of a snake in 3D

Not all animals propel themselves with the use of arms and legs. Some use their bodies.

fish

Fish propel themselves through a fluid environment, which is very pertinent to the way that they move. They do this by flexing their backbone in such a way that a wave runs along the length of the body. As it travels

along the fish's body the wave gets big-ger. This is called a sinusoidal wave! Take a look at shark.avi in movies007, chap-ter007 of the CD-ROM.

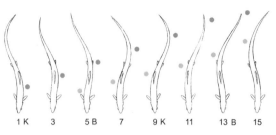

1 K 3 5 B 7 9 K 11 13 B 15

It's not unlike the flag cycle in Chapter 4. Think of the key positions as being at frames 1 and 9. These are the mirror image of each other. The breakdowns are at frames 5 and 13. Take a look at fish_wave_2D.avi in animations007, chapter007 of the CD-ROM.

how they swim

The density of water makes it very difficult to move in, but fish can move very smoothly and quickly. A swimming fish is relying on its skeleton for framework, its muscles for power, and its fins for thrust and direction.

The skull acts as a fulcrum, the relatively stable part of the fish. The vertebral column acts as levers that operate for the movement of the fish. The muscles provide the power for swimming and constitute up to 80% of the fish itself. The muscles are arranged in multiple directions (myomeres) that allow the fish to move in any direction.

A sinusoidal wave passes down from the head to the tail. The fins provide a platform to exert the thrust from the muscles onto the water. This wave passes down the body on a vertical plane. The length of this sinusoidal wave along the fish's body is depend-ent on the structure of the fish.

Fish have a swim bladder in their gut, which is basically a bag of air. This allows the fish to control its level in the water. Sharks don't have a swim bladder which means they need to swim constantly – otherwise they will float to the surface of the water (although I've seen many sharks resting at the bottom of tanks at aquariums).

drag

Drag is minimized by the streamlined shape of the fish and the special slime they excrete from their skin. This minimizes fractional drag and maintains laminar (smooth) flow of water past the fish.

two swimming types of fish

Fish swimming can be very simplistically broken down into two types of fish movement; 'cruisers' and 'burst' swimmers.

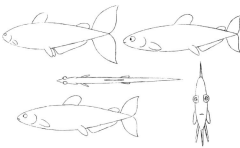

cruisers

These are the fish that swim almost continuously in search for food, such as the tuna. They tend to be very streamlined in order to make swimming as easy as possible. These fish are likely to be found in a school (big group) for protection. Sharks are cruising fish but tend not to school.

burst swimmers

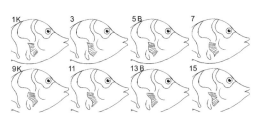

These fish usually stay still or move slowly for most of the time and then will move suddenly to another position. Most reef fish fit into this category. They are often tall and thin to get in and out of tight spaces. They are also more brightly coloured. This is for display and because they can hide more easily from predators. They will use their pectoral fins to maintain a stable position in the water.

If the fish is staying relatively still in the water, the fins will gently undulate in a 'flag cycle' motion. This helps the fish stay relatively still in the water. Take a look at fish_fin_2D.avi.

schooling (shoaling)

A large number of fish will group together for company and protection, forming a school or

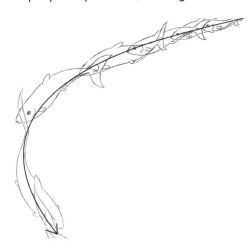

shoal. They will usually all be the same species. It's much harder for a predator to hunt a fish in a school, than when the fish is on its own. Predator fish, such as the piranha, will form schools in order to hunt larger prey. Schools of fish may be either polarized (with fish facing the same direction) or non-polarized (all going every which way).

When a fish swims along, it will follow a path of action with its body producing a sinusoidal wave to propel the fish.

When a fish turns, it will flick its tail into the corner that it is turning, a bit like the rudder of a boat. The flicking of the tail will swing the head into the turn. The body of the fish will stay slightly curved with the sinusoidal wave running through it as it completes the turn. Each swish of the tail will be greater on the inside of the turn than the outside.

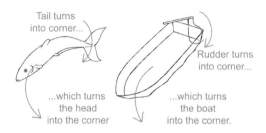

Before it does this turn it will usually flick the tail slightly outward first in order to anticipate this major swish of the tail inwards.

swimming mammals and flatfish

Flat fish (plaice, Dover sole, etc.) are fish which live on their side. They do this because they live on the ocean floor. When they are born, they swim like any ordinary fish but as they grow they start to swim on their side and one of their eyes rotates round to what has now become the top of their body. They end up looking a bit like a Picasso painting! Take a look at flat_fish.avi in movies007, chapter007 of the CD-ROM.

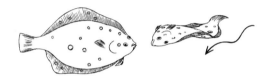

The sinusoidal wave passes down the body in a horizontal plane.

Mammals and birds that spend most of their time in water (for example, whales, dolphins, seals and penguins) also use a sinusoidal wave in a horizontal plane. Their flippers are used in a similar way to the fish's fins.

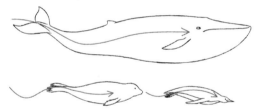

rays

The ray family have flattened bodies, with gills on the underside of the fish and move themselves by undulating their 'wings' with a sinusoidal wave. Take a look at ray.avi in movies007, chapter007 of the CD-ROM.

Have a look at ray_2D.avi in animations007, chapter007 of the CD-ROM.

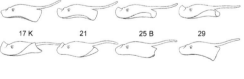

fins

Fins give a fish control over its movements by directing thrust, supplying lift and even acting as brakes. A fish must control its pitch, yaw and roll.

caudal fin

The caudal fin provides thrust and controls the fish's direction.

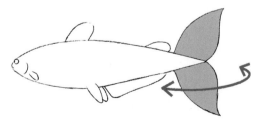

pectoral fins

The pectoral fins mainly act as rudders and hydroplanes to control yaw and pitch. They also act as brakes by causing drag.

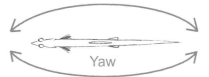

pelvic fins

The pelvic fins mainly control pitch.

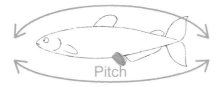

dorsal/anal fins

The dorsal and anal fins control roll.

snakes

basic movement

Snakes have several means of propulsion. The basic method of loco-motion is by wriggling the body using complicated muscles, ranged down either side of the backbone. The muscles are shortened on one side of the body, the contraction starting at the head and moving back-wards along the length of the snake. Following this, a wave of con-traction is sent down the other side of the body from head to tail. As a snake can be very long not all the muscles on one side are contracted at the same time with the effect that the body is thrown into horizontal waves, or undulation, as the muscles pull first to one side and then the other. These waves of contraction will expand and contract the ribs relative to each other. The scales on the under belly contract and expand as well. Take a look at snake.avi in movies007, chapter007 of the CD-ROM.

A snake follows a wave-like, looped path along the ground. If a snake is placed onto a smooth surface, such as glass, these movements fail to propel the snake anywhere since there must be something for it to push against. On ordinary ground, small surface irregularities will

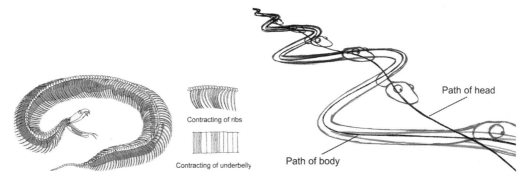

Contracting of ribs

Contracting of underbelly

Path of head

Path of body

provide the necessary points of resistance. As the body undulates, the outer and rear parts of each body loop come into contact with the irregularities. Their resistance is sufficient to stop the loop moving backward on the ground and, as the snake is exerting muscular effort at this point, it propels part of the body forward. The result is usually, that, while the snake sends waves of contraction along its body and moves forward, the position of each loop relative to the ground remains stationary, the tail moving steadily along the track left by the head.

At its most basic a snake follows an undulating path along the ground. A snake will usually hold its head up and the head will follow a more direct path than the body.

Take a look at snake_2D.avi in animations007, chapter007 of the CD-ROM.

concertina movement

This is used by a snake to move through a confined space such as a tunnel or a hollow in the ground. As such it would rarely be seen in an animated film, but it's worth knowing about! This involves the snake making a concertina movement, throwing out loops at the front of the body to press against the walls and grip while they draw up the rear part of the body. The rear is then looped and pressed against the walls while the head end is straightened and moved forward.

crotaline (sidewinder) movement

In the shifting sand of deserts live vipers and rattlesnakes that employ a very different means of locomotion. This is known as crotaline or sidewinder movement. On loose sand it is impossible to get a proper grip with the sideways undulations that most snakes use, so sidewinder snakes move along by pushing downwards rather than horizontally. A snake that is side winding throws a loop of the front end of the body forward and places its neck on the ground. The rest of the body is than twisted clear of the ground, to lie in front of the head and neck in the direction that the snake is moving. The foreparts touch the ground first, followed by the rest of the snake and eventually the tail. However, long before the tail reaches the ground, the snake has thrown its head and neck to a new position forward and sideways and the rest of the body follows.

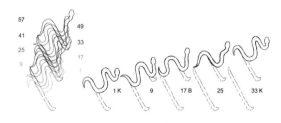

The result of this is that usually only two short lengths of the snakes body touch the ground at one time. It appears to be spiralling along sideways, leaving a series of tracks shaped like a capital J. The crook is where the neck was placed with the head facing forwards and the stem of the J is formed by the body, as it is brought forward in front of the neck. Lastly the crosspiece is made by the tail as it pushes clear of the ground. This takes about 32 frames and the same movement is repeated again as the snake moves along.

Take a look at sidewinder_top_2D.avi in animations007, chapter007 of the CD-ROM.

Take a look at sidewinder_side_2D.avi in animations007, chapter007 of the CD-ROM.

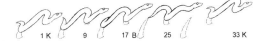

1 K 9 17 B 25 33 K

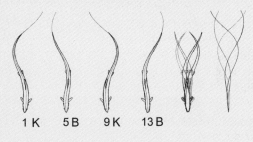

first (the ones at frames 1, 5, 9 and 13), but try to imagine the fish rotated round so that it looks correct on your path. When you get to frame 17 on your fish animation, copy frame 1 from your fish cycle and so on.

Take a look at fish_swim_breakdowns_2D.avi in animations007, chapter007 of the CD-ROM.

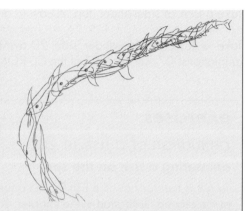

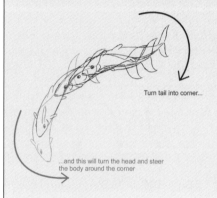

Turn tail into corner...

...and this will turn the head and steer the body around the corner

At the sharper corners, angle the tail of the fish in towards the turn.

Once this line test looks OK, in-between it.

Take a look at fish_swim_2D.avi in animations007, chapter007 of the CD-ROM.

animation of a fish in 3D

Copy the folder that contains your model (3dsmax_fish, lightwave_fish, maya_fish and xsi_fish) onto your C drive (in the case of xsi_fish copy it into the data folder). Open up max_fish.ma, maya_fish.mb, xsi_fish.scn or lightwave_fish.lws. The fish model has a series of bones running through it from the back of the head to the tail. With these you can make the sinusoidal wave run through the fish's body. These are called Bbone01 to 18. There is one bone through the head called HeadBone. It also has a circle running through its head called BodyControl. You can move the fish up, down and sideways and rotate it with this handle.

The pectoral fins have bones through them called RPectoralBone and LPectoralBone. Rotate these to move the pectoral fins. The pelvic fins have bones called RPelvicBone and LPelvicBone. Rotate these to move the pectoral fins.

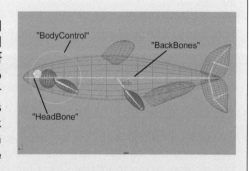

"BodyControl"

"BackBones"

"HeadBone"

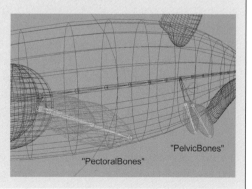

"PelvicBones"

"PectoralBones"

The eyes are controlled by a handle called EyeControl, just like the man and the dog.

animating a fish on the spot

First have a go at animating a 3D fish on the spot. Take out your drawings of your fish cycle (or have a look at the top illustration on p. 140 and middle illustration on p. 145). Load up your 3D fish from chapter007 of the CD-ROM.

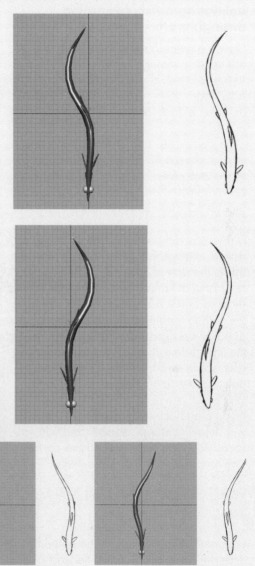

In your chosen 3D program, view the fish from above. Set your piece of animation to be 17 frames long. Move the time/frame slider to the first frame (frame 1 in Maya and XSI, frame 0 in Max and LightWave) and take out the first drawing from your fish animation. Select each of the bones through the fish's back and rotate them to make the shape of your 3D fish similar to the shape of your 2D fish, setting keys as you go. Move the frame/time slider to the last frame (17 in Maya and XSI and 16 in Max and LightWave) and set a key just the same as the first.

Then move the time/frame slider to the next key position (frame 9 in Maya and XSI and frame 8 in Max and LightWave) and move the 3D fish to a position that is the same as frame 9 of your drawn animation.

Once these key positions are done do the breakdown positions at frames 5 and 13 of the drawn animation. These will be at frames 5 and 13 in Maya and XSI and 4 and 12 in Max and LightWave.

Frame 5 (4) Frame 13 (12)

If you have followed your drawn animation of the top illustration on p. 140 and the middle illustration on p. 145 you should have a fish that is swimming in a fairly convincing manner.

Adjust the pectoral and pelvic fins so that they drag behind the body a little by rotating the pelvic and pectoral bones. Also get the tail to drag slightly by rotating the tail bones.

Have a look at fish_wave_3D.avi in animations007, chapter007 of the CD-ROM.

animating a fish swimming through water

Now we need to have a go at getting our fish to swim through water.

Take out your drawn fish animation or have a look at the top illustration on p. 140.

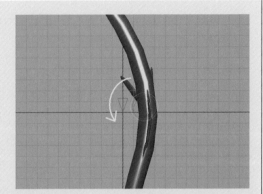

In your chosen 3D program, load your fish model and select the top view. Zoom out a certain amount and set the scene length to around 65 frames.

Draw a curved path of action on the screen with a chinagraph pencil and move your fish to the start of this path and then save a key frame at frame 1. Move the time/frame slider to frame 35 and move the fish along the path to a point where the path changes direction and save a key frame. Then move the time/frame slider to the last frame of your scene and move the fish to the last point on the path and save a key frame.

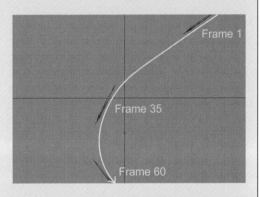

If you play back your animation, the fish will travel through space and do a broadside type slide around the corner. Don't worry; we'll sort that out later.

We now need to put the sinusoidal wave through the fish.

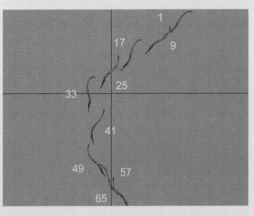

Look at your drawn animation of the fish cycle (or have a look at the second illustration in the chapter). Put in the key frames first. These happen at frames 1 and 9 of the fish cycle. Go back to the first frame of your 3D animation and then re-shape the body of the fish like frame 1 of the fish cycle. Then go to the ninth frame of your 3D animation and re-shape the fish like frame 9 of the fish cycle. Then go to the seventeenth frame of your 3D animation and make the fish look like frame 1 of the fish cycle. Then go to the twenty-fifth frame of your 3D animation and reshape the fish like frame 9 of the fish

cycle. Continue through your 3D animation like this.

When you get to a corner remember to kick the tail fin into the corner more, then move the head round and with a slightly twisted body, continue the sinusoidal wave through the fish until the corner is completed. Then straighten the fish.

Once the keys are done, go back and do the breakdown positions. These correspond to frames 5 and 13 of the fish cycle. Copy these for each relevant frame on your 3D fish. (The shape of frame 5 of the fish cycle should be copied onto the fifth,

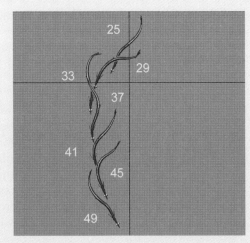

twenty-first, and thirty seventh frames of the 3D fish and frame 13 of the fish cycle should be copied onto the thirteenth, twenty-ninth and forty-fifth frames of the 3D fish).

Hopefully you will end up with something like fish_swim_3D.avi in animations007, chapter007 of the CD-ROM.

animation of a snake in 2D

To animate a 2D snake, first work out a path that the snake will follow. Take a look at the bottom illustration on p. 143.

Draw a snake at successive key positions along the path. Make sure that it is fairly long. The shorter the snake the harder it is to animate.

Remember that the head is held up slightly and follows a far less exaggerated path than the rest of the body. To give the snake more character, have it look to one side and then to the other. This will make it seem less mechanical!

Take a look at snake_2D.avi in animations007, chapter007 of the CD-ROM.

When you've done this have a go at a sidewinder!

It's probably worth animating the sidewinder from above to get the feel of its individual movement. Take a look at the bottom illustration on p. 144.

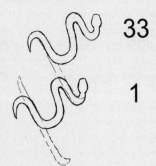

Start by drawing the first key position. Then lift the paper off the peg bars and trace this key a little further up, making sure it fits with the tracks left by the snake. This will be the key at frame 33.

Do the breakdown at frame 17. This is positioned half way between the drawings at frame 1 and 33.

Go back and do the drawings at 9 and 25. Follow the bottom illustration on p. 144 for guidance.

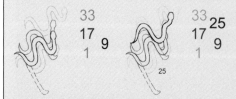

Test it to see if it works, shooting each drawing for four frames. If the animation is successful, in-between it all again and shoot each drawing for two frames and hopefully you'll end up with something that looks like sidewinder_top_2D.avi.

Once you've done the top view have a go at a side view. As with the top view start with the drawings at frames 1 and 33.

Then draw the breakdown drawing at frame 17.

Then do the drawings at frames 9 and 25. Look at the first illustration on p. 145 for guidance.

Test it to see if it works, shooting each drawing for four frames. If the animation is successful in-between it and shoot each drawing for two frames and hopefully you'll end up with something that looks like sidewinder_side_2D.avi.

animation of a snake in 3D

The animation of a snake tends to be rather specific to each of the computer programs so have a look at the .pdf files; 3DSMax_snake.pdf, LightWave_snake.pdf, Maya_snake.pdf and XSI_snake.pdf in chapter007 of the CD-ROM.

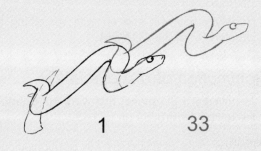

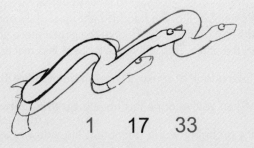

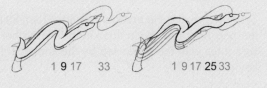

animation of birds

flying

Birds are adapted for flying in several ways. Their forelimbs are specialized as wings covered with flight feathers; they have powerful wing muscles, a rigid body skeleton, light hollow bones, a large heart and a well-developed nervous system.

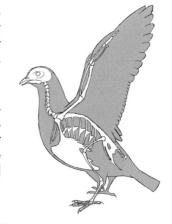

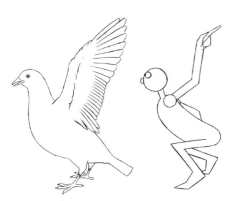

Think of the wings as being elongated arms (in the same way that you should think of the front legs of an animal as being like humans' arms).

In order to generate the power required to fly, a bird must have huge wing muscles. These wing muscles make up about 40% of the weight of a bird.

In order to anchor the huge wing muscles there has to be a keel at the front of the rib cage. This is called the sternum.

There is also a system of air sacs within the bones and between the body organs that provides extra air for the increased respiration while the bird is in flight. Consequently birds of the same volume as a non-flying animal are far lighter in weight. This gives lightness to the way that they move. The wings are concave below and convex above and

have a thick front (leading) edge tapering off to a thin trailing edge, like the wings of an aeroplane.

They provide the initial lift to launch the bird in the air, and then give it forward propulsion through the air. Birds take off with a jump or short run, preferably into the wind, followed by powerful semicircular beating of the wings, which pro-

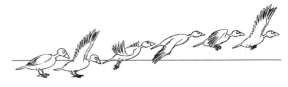

duces lift on the down-stroke and forward thrust on the up-stroke.

After gaining height the wings move with an up-and-down flapping, with the lift and thrust coming from the down-stroke.

I always find it looks better if the body of the bird falls on the up-stroke (no downward propulsion) and lifts on the down-stroke (lots of downward propulsion). The key positions are at the extremes of the movement. These are when the wings are pointing upwards and the body is at its lowest position in the air and where the wings are pointing downwards and the body is at its highest position in the air.

Waterfowl, such as ducks and swans, have greater difficulty in taking off from water as there isn't a firm surface to push from. The downward thrust causes the water to move – giving less air resistance. To overcome this they raise themselves with much more wing flapping.

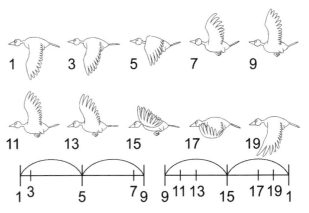

In the case of this flying cycle the key positions are at frames 1 and 9. There are three in-between drawings between 1 and 9 (the up-stroke) and five in-betweens between 9 and 1 (the down-stroke). Take a look at bird_flap_side_2D.avi in animations008, chapter008 of the CD-ROM.

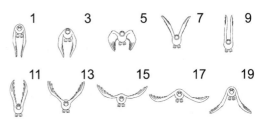

Sometimes I like to think of flying as swimming through the air. The wings have to force as much air as possible downwards and backwards on the down-stroke and then have to cause as little wind resistance as possible on the up-stroke.

When flapping downwards the wing will spread open to push as much air as possible backwards and downwards. When moving upwards, it will tuck in on itself in order to cause as little air resistance as possible. The tail helps to steer and the legs are tucked out of the way making the body smooth and streamlined. Take a look at bird_flap_front_2D.avi in animations008, chapter008 of the CD-ROM.

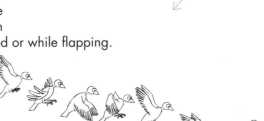

The tail tends to be angled down on the down-stroke and up on the up-stroke. This is partly because the tail is following through the action of the bird's body. The head does something similar.

When turning a corner in the air a bird will bank like an aeroplane. This involves angling the wings. The wing on the inside of the curve will be lower than the wing on the outside of the curve. This can happen when the bird is gliding with the wings outstretched or while flapping.

When landing, a bird slows down by widening its wings and tail and pushing its body vertically downwards to act as an air brake. It will also flap its wings faster to gain more thrust.

wings – insects and humming bird

The wings on these animals move very fast! Anywhere between 60 to a 100 wing-beats per second.

With a frame rate of 25 frames per second only a fraction of the movement is ever going to be caught. This means that you have got to give randomness to your animation. You will also need to blur the wings.

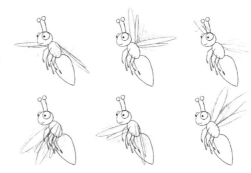

You can do this by giving the impression of catching the position of the wings in a single frame with indications of their position a fraction of a second before.

To produce an insect flying and hovering, use repeated, translucent images of the wings on

each frame in order to give a blur. Work out between four and six different wing shapes, and shoot these at random. Take a look at fly_flap_2.avi (the main problem with this piece of animation is that the fly looks like it is nailed to the spot. The body really needs to float around a bit to give a proper idea of hovering).

To get an insect or humming bird to fly around the screen, animate the body first and then add the random wings later.

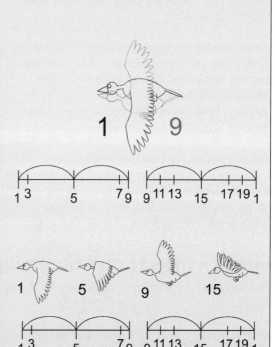

exercises

animation of a bird in 2D

2D bird flying on the spot

First off we will animate a bird flying on the spot, performing a flapping cycle.

Take a look at the sixth illustration. Copy each of the key positions and make sure your bird bobs up and down. The highest key position is at frame 1 (where the wings are down) and the lowest key position is at frame 9 (where the wings are up). Make sure the bird stays on the same vertical plane. Have the head follow the movement of the bird's body but about four frames (two drawings) late.

The first breakdown is at frame 5. This is where the wing is on the up-stroke and is tucked in to cause minimum wind resistance. The second breakdown is at frame 15. This is where the wing is on the down-stroke and is trying to push the maximum amount of air downwards. Consequently the wings are stretched out as far as possible.

In-between these drawings according to the timing charts, making sure the feathers trail downwards on the up-stroke (between frames 1 and 9) and upwards on the down-stroke (between frames 9 and back to 1).

Test it and hopefully you will have something that looks like bird_flap_side_2D.avi in animations008, chapter008 of the CD-ROM.

2D bird flying through the air

For our next exercise we are going to animate a bird flying along a path. Take out the animation of your bird flying on the spot for reference (or have a look at the sixth illustration).

First draw a path of action for your bird to follow. Then draw the key positions of the bird along the path.

Draw the breakdowns and in-between it as with the animation of your bird flying on the spot (or the sixth illustration).

Hopefully you will end up with something like bird_fly_2D.avi in animations008, chapter008 of the CD-ROM.

animation of a bird in 3D

Copy the folder that contains your model (3dsmax_bird, lightwave_bird, maya_bird and xsi_bird) onto your C drive (in the case of xsi_bird copy it into the data folder). You will find them in the bird_models folder in chapter008 of the CD-ROM.

Load up maya_bird.mb, max_bird.max, lightwave_bird.lws or xsi_bird.

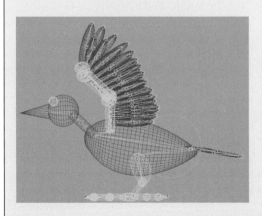
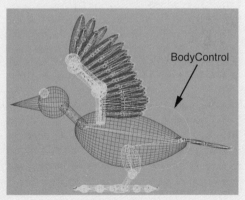

The model consists of a body with a single bone running down its length and a circle at the back called BodyControl. Selecting this will move and rotate the entire bird.

At the junction between the wings and the body are two further circles called Left WingControl and RightWingControl. Selecting and rotating these will make the wings

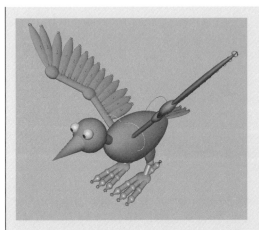 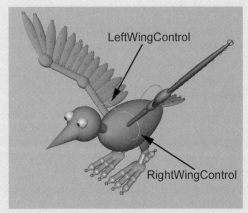

flap up and down. The wings consist of an arm shape with lots of feathers attached to it. Rotating the joints of the arm will move the arm and the feathers.

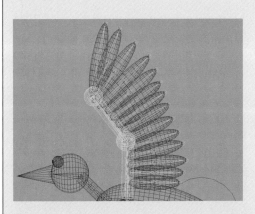 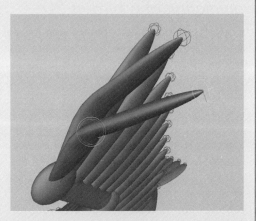

The feathers have two bones running along their length. Rotation of these bones will bend the feather.

There is no inverse kinematics on this model. That means that to move the wing, you have to rotate all the joints of the wing from the lowest joint upwards rather than from a handle at the top of the wing (as with the handle at the end of the arm on the model of the man).

The eyes are controlled by a handle called EyeControl, just like the man, dog, snake and fish.

3D bird flying on the spot

Take out your drawn animation of a bird flying on the spot for reference (or have a look at the sixth illustration).

We will make the 3D scene one frame longer than the drawn animation. End the new scene at frame 21 (Maya and XSI) or 20 (LightWave and 3DS Max). This will let us position the bird in the same place at the start and end of the scene as a reference point (as in the man and dog walk cycles and the fish cycle). Put the time slider/ frame slider to frame 1 (Maya and XSI) or frame 0 (Lightwave and 3DS Max). Position your bird like frame 1 of your drawn animation. The body is at its highest position; the wings, head and tail are down. Set a key frame on all the parts you've moved. Move the time slider/ frame slider to the last frame of the scene and set a key on every thing that you've moved.

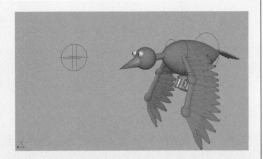

Go to frame 9 (Maya and XSI) or frame 8 (Lightwave and 3DS Max) and copy the key position at frame 9 of your drawn animation. This is where the body is at its lowest point and the wings, head and tail are up.

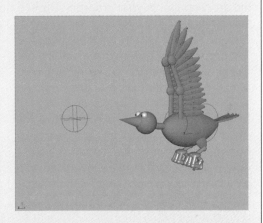

When it comes to doing the breakdowns, between the first and second key frames the wing is on the up-stroke and has to be moved up quickly. Copy the drawing at frame 5 of your drawn animation onto frame 5 (Maya and XSI) or frame 4 (LightWave and 3DS Max). All the feathers will be bent downwards. Select the bones in the feathers and shape them as in drawing 5 (it will probably be worth saving key frames on all the feathers at the first, second and last key frames, so things don't get too confusing).

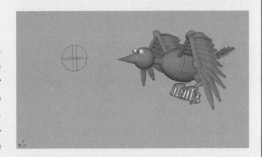

The next breakdown is at frame 15 of your drawn animation. This is where the wing is on the down-stroke and is spread out as far as possible. Bend the feathers upwards.

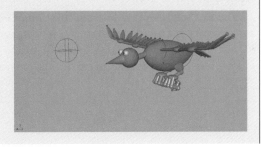

Once these are done you should only need some minor fiddling to sort out your animation. Render a movie one frame shorter than your animation (the last frame was for reference, remember?)

Have a look at bird_flap_3D.avi in animations008, chapter008 of the CD-ROM.

3D bird flying through the air

With your drawn bird cycle as reference, plot a rough path for your bird to fly along. This can be done by drawing on the screen with a chinagraph pencil or using the drawing tool in your program. Draw a path which copies that of your 2D bird flying through the air.

The drawing tool in Maya is either the CV Curve Tool or the EP Curve Tool. Go to Main Menu>Create>E P Curve Tool. As you place the dots on the screen a line will form between them. When you have finished dotting, press enter (on your keyboard) to get out of this mode. Move the dots with the move tool until you have a path that roughly matches the path of your drawn animation.

We are not going to attach the bird to the path. It is a guide for the flight path of the bird.

Select the BodyControl handle and set key frames at the equivalent key for your drawn bird cycle. Remember, the body is higher on one key frame then lower on the next, then higher and so on. Move the wings so that they are down as the body reaches its highest point and up as the body is at its lowest point.

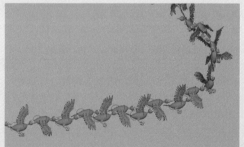

Once this looks approximately right complete the breakdowns (wing on the up-stroke will be tucked in, wing on the down-stroke will be spread out).

Once this is done render a movie and it should look something like bird_fly_3D.avi in animations008, chapter008 of the CD-ROM.

animation of acting – body language

full animation acting
mime

● *analysis of a character*

● *exercises*
 animation of acting in 2D
 animation of acting in 3D

acting

Developing a sense of the dramatic will help with your ability to realize what you want your character to express. In the same way that all movement in animation must be exaggerated to make it more convincing, the same is true of animation acting. I've found that animation acting has more in common with theatrical acting than live action film acting. Theatrical acting has to be big and demonstrative for the audience to see and understand what's going on. The exaggeration required for this is similar to exaggerated cartoon movement. Whereas film acting requires a certain amount of restraint, the camera can cut right into somebody's face and a whole range of emotions can be put over with the movement of an eyebrow. This is something that animation finds very difficult to do. The closer you cut into the face of your character, the more obvious it is that your character is artificial.

There are many theories about acting but I'm going to concentrate on the ones that I've found most useful. These are method acting and more traditional theatrical acting.

method acting

Think of this form of acting as constructing a character from the inside out.

Method acting is a style of acting that was developed by Konstatin Stanislavsky. He was a Russian actor, director and producer of stage plays and a founder of the Moscow Art Theatre in 1898. His book *An Actor Prepares* is well worth a read! The basic premise is that an actor lives and breathes the character of the part he is about to play so that when the actor's character is put in a given situation the character will react in a convincing way. This living and breathing of the character is carried out by workshops with other actors, the director making the actor act out spontaneous situations and also by the actor taking his roll home with him and acting the character out in real life situations. Imagine going out for the evening as King Henry the Eighth!

The actor is meant to use his or her own emotional experience and memory in preparing to live a role. So when an actor comes to reciting his lines the body language, intonation of voice and facial expressions will come naturally. It is a style of acting that is particularly suited to film. Quite often a camera will be left running while the actor acts out a scene, not

knowing exactly how it will end. This 'acting on the hoof' can result in some very powerful performances. It can also end up looking rather ragged and messy depending on the actor's ability and plain good luck.

This form of acting training was carried on by Lee Strasberg at the Actors Studio in New York from the 30s onwards.

An actor using this method is likely to ask, 'what is my motivation for this scene?'.

For animation this technique is useful for working out how your character would act in a given situation. Act out what your character would do in front of a mirror. Then use what you've learnt in your animation.

theatrical acting

You can almost think of this form of acting as constructing the character from the outside in. The inspiration for the character to the actor is derived from the script. The director and the actor work out a series of positions and facial expressions to adopt while each line is read. Sometimes this form of acting is referred to as negative acting. Depending on the actor's ability it can seem over the top, or it can be breathtaking.

This technique is best used in animation to work out the main poses and facial expressions that your character will adopt during a scene.

consequence

In real life any demonstrations of an emotion (body language, facial expressions and tone of voice) will be as a consequence of emotions being felt internally.

With method acting the body language, tone of voice and the facial expressions are as a consequence of genuine (or imagined) emotions being felt by the actor (by using their experience and memory to achieve these).

With theatrical acting the actor mimics the body language, facial expressions and voice intonations that are a consequence of emotions being felt in order to put over these to an audience.

Method actors are very disparaging of theatrical actors because of this mimicry. Theatrical actors are disparaging of method actors because they seem unable to act out a scene with out knowing everything about the character they are playing.

Animators have to use both acting techniques. They have to understand the characters inside out and know how a character will behave in a given situation (this is the bit where an animator will act out the scene in front of a mirror). They then have to mimic the visible manifestations of these emotions (body language, facial expressions and tone of voice) in their animation.

emotions

Emotions are the manifestations of conscious feelings. They can include feelings, an attitude, a state of mind of a character or a character trait.

Emotions can be divided up into three types, each of these types having a sliding scale of intensity.

Positive and negative. These emotions can range from happiness and excitement (positive) to anger, sadness or boredom (negative).

Engagement and rejection. These emotions can range from surprise and attention (engagement) to disgust and contempt (rejection).

Neutrality and high intensity. These emotions can range from calmness (neutrality) to being highly excited (high intensity).

Each of these three groups of emotions can be intermixed; for example, anger combined with contempt (negative and rejection).

Emotions can be experienced very briefly (for only a few seconds or fractions of a second) or for a long time. A mood could last for several days and an attitude or state of mind could last for a very long time. A character trait will be a part of the character's emotional make-up and will give a clue to the character's outlook on life. For example if a character is constantly miserable, they will have a sad or angry look on their face. Their shoulders will be stooped and their motions will be laboured.

Acting is the bodily expression of these emotions.

general body language

Sorting out the body language is the first thing you should do when animating a character. If you can put over what a character is thinking, looking at or doing just using body language, you are doing very well. When you add the facial expressions to your animation it will only get stronger.

We look at other human beings every day and we try to read from their facial expressions and body language what that other person is thinking and feeling. We've been doing this for almost every day of our lives and have become remarkably good at it. So good in fact that a large amount of this information is taken in subconsciously. We've all been in a situation where we've met someone who is all smiles and bon homie but there is something not quite right about them. Something a bit false, a bit dodgy. You could say that various door-to-door salesmen fit this category and the best ones are the ones that are able to get themselves into your confidence while not putting over the impression that they are trying to sell you something that you don't want! There must also have been times, for example at an interview, where you have not been able to come across as you would have liked. It may

have been down to the fact that you were nervous and didn't come over as someone in control and confident.

In order to animate subtlety we have to become an anthropologist with a deep interest in all human beings.

A lot of puppet animation (and puppetry in general for that matter) relies purely on body language. The faces of puppets can't change expression to the same degree as drawn animation or 3D computer animation, but puppet animation and puppetry can be just as expressive (if not more so) as any other sort of performance. Watch puppet shows like the *Muppets*

and animated films like a *Nightmare before Christmas* and see how the characters express themselves.

This is not to say that facial expressions are not important. Humans have the most expressive face of any animal and one of the main reasons that it exists is to communicate with other human beings. I like to think of the face as a canvas that different expressions are painted onto (more about faces in Chapter 10).

The one amazing thing about human beings is their ability to lie. We can be feeling miserable but we can still have a smile on our face. This ability to lie is at its best in the face. We can say that we are OK and we can smile to cover up another emotion. As we move down the body this ability to lie weakens. To put it bluntly our bodies are more honest. So if we are feeling miserable, we can put on a happy face. We may be able to hold our shoulders up when we want them to droop but there will be a strange strain to the position, perhaps they are held up slightly too high and are stiff in movement. As we move down the body the arms and hands could hang in a way that suggests that any movement is an effort. The small of the back will want to bend outwards and if the character walks the feet will drag. Very corny I know, but all these little things can add up to telling your audience what a character is feeling.

basic body postures

From the moment we wake up to the moment we go to bed we are spending our day reacting to things that we are presented with. Whether it's people, ideas, situations or problems, smells or sounds, everything we do is a reaction to something else. How we react to these situations is reflected in the body language we adopt. There are a huge amount of signals that can be given off by the positions adopted by different parts of the body. These postures can compliment each other or can contradict each other depending on the situation. For example, if somebody is depressed and openly expressing this the back will be bent and the body slumped forward, the shoulders will be slumped downward. The arms will be hanging down, the head will be hanging down with a sad look on the face and the legs will be bent at the knees, making the person look heavy. All off the different parts of the body are saying depressed and

adding up to a whole look of depression. If the same person is depressed but wants to cover this up the head would be held up with a forced smile on the face, the shoulders will be slightly slumped down, the arms will be bent at the elbows but the hands will be limp. The back will be slightly bent but the legs will be very bent at the knees, making the person look heavy. Although some of the signals given off by parts of the character's body say something else, the majority of the signals say depressed and so the observer will still get an overall feeling of depression.

Generally there are four basic forms of body language postures, *open*, *closed*, *forward* and *back*.

We use a combination of these postures to give out signals to other people. Remember, acting the emotion that your character is feeling in front of a mirror is always the best way to make the action clear to yourself. In order to keep things clear I have deliberately made the following illustrations as simple as possible.

open body postures

These are indicated by the arms being apart, the hands shown open, the legs being apart with the feet planted on the ground and the body fully facing the object of interest. This shows that your character is reacting positively to the messages they are receiving.

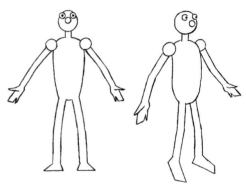

closed body postures

These are when the arms are folded and the legs are crossed (if seated). The body may be turned away from the object of interest. The head might be lowered. This shows that your character is rejecting messages that they are receiving.

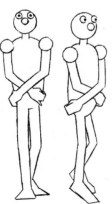

forward body postures

These indicate that a character is actively accepting or rejecting a message given to them. When they are leaning forward and pointing toward something with a fist or a finger, they are involved, absorbed or passionate about what they feel.

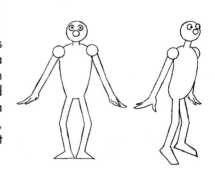

back body postures

These indicate that a character is passively involved or ignoring a message that it is receiving. If your character is leaning backwards, looking up at the ceiling, engaged in some other activity such as cleaning glasses, winding a watch or doodling on a pad you can say that they are passively absorbed or ignoring messages given to them.

These four postures combine together to create four basic modes: *responsive, reflective, combative* and *fugitive*.

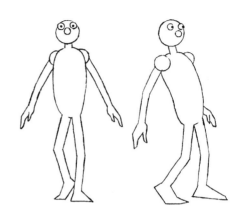

Here are some suggestions for body postures and actions during a range of emotions. Remember, nothing is better than working out these postures by acting the emotions in front of a mirror.

responsive

When a character is reacting *responsively* they will display a combination of open and forward postures. The moods covered by this can be happy, interested, engaged and occupied with something, in love, wanting something, eager and liking something.

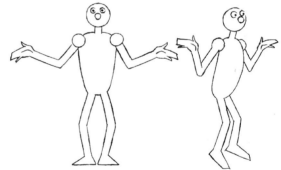

A list of different types of responsive body language and the mood that triggers them are now given.

When a character is happy, the body could be angled forward and the head held up. The legs could be apart and the arms and hands open.

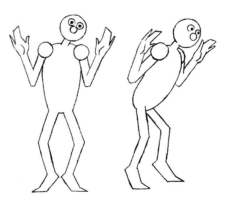

When a character is interested, engaged or occupied with something the body will be held forward and the head even more so. They may be standing on tiptoes, putting the head to one side.

When a character is in love they will have very open body postures and the body will lean

towards the object of their affection. The arms will fall loose and be uncrossed, and the palms are turned forwards. The head could be tilted to one side.

When a character is eager, they will also lean forward and be on the edge of their seat (if they are seated). They could grip something like the edge of a table or a pencil. Their head may be jutting forward and their legs kept apart.

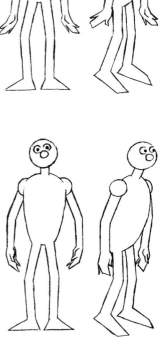

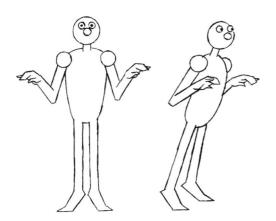

When a character likes something, think of your character doing a down-played version of being in love.

When a character wants something they could put their head on one side, put out their arms with the palms upwards, lean forward and open up the body.

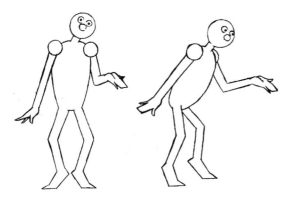

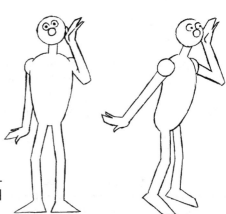

When a character is listening, lean the body forward, tilt the head, raise the arm to cup the ear and have the head nod occasionally.

reflective

When your character is in a *reflective* mood, they should display open and back postures. This is when your character is considering something, thinking and evaluating or feeling perplexed.

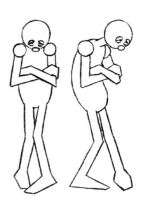

When a character is thinking and evaluating, they may do any of the following. Lean the body back, suck a pencil, stroke the chin or scratch the head. The head position may be angled to one side or looking up to the heavens (often to the right).

The legs could be crossed with the ankle on the knee (if sitting).

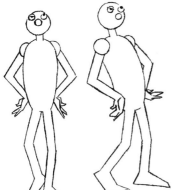

When a character is feeling perplexed, this usually involves a contradiction of body postures. Have the top part of the

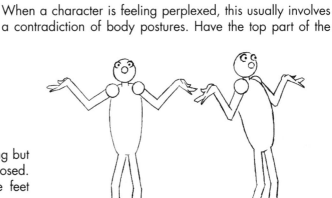

body open and similar to thinking but have the lower part of the body closed. Have the legs crossed and the feet occasionally moving on tip toes.

A raising of the shoulders and the opening of the arms and palms produces a shrug. This says 'I don't know'.

fugitive

When your character is in a *fugitive* mood they will display closed and back postures. This is when your character is feeling any of the following; rejected, bored, sad or miserable, is in denial, not quite sure of themselves, lying, wanting to get away or is resisting an idea.

Below are a list of different types of fugitive body language and the mood that triggers them.

When a character is feeling rejected or dejected, the body will be leaning back and slumped forward, arms folded, legs crossed with the thigh on the knee (if sitting) and the head down.

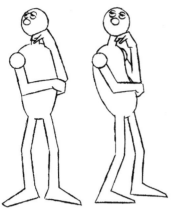

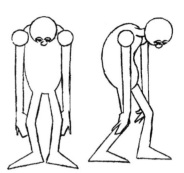

When a character is bored, the body could be slumped or angled back with the head staring into space. The character may be stifling yawns, tapping their feet or fingers, doodling with a pen or looking around for something interesting.

When a character is sad or miserable, the body will be very slumped. The arms will hang lifeless. The head will be hung low. Everything will seem to be an effort and difficult to do.

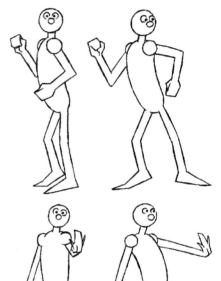

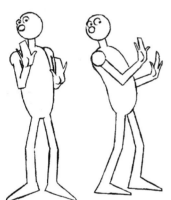

When a character is in denial, angle the body backwards and have the arms sweep across the body as if pushing something away. Have the hands form a fist or a pointing finger. Make the neck tense and hunch the shoulders.

When a character wants to get away, angle the body towards the main route of escape (usually away from the thing that they want to avoid). They will be looking around for a means of escape.

When a character is resisting an idea the body language will be rejecting the idea, the head will be shaking and the head is lowered.

combative

When your character is in a combative mood they will display closed and forward postures. This is when your character is: angry, wants to put over a point forcefully, is being defiant, wants to have or is having an argument.

When a character is angry the body will be leant forward. Hunch the shoulders and tense the neck. The arms will

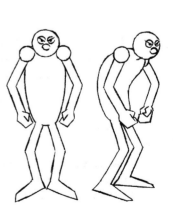

hang straight down or will be folded. The hands can form fists or a clenching shape. Tap the toes or stamp the feet.

When a character is putting over a point forcefully they will point with the hands and lean forward as if they are putting them-selves forward.

When a character is being defiant them will pull themselves up and cross their arms. The head will be held up high and angled back.

When a character is having an argument they will lean for-ward, wave their fists, strike things, hunch the shoulders and gesticulate wildly.

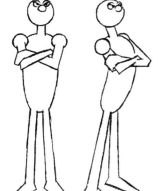

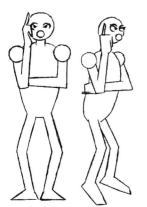

When a character is lis-tening to something that they disagree with they will partly cover the face with the hand. This could have a single upturned finger. The other arm will cross over the body. If seated the legs will be crossed.

palm, hand, arm and leg gestures

The hands and arms play a crucial part in our communication with other people. The pos-tures adopted by the legs reinforce these gestures.

palm gestures

The use of the palm can be used to suggest openness and hon-esty or the lack of it. Honesty and submission are suggested by a character gesticulating with open palms facing upwards or away from the character's body and towards the person they

are gesticulating to. You will see this sort of palm signal with the following examples: when people are shrugging, when they are happy, eager, interested or contemplating something.

Dishonesty or dominance are suggested by the palms being open but facing downwards or towards the character's body. You will see examples of this when people are being defiant, bored, sad or annoyed. When you see the open body language associated with a 'responsive' body posture but the palms are facing downwards or in towards the character, something doesn't seem quite right and you tend not to believe the character. This could suggest the character is lying.

The closing of the palm suggests anger and aggression or exaggerated dominance. You will see this form of display if somebody is aggressively pointing while talking or chopping the hand across the body. Examples of this type of palm signal will be seen when a character is angry, trying to put a point over, disagreeing with something or being argumentative.

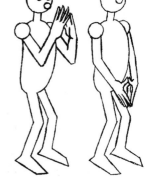

hand gestures

Rubbing the palms together suggests eagerness, excitement and expectation. Rub your hands together before you say something such as 'we're going to make a lot of money on this' and it suggests to an observer that they should be eager and excited too. Rub your hands together as you are saying the same phrase and you will come over as too eager about what is going to happen and will seem to be pulling a fast one over the observer.

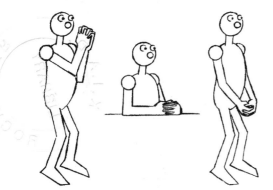

Clenching the hands together by interlocking the fingers suggests frustration and that the person doing this is holding back negative feelings. The hands can be clenched together in front of the body at different positions. If the hands are higher it suggests increased levels of frustration.

When all the thumb and fingertips of each hand are pressed together and the hands are held upright, this gives an impression of superiority. It's usually done when the character is talking, or more accurately pontificating. It's a bit smug and 'know it all'.

When somebody is listening attentively to something the thumbs and fingertips can be pressed together but the hands will be held downward.

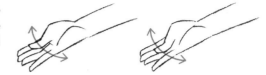

Rubbing the thumb and fingers together suggests money!

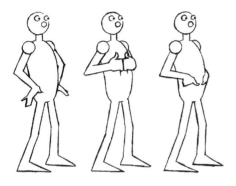

Prominent thumbs suggest confidence, dominance or coolness.

Pointing with the thumb is a demonstration of a character pointing at someone or something in a derogatory manner.

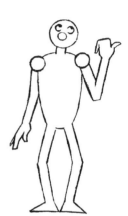

arm crossing

Hiding behind something is a way of protecting ourselves. If a character crosses their arms in front of them it's as if they are hiding behind their crossed arms. It may be because the character disagrees with something that has been said or it may not be comfortable with the situation it is presented with.

Clenching the fists while crossing the arms gives a hostile signal.

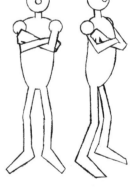

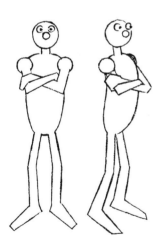

Gripping the arms tightly with the hands while the arms are crossed suggests nervousness and stress.

Partially crossing the arms shows a lack of confidence (for

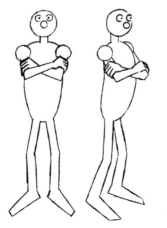

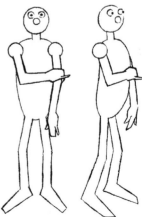

example in a situation where the character is with a lot of strange people).

Crossing the arms at the hands, suggests humility.

leg crossing

Leg crossing gives off a similar signal to arm crossing but is far less strong. A basic cross-ing of the legs can give the impression of defensiveness, but could actually have been adopted by a person try-ing to make themselves comfortable.

Combine a leg cross with an arm cross and back-ward body posture and a sour look on the face and you definitely get an impression that a person is showing displeasure.

Crossing the leg with the heel at the knee gives a competitive, aggressive impression.

Crossing the legs at the ankles gives a prim and proper look.

Entwining the legs around each other gives an impression of a lack of confidence or ner-vousness. This can be done both sitting and standing.

Crossing the legs when standing reinforces the closing off of the body.

Remember. All of these body positions and gestures can be mixed and matched to produce a convincing overall body posture, but nothing beats acting it out in front of a mirror.

acting out a scene in animation

I tend to think of straight-ahead animation being more like method acting whilst key-to-key or pose-to-pose animation has more in common with theatrical acting.

Straight-ahead animation can throw up some interesting, spontaneous touches but can go out of control, whereas pose-to-pose animation has more control but can sometimes seem wooden and clunky.

In the end you should use a combination of the two.

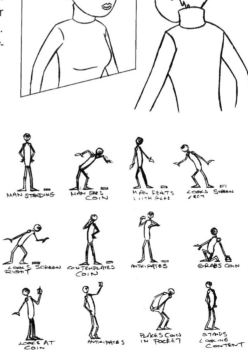

Work out your character by acting out a scene yourself. It doesn't matter if your acting is not particularly good. Do it in front of a mirror in the privacy of your own home. Think how your character would behave in a given situation. How does your character think? This will govern the way it moves. Note all this down.

When it comes to animating a scene, act it out first then sit down and work out a series of thumbnail sketches. Think of the minimum your character has to do in a scene to make sure an audience is going to understand what is going on. Make sure you have good strong silhouettes. One thing to avoid is something called 'twinning'. This is where the arms (for example) do exactly the same thing at the same time. If the arms are doing a sweeping gesture downwards offset one arm slightly from the other (if you act everything out thouroghly you tend to avoid twinning anyway).

MAN STANDING MAN SEES COIN MAN FEELS WITH GLEE LOOKS SCREEN LEFT

LOOKS SCREEN RIGHT CONTEMPLATES COIN ANTICIPATES GRABS COIN

LOOKS AT COIN ANTICIPATES PLACES COIN IN POCKET STANDS LOOKING CONTENT

When you've completed your thumbnails, shoot them with your line tester and play

about with the timing. It doesn't matter if the sizes of the character change, all you are doing is feeling your way through the scene.

You can now re-draw the thumbnail sketches onto full size paper, modifying them as you go along. You could always blow them up on a photocopier! The idea is to retain the spontaneity of the thumbnails in your animation. Shoot these to the same rough timing as your original pose test with your thumbnails, making sure that nothing is bouncing about too much, such as feet touching the ground or hands touching the scenery. This test would consist of the major key positions.

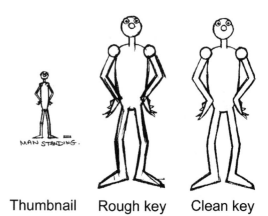

Thumbnail Rough key Clean key

After this, sketch in the minor key positions (all the anticipations and overshoots) and some of the major in-between drawings (the breakdowns). Shoot it again. Keep flicking, flipping and rolling all the time.

Generally the way we move in both real life and when acting is to shift from one major pose to another. When we reach each of these poses we still keep moving but make only minor moves. If you want to see a good example of this, just fast forward a feature film and watch how the actor will move quickly from one position to another and then stay put for a short period of time.

Once you've worked out these major poses and the minor key positions (the anticipations out of a position and overshoots into a position) think about things that you can get your character to do while in those poses.

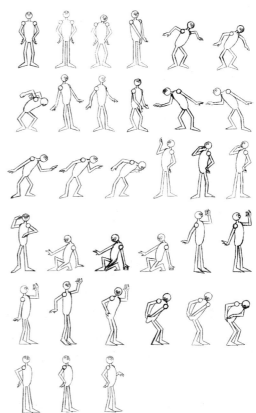

Move your character through a pose in a way to emphasize what the character is doing. If your character is looking off to screen right, move the character into that position and then move them slowly forward a small amount while looking.

Think about the most extreme position as being one key position and the position that the character moves to as another key position. Then do some timing charts to work out where to place the in-betweens and then complete the in-betweens!

Make sure that when you do the in-betweens different parts of your character move at different rates depending on the item you are animating. For example the drapery will follow through the main movement of the character. One way to do this is to roughly animate one part of the character all the way through the scene. For example, first animate the main movement of the body, then go back and animate a different part of the character (e.g. the drapery). This technique is referred to as building the animation up as layers.

You start with the basics (your characters as simple ball-like shapes), then add the details!

Keep adding to these layers until your animation is finished in rough. Then and only then clean up each animation drawing onto another piece of paper.

the different sorts of animation acting

Depending on the budget, time scale and type of production, most acting in animated films tends to fall into the following categories.

animated radio

Also known as limited animation, this form of animation is a series of pictures that illustrate the script.

This is probably the simplest form of animated acting. It is frequently used in low-budget TV series. The characters move as little as possible and tend to be flatter in design, to save time

and money. When using limited animation your script needs to be as good as possible because you can't use the animation to distract from weaknesses or holes in the plot.

Animators working on these productions have to think far more about the drawings they do and they have to be very good drafts-persons. The audience is relying on fewer drawings to convey the story.

pose-to-pose animation acting

Generally this is the type of acting employed in Hollywood animated shorts. The best exponents of this are Tex Avery (Droopy, Screwy Squirrel) and Chuck Jones (Wile E. Coyote, Daffy Duck, Bugs Bunny).

Pose-to-pose animation involves drawing the best poses which emphasize the central themes to the story line and animating between each as quickly as possible. When your character is in these strong poses you then give them something to do. This type of animation makes a virtue out of the strong poses it uses.

It's the kind of animation that expresses a point effectively but won't get in the way of your ideas or gags. It suits fast aggressive, violent humour.

This kind of animation could not sustain a feature film – you'd be worn out after 70 minutes. Having said this, it's fast and furious and if done well, very funny.

full animation acting

This is the kind of animation used in feature films and is probably the hardest to do. It's animation that requires light and shade. You have to spend time with the characters in order to know them well enough to care about them for 70 minutes. In earlier animated feature films the heroes were usually as dull as ditch water but the villains (and the comic relief characters) were really exciting. Nowadays, scriptwriters tend to emphasize the comedy (and the flaws) of the heroes in animated feature films. It's because their characters are flawed that they are interesting.

Full animation will involve using similar techniques to pose-to-pose animation but the poses won't be as obvious. The movement will be more fluid and continuous. Although an animator will draw the key poses and in-between them (or set keys on his/her computer model in 3D) the animation will not look as if it's moving from one deliberate pose to another. It is a type of animation that has the freedom and fluidity of straight-ahead animation and the discipline of pose-to-pose.

One way to help with full animation is to leap about in front of a mirror and live and breathe the character you are animating. Draw sketches of the movements and poses and shoot them in sequence as a 'pose test'. From here draw the sketches as the key drawings and animate straight ahead between each drawing aiming roughly at the next key position (use the timing you worked out in the pose test). If, when you reach the next key, your straight ahead drawings have changed from the original key position, go with it. Continue going through

the sequence in this way. Animate straight ahead but use the key drawings as a guide to where and when you will end up during the animation.

One of the main processes animation studios use to make its characters more real and believable is for an established actor to provide the voice. They will also often film an actor performing most of the movements, sometimes, the same actor who provides the voice.

The best characters in most animated feature films are often the villains. The movement and acting tends to be far bigger and more exaggerated. Because of this, they are frequently voiced by stars who can throw themselves into the roles with zeal. Sometimes the heroes can seem rather dull in comparison. These characters can be more difficult to animate. The acting required is much more subtle. The best way to make their characters more interesting is to emphasize their humorous side.

Fully animated characters should be fairly simple in their design and not have lots of complicated bits and bobs attached to them. The more complicated the character the more awkward it is to animate and the more awkward it is for an audience to watch.

When using full animation some actions are more difficult to animate than others. The subtle movements made when somebody is sitting down and doing nothing other than thinking can make this difficult to animate well. Animating a swash-buckling sword fight is much easier to do because of the complexity and speed of the action. There's only one thought going through the head of a sword fighter and that is 'how do I swing at my opponent again?' When animating somebody falling in love, there are hundreds of thoughts going through their head. To convey these emotions and thoughts you've got to animate them all bubbling to the surface. It's much easier to act out a sword fight in front of your full-length mirror than it is to convincingly portray a believable love scene. This is because complex action is very different to complex acting.

Full animation also demands a good use of timing and sense of design for the overall screen image. For this kind of film making you not only have to know when to slow your animation down and when to speed it up, you've also got to know when to hold back with your background animation and when to exaggerate. It's all very well having the most brilliant animation in the background but if it distracts the eye from the main purpose of the scene it's worse than useless.

mime

It is worth looking at and studying mime artists. If they are performing well, they have amazing control of their bodies and are able to convey emotions with the smallest gesture. The whole body can portray emotion. For example, the head hung low, the shoulders dropped, the body bent over and the legs dragging the feet suggests an air of depression. The folding

over of the arms and legs suggests somebody that is lying or feeling uncomfortable. Somebody who is happy will walk with a spring in their step, their movements will be quicker and quirkier.

Mime is used in a lot of European animated films. If you make a mute film it can be viewed by a larger global audience. This is why they are so popular around the world.

analysis of a character

The basic idea is to live and breathe your character – act out everything your character has to do and present it to an audience so they understand what makes that character tick.

Actors have drawn inspiration from animation, as well as the other way round. Laurence Olivier based his portrayal of Richard the Third, in the film of the same name, on the wolf in Disney's *Three Little Pigs*.

One of the best things to do before you start animating is to write down a list of the main character traits of the character you are about to animate. On a professional animation project, your director has, hopefully, already done this and will be able to brief you before you start animating. When you're working on your own project you'll have to do it for yourself!

> MY CHARACTER IS:
>
> GREEDY.
> A COWARD.
> THE KIND OF PERSON
> DISASTERS HAPPEN TO.
> SELFISH.
> (MY GOD! IT'S ME!)

Make sure you also have a good collection of model sheets to work from.

exercises

animation of acting in 2D

The exercise below is of a character spotting a coin on the floor, looking around and quietly pocketing the money. As with all the exercises this is a guide which can be followed. Other ideas include somebody picking an apple out of a tree, a book off a shelf, a cake off a plate on a table or picking somebody's pocket. The aim is to have a character see something, covet it and sneakily take it.

Have a character standing in medium shot, slightly to one side of the screen. To the character's side on the ground is a coin. The character is going to see the coin, sneakily look from side-to-side, pick up the coin, look at it and then pocket it. Act it out in front of a mirror and draw a series of thumbnail pose sketches (or have a look at the bottom illustration on p. 174) of the major key positions. Shoot the thumbnail sketches as a basic linetest. Take a look at coin_thumbs.avi in animations009, chapter009 of the CD-ROM.

Once you're happy with the timing of the thumbnails, draw them full size and think about the minor key positions. These are the smaller movements your character makes when in a pose. They are also the anticipatory movements out of one position and the overshoot positions into another. Remember to slug out these actions in the action column on your x-sheet.

Between the equivalent of the first thumbnail sketch (character standing) and second thumbnail sketch (character looking at coin), have the character straighten up and then glance down at the coin, do a double-take and then do a big look at the coin. Key 1 (frame 1) is basically the same as the first thumbnail sketch; the character is standing centre screen. Key 2 (frame 11) is at the highest point of the straightening up. Key 3 (frame 33) is at the point where the character finishes glancing at the coin. Key 4 (frame 37) is at the anticipation of the second look. Key 5 (Frame 45) is the big look at the coin and is the equivalent of the second thumbnail sketch.

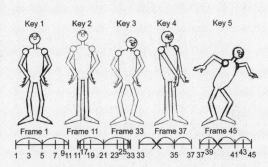

Between the equivalent of the second thumbnail sketch (key 5, frame 45) and the third (character standing back and looking at the coin with glee (key 8, frame 69)), have the character looking at the coin as it moves closer to the coin and do an anticipation into the look of glee. Key 6 (frame 57) is at the end of the movement forward as the character is looking at the coin. Key 7 (frame 63) is the anticipation position, which then leads the character to move into the look of glee (key 8, frame 69).

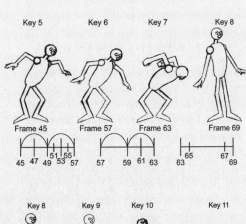

Between the equivalent of the third thumbnail sketch (key 8, frame 69) and the fourth (character looking screen left (key 11, frame 93)), have the character move forward as it is looking with glee and then do an anticipatory move into the look screen left. Key 9 (frame 81) is at the last position where the character has moved forward. Key 10 (frame 85) is an anticipation position, which then leads the character to the look screen left (key 11, frame 93).

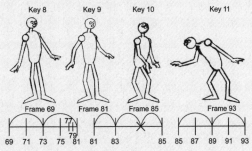

Between the equivalent of the fourth thumbnail sketch (key 11, frame 93) and the fifth (character looking screen right (key 13, frame 115)), have the character lean forward in the direction that it is looking. Then have it move quickly into the look screen right. Key 12 (frame 107) is the last position where the character has leant forward, before it moves to key 13 (frame 115) where it is looking screen right.

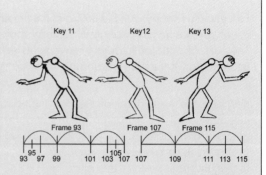

Between the equivalent of the fifth thumbnail sketch (key 13, frame 115) and the sixth (character pondering coin (key 17, frame 145)), have the character move in the direction of the look off screen right, then anticipate the movement up into the pondering position, overshoot and then go back down into the pondering position. Key 14 (frame 129) is the last position of the move towards the look screen right. Key 15 (frame 133) is the anticipation position. Key 16 (frame 141) is the overshoot position, which then leads back down to key 17 (frame 145), where our hero is pondering the coin.

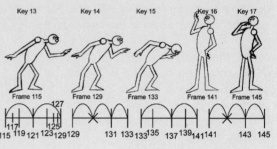

Between the equivalent of the sixth thumbnail sketch (key 17, frame 145) and the seventh (character anticipating grabbing the coin (key 19, frame 163)), have the character straighten up slightly whilst pondering the coin. Key 17 (frame 145) is the first position of the character pondering the coin. Key 18 (frame 159) is the last position of the character pondering the coin, having straightened up slightly. Key 19 (frame 163).

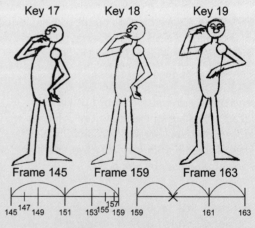

Between the equivalent of the seventh thumbnail sketch (key 19, frame 163) and the eighth (key 21, frame 173), have the character overshoot the coin-grabbing position with the fingers outstretched and then bring the character up slightly as it grabs the coin. Key 20 (frame 169) is the overshoot position. Key 21 (frame 173) is the coin-grabbing position.

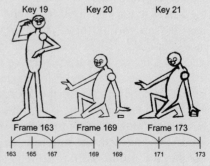

Between the equivalent of the eighth thumbnail sketch (key 21, frame 173) and the ninth (character holding up coin and looking at it (key 24, frame 187)). Have the character, while it is still grabbing the coin, move down slightly and then move up to and overshoot the position where it is looking at the coin. Key 22 (frame 177) is where the character has moved down a little. Key 23 (frame 183) is the overshoot position. Key 24 (frame 187) is the point at where the character looks at the coin.

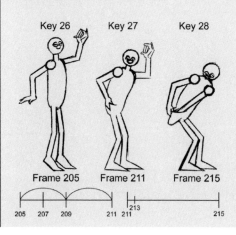

Between the equivalent of the ninth thumbnail sketch (key 24, frame 187

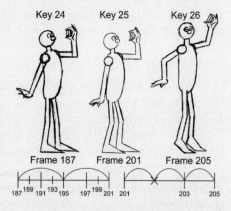

and the tenth (key 26, frame 205)) have the character move slightly as it looks at the coin and then lift the arm up as an anticipation position. Key 25 (frame 201) is where it is still looking at the coin but has moved its arm outwards a bit. Key 6 (frame 205) is the anticipation position of the arm going up before it is plunged into the pocket.

Between the equivalent of the tenth thumbnail position (key 26, frame 205) and the eleventh (character with hand plunged in pocket (key 28, frame 215)). Have the character grab the pocket at key 27 (frame 211).

Between the equivalent of the eleventh thumbnail position (key 28, frame 215)

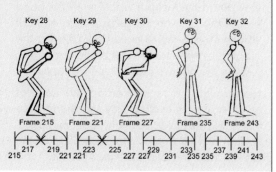

and the twelfth (character standing look-
ing innocent (key 32, frame 243)), have
the character pull its hand out of the
pocket and put its hand on its hip. In key
29 (frame 221), the character still has its
hand in the pocket. Key 30 (frame 227)
anticipates the character popping up.
Key 31 (frame 235) is where the charac-
ter overshoots into the hand on the hip
pose which is key 32, frame 243).

At the end the character keeps still but
brings up its arm.

Take a look at coin_2D.avi in chapter009
of the CD-ROM.

animation of acting in 3D

Load your character onto your program
and at the first frame set the character up
so it is stood exactly like frame 1 of your

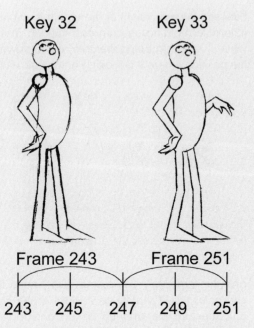

drawn animation (the first illustration on p. 179). Make the length of the scene the same
length as your drawn animation (in this case 252 frames long).

Create some ground for the character to
stand on either by creating a grid or a very
short, wide and deep box and place it under
the character's feet.

Make a coin by creating a cylinder and give
it a radius of 0.5 and a height of 0.2 (5 and
2 in 3DS Max). Place the coin on the ground
to the right of the character, about 5 units
from the centre.

Create a second coin and parent it (attach it)
to the hand that will pick the coin up. Make
the coin in the hand invisible until the hand
grasps the coin on the ground then make it
visible. At this point make the coin on the
ground invisible for the rest of the scene. (It's
just like the ball we picked up in Chapter 3.)

Go through the sequence copying each of
your drawn animation key positions onto
you 3D-program or copy the bottom illustra-
tion on p. 174 and all the illustrations in the
previous 2D exercise section.

Take a look at coin_keys_3D.avi in chapter009 of the CD-ROM. The movement during the sequence is close to being as it should. However there are some important faults. The movement/dynamics throughout the scene are slightly too even. The character seems to sway around at the points where it should be making a small amount of movement (e.g. where the character looks off screen and the point where he looks at the coin). The legs also act very strangely. Go through the animated sequence inserting further keys at the positions of the breakdowns (the major in-betweens) between the keys you have already set.

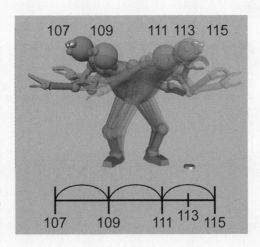

At the points in the animation where the character should only move slightly, flatten out the animation curves to make them linear. This will take out the swaying motion.

Finally when this is working, go back and animate the hands and fingers, the eye blinks and the swivelling of the feet on the ground. It's often best to animate the hands straight ahead.

You could even have a go at making a pocket out of a sphere. Shape it as a cup shape and make it appear as the 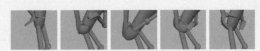 character opens the pocket. Scale it as the coin is thrust into it and make it disappear as the character's hand lets go of it.

Take a look at coin_3D.avi in animation009, chapter009 of the CD-ROM.

chapter 10

animation of acting – facial expressions

animating the mouth with Morpher in 3D Studio Max
animating the mouth with Animation Mixer in SoftImage XSI
animating with Morph Targets in Lightwave

We have the most expressive faces in the animal kingdom. With a combination of eight basic expressions we can pull around 5000 different faces all with slightly different meanings. The majority of these expressions are universal to all human cultures.

The face is used as a signpost to other people. It shows how we are feeling and what we want, or can be used to mask the way we feel. Almost half of our brain is concerned with seeing and almost half of this part of the brain is dedicated to recognizing human faces and facial expressions.

When we look at someone, we study the face. We look at the eyes, the eyebrows, the lips and the forehead. A combination of signals given by these give us information to form an opinion as to what the owner of the face is thinking.

When animating your character, because facial expressions can be very ambiguous and misleading, it is always best to work out the body language first and then add the facial expressions.

I have deliberately kept the illustrations and examples in this chapter as simple as possible. It's up to you to act out these emotions in a mirror to elaborate on them.

emotions

Facial expressions are the ultimate demonstration of our emotions. We use the face to broadcast and communicate our emotions. Facial expressions are a form of behaviour that are caused by the contraction and relaxation of the facial muscles.

Facial expressions will be as a result of somebody hearing something, seeing something, smelling something, tasting something, feeling something or thinking something. As a character goes through a scene the facial expression will change depending on these stimuli. Think of each of these facial expressions as key positions and animate between them and hold them as necessary.

At its most simplistic, there are eight basic emotions: happiness, sadness, surprise, fear, anger, disgust/contempt, interest and pain.

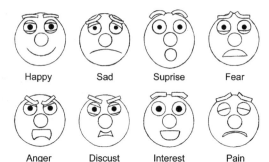

Happy Sad Suprise Fear

These are inherited and not learned. Each of the basic emotions has an appropriate facial expression to display it. These are common to all human cultures. Some variations of these expressions are cultural specific and learned.

Anger Discust Interest Pain

A combination of these basic facial expressions can appear on the face at the same time, such as happiness and surprise. All of these basic facial expressions can be varied depending on the intensity of the emotion portrayed.

The design of a character could emphasize a certain emotion. A down-turned mouth will make your character look morose, sad, angry or irritable. Heavyset eyebrows can produce the same effect. When this character displays an emotion other than the over-riding emotion suggested by the design, the new emotion must be exaggerated to make up for the character's design.

True expressions are involuntary and display the emotion being felt by the character. They tend not to be held for long periods and flit across the face as the person changes mood.

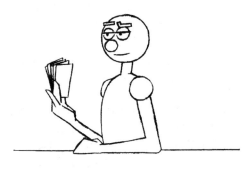

False expressions convey something other than how the character is feeling. Actors, liars, con artists, sales people, for example, use false expressions to varying degrees. I suppose animators do when animating their characters.

These false expressions can take the form of a character putting on a neutral face when a deep emotion is being felt. For example a poker face when holding a royal flush!

Another example of a false expression is an emotion that is simulated when none is being felt; for example, the sincere face of a used-car salesman.

One further example of a false expression is one that is covering up the true emotion being felt underneath. Smiling when you want to cry.

Sometimes in animation, we tend to only include readable/appealing facial expressions; however, it's useful to include neutral almost undistinguishable expressions to compliment these.

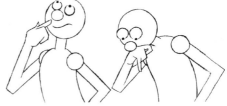

the eyes

'The eyes are the windows of the soul'.

The main feature which makes a character seem alive is the eyes. If the eyes are not focusing on something your character will look

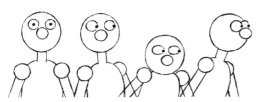

like a groggy doll. Always give your character something to look at either on screen or off. The only times your character will not be looking at something is when their eyes are glazed and looking into the middle distance or they have crossed eyes (when they are thinking or have been drugged or knocked out and are dazed).

The eyes will lead all movement of the face and body. When a character looks off screen the eyes will move first, then the head, then the shoulders and then a twisting at the waist.

Following are some examples of emotions and the different looks connected with them.

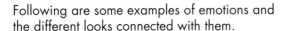

When a character is thinking they may also make a look. They could look up heavenwards for inspiration or down at the ground.

When a character sees something that they like or love the pupils of the eyes will dilate (they will get bigger). This will also make the character look more attractive or cute.

When a character is frightened the pupils will contract into tiny pinpoints. This also happens when a character is evil or hates something or is untrustworthy.

When a character is surprised the eyes will bulge, emphasizing the whites of the eyes.

When a character is shifty and evil and appears to be happy, smiling and laughing, the eyes will narrow; reducing the white of the eyes visible.

When a character is feeling sexy and wants to give a sexy look, the upper eyelid is lowered

and almost cuts the eye in half. The head is usually turned away from what it is looking at. Combine this with fully dilated pupils for maximum effect.

The two main functions of a blink are to clean the eyes and to protect them from danger. When we blink we shut our eyes in different ways to portray different emotions.

A baby will blink infrequently and with a slow opening and shutting of the eyes. The opening and shutting will look very deliberate. Combine this with a direct stare and large pupils and you have a cute, loving look. This can be replicated by adults who are in love with the object they are looking like.

With a standard blink, the eyelid will close slowly and open quickly. By making the eyelids pop open quickly, the character looks alive and awake.

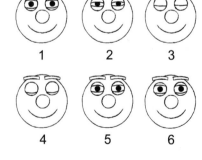

When somebody is sleepy or not very bright (stupid) the eyelids will shut slowly and open very slowly, with a lot of drag on the lids. This gives the impression that opening the eyes is a huge effort.

A real cliché when it comes to blinking is the fluttering of eyelashes. This happens when a feminine character tries to look attractive and get the attention of another character. The eyelids

will open and close quickly with the (elongated) eyelashes following though in an exaggerated manner.

When drawing the eyes (or building them in 3D) make sure that you take into consider-

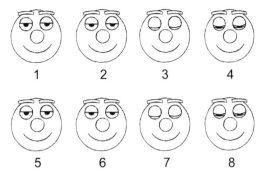

1 2 3 4

5 6 7 8

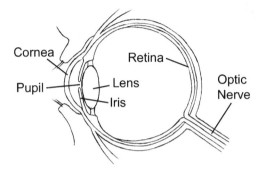

ation the fact that the pupil and the iris have a convex lens in front of them called the cornea.

The way to illustrate this is with drawn animation; for example, when your character is

looking to the side, draw the pupil slightly through the outer line of the eye rather than on the inside of it. This will give more direction to the look and will make the eyes seem more three dimensional. Because of the exaggeration of this drawing it will also make it more cartoon-like.

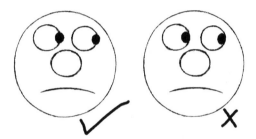

facial expressions

The facial expressions that portray the seven basic emotions are: happiness, sadness, surprise, fear, anger, disgust and contempt.

happiness

There are different degrees of happiness, ranging from mild amusement through to ecstatic laughter.

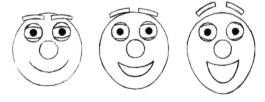

a smile

The eyebrows on a normal smile will be raised evenly. The corners of the mouth are raised, symmetrically, into a smile. This can be with the mouth open or closed. With the mouth closed the lips narrow and are stretched over the teeth and gums. With the mouth open, a smile can be with the teeth closed, exposing the teeth and gums or with the teeth open and the jaw dropped. Each of these mouth positions makes the emotion expressed

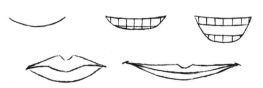

more intense. The gap between the top lip and the bottom of the nose narrows. The lips will become thinner as they are stretched.

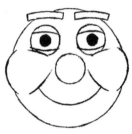

A furrow appears between the corner of the mouth and the nostrils on either side of the face, making the cheeks puff up and outwards. Depending on the width of the smile a furrow can form between the corner of the mouth and the chin on both sides of the face.

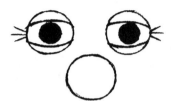

Crow's-feet form on the outside of each eye. A muscle around the eye contracts making the skin underneath it puff out. This narrows the eyes. The pupils will dilate to suggest the character likes what they are seeing or feeling. The ears can also move up.

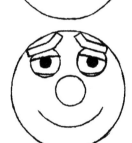

In a false smile the lips and eyebrows may be slightly asymmetrical. The muscles around the eyes don't contract so there are no crow's-feet or puffing of the skin under the eyes.

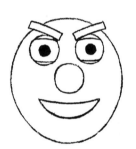

If the eyebrows are angled downwards and inwards, you get an evil smile. With this smile you could contract the pupils to make the character look more sinister.

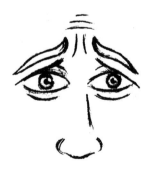

If you angle the eyebrows downwards and outwards, you get a forlorn, sad smile.

sadness

This emotion can range from disappointment through to crying with despair.

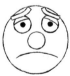 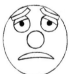 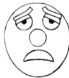

The inner ends of the eyebrows will be raised and the outer ends lowered. This pushes the outer edge of the eye socket over the eyes. The upper eyelids may drop slightly. There will be concave furrows on the forehead.

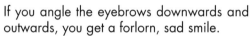

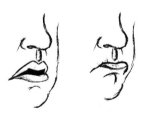

The corners of the mouth will be turned down causing two furrows to run downwards from the nostrils to the chin via the corners of the mouth. The lower lip could be pushed upwards and

outwards, increasing this downturn. This can be accompanied by a depression immediately under the lip. This is particularly apt for the face of a sad baby.

The jaw can be dropped while the lips are still shut, this will give your character a long face. The mouth could open, especially during crying. Another thing that looks good is to make the bottom lip quiver.

When a character is sad the eyes may look downwards. During crying the eyes will be closed or almost closed. If a character looks to one side when sad the pupils could move slower.

False sadness could be given away by a slight curling up of the corners of the mouth, crow's-feet appearing at the outer corners of the eyes, puffy bags at the bottom of the eyes and an irregularity of the eyebrows.

surprise

This emotion can range from slight surprise through to amazement. If the mouth has a smile you get a look of delight.

The eyebrows are raised high above the eyes and the forehead is furrowed.

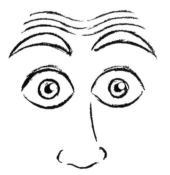

The eyeballs will bulge out, making the eyes look bigger. The eyes tend to stay fixed on the object that has surprised the character.

The mouth will usually be open with the jaw dropped. The mouth will take on an oval or round shape.

When the character is first surprised there will be an anticipation move and then a rapid movement of the head back

and a blinking of the eyes. The head may also shake from side to side.

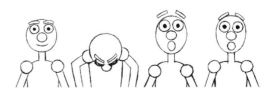

False surprise will be similar to the above but the movement will be slightly delayed. There may first be a slight look followed by the reaction. When animated the surprised look could

be held slightly too long. The mouth could be squared off, as if it's being held open deliberately and the eyebrows could be uneven. The pupils will not be able to keep their fixed look on the object of their surprise.

fear

This emotion can vary from apprehension, through worry to shock and plain terror. The mouth will be open with the jaw dropped the corners of the mouth pulled outwards and downwards.

The eyebrows will be drawn together and raised and vertical lines will form on the forehead. Both the upper and lower eyelids will be raised, the lower eyelid being tense, pulling it straight across the eye. The pupils could be dilated.

Generally there would be a large amount of movement of the body and head through the main fear pose. Mock fear would involve an over the top face and body pose but the character staying still. The eyes may move more erratically.

anger

This emotion can range from slight irritation to blind fury.

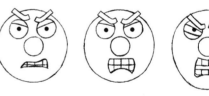

The inner ends of the eyebrows are pulled inwards and downwards. There will also be a fold of skin between the eyebrows. The eyebrows will press down onto the eyes. The eyelids could narrow or the eyes could bulge. The pupils could be contracted into tiny pinholes.

The nostrils can get bigger and flare out.

The baring of the teeth is considered as a sign of aggression.

The mouth can be closed with lips pressed hard together and the mouth narrow. This tends to suggest suppressed anger. The mouth can be open with the teeth clamped together and the mouth squared off or in a frown shape. The jaw could also be dropped with the teeth apart.

Sometimes it can be effective to make the character's face and body vibrate or shake with suppressed rage. This can be done either with the head staying on the spot, or following a path up and away from what the character is looking at or down and towards it. Draw two key positions and in-between them evenly. Stagger their shooting.

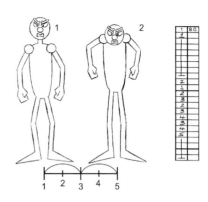

A false display of anger will involve this expression being forced onto the face. The mouth may be crooked, as are the eyebrows. The character won't be able to keep this face up for long and, hopefully, will collapse into a fit of giggles or a big smile.

disgust and contempt

Disgust is an emotion that can range from dislike through to nausea.

This involves pulling the head away from the object of disgust. The chin is tucked into the neck or body. The eyebrows are lowered and pulled together horizontally. This causes wrinkles to form around the bridge of the nose and on the insides of the eyes. The eyes are narrowed and the pupils are contracted.

One or both corners of the upper lip can be raised (raising one corner of the lip gives a more contemptuous look). This makes the furrow between the nose and the

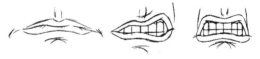

chin take on a squared-off shape. If the mouth remains closed the lips will be pressed tightly together.

With a false look of contempt, the character needs to occasionally slip slightly out of the contemptuous look.

interest

This emotion can take many forms, alertness, attentiveness, expectancy and anticipation. It's really an elaboration of other expressions.

The eyebrows can be raised, producing a furrowed forehead. Both of the eyebrows could be brought together. One of the eyebrows could be higher than

the other. The pupils could dilate and will always stare unblinkingly at the object of interest. The eyebrows are positioned like surprised facial expressions but the mouth usually has a smile.

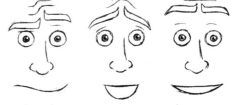

The head could be 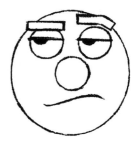 brought forward and even put onto one side.

Interest and excitement usually are accompanied by another facial expression such as surprise or happiness.

The opposite of interest is boredom. The face becomes relaxed and unanimated; the eyes will droop and look up or straight ahead, not focusing on anything. The whole upper body may lean forward 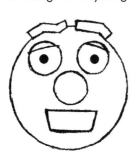 until the character catches themselves and moves suddenly back to an upright position. The character could also fiddle with things to occupy them. Yawning is a good sign of boredom.

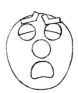

Somebody feigning interest will hold any of the poses described earlier but will occasionally lapse into boredom, making any of the above gestures for a short period and then reverting to the positions of interest.

pain and distress

This emotion can range from discomfort through to extreme pain.

The mouth could be open and squared off, the jaws open, or shut with the jaw tightly clenched.

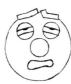

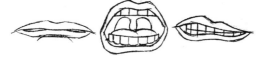

The eyebrows are drawn together with the inner ends up and the outer ends down. They could switch to be the other way round. The eyes will be shut for most of the time.

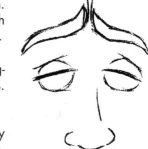

Generally the face is screwed up and will move from one configuration to another, whilst the character is feeling pain or distress. The look is almost like a cross between sadness and anger.

When somebody is putting on pain, they will recover remarkably quickly. Somebody in real pain will feel it for a long period of time.

combination of facial expressions

As I said earlier there can be any number of combinations of these basic facial expressions happening at any one time. Here are a few examples deliberately drawn as simply as possible to allow you to see the basics of facial expressions. The best thing to do is to watch yourself in a mirror pulling the expression you want to animate. To re-enforce the point; there is nothing better than acting and observing the emotions you want to express in animation. So get acting. Don't be self-conscious. Don't worry if people think you are mad. If an audience understands your animation, you have done a good job. If it means rolling around on the floor and people laughing at you, so be it!

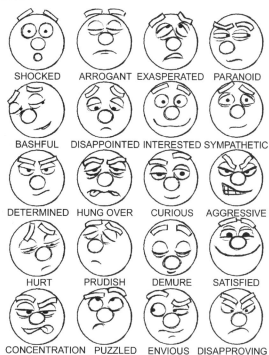

SHOCKED ARROGANT EXASPERATED PARANOID

BASHFUL DISAPPOINTED INTERESTED SYMPATHETIC

DETERMINED HUNG OVER CURIOUS AGGRESSIVE

HURT PRUDISH DEMURE SATISFIED

CONCENTRATION PUZZLED ENVIOUS DISAPPROVING

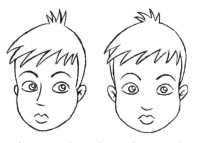

Only rarely will you see a character in an animated film face directly at the camera, especially in drawn animation. It's acceptable to hold a straight-on face at the end of a movement but when doing a head move from one side to another, do not have a drawing or image where the head is straight on to the camera. Make sure all the heads are at a slight angle.

This is because a drawing of a face that is straight on will often look different in character to one that is slightly side on. A view straight on can look open and innocent or intense. A side on view will seem more guarded. This is also true of both puppet animation and 3D-computer animation.

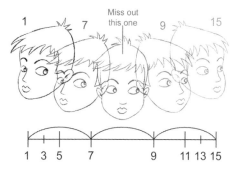

When moving a head quickly it's fine to distort it along the path of movement, but always keep the cranium the same shape and size. Distort the cheeks, jowls and the jaw.

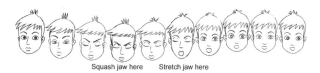

Squash jaw here Stretch jaw here

Have a look at distorted_head.avi in animations010, chapter010 of the CD-ROM.

head angle

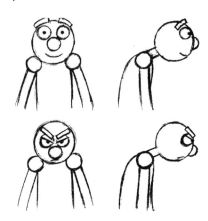

The head moves in an arc in relation to the neck and shoulders. The expression on the face is important but the angle of the head has to be right.

Angling the head forward but upwards indicates a will-ingness to engage, either the character is interested in something or wants to challenge it head on. Angling the head forward and down can give an argumentative or determined look. It can also give a tired or stupid impression.

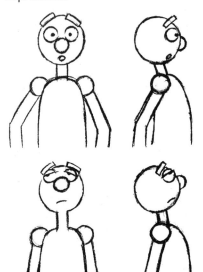

Angling the head backward and upwards gives an arrogant or snobbish look. Angling the head back and down gives a frightened or nervous look.

Angling the head to the side can indicate that somebody is looking to one side, if the eyes are looking in the same direction as the head. It can also indicate that somebody is shy of something or interested in some-

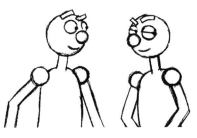

thing but wants to cover his or her interest. If somebody is attracted to somebody else they will look at this person directly. If the attractive person looks at them they will angle the head away, but sneak a look with the eyes.

Rotating the head to one side while looking directly at somebody is an asking gesture. The person doing this action wants something from the person they are looking at. This is a very deep-seated gesture that is seen a lot in young children.

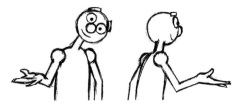

hand-to-face gestures

People frequently touch their faces. This will take place while they are listening to something, seeing something or feeling something, while talking to somebody during a conversation or when contemplating something. The relevance of these gestures depends on the way they are done and the emotion being felt by the person.

These gestures can be divided up into the following categories; evaluation, deceit and stress.

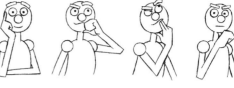

evaluation

If somebody is considering something they may stroke their chin or support their face delicately.

If somebody is bored they will support their head with their hand as if their head were heavy.

deceit

When a young child is telling a lie they will often cover their mouths involuntarily, as if they are trying to cover up the lie they are saying. Adults will do a similar action but will try to disguise it by turning the gesture into something else. Touching the nose or cheeks, gives the impression of somebody who is being economical with the truth.

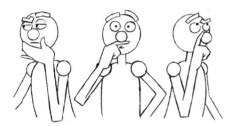

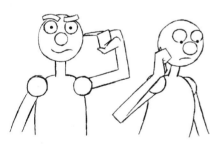

Strangely enough if a person is hearing somebody telling a lie they may also do a 'mouth cover' gesture, giving the impression that they doubt what they are hearing.

If a person is rubbing their eyes this could be because they are tired or it is because they want to avoid eye contact with the person they are lying to or they don't believe what they see. The eyes may also move more erratically.

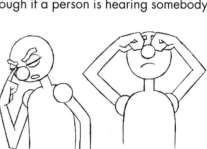

Rubbing or generally fiddling with the ears indicates somebody doesn't believe what they are hearing or they are telling a lie.

Scratching the neck or pulling the collar indicates that somebody is feeling nervous because they are telling a lie or that they are angry or frustrated.

stress

When somebody is stressed, nervous or frightened they will stick their fingers in their mouth for comfort. Biting the finger nails is a complication of this.

Slapping the front of the forehead, scratching the top of the head or rubbing the back of the neck are also signs of stress or frustration.

extreme close-ups

In many live action films there are often extreme close-ups of the main actors. This is where you have only the eyes and nose in screen. These sorts of close-ups tend not to work so well

in animation. With drawn animation it's difficult to decide how thick the line should be. Drawing the lines can be problematic because the audience very easily sees any inaccuracy. It is easy for the lines to wobble and ooze. This makes an audience stop believing in your characters. With 3D computer animation line wobble is less of a problem but close-ups of polygons or skinning or

YES

NO

texture mapping never look quite right and make an audience uneasy about your characters. If you must do an extreme close-up keep it quick (less than 2 seconds).

how to animate a piece of facial acting

How do you put all of this information together? How do you make your character live and breathe and express themselves? Well, we as humans look at other people and work out what they are thinking by the signals displayed on their faces and the body language they adopt. Use this with your character. Work out what they are thinking and make their face and body language display this thought. Most of the acting your character does is as a result of reacting to something that happens to them. They may see something, hear something or feel something and the result of that reaction will be seen on the character's face and in their body language. The main thing to work out is how long an audience needs to see a facial expression to understand what the character is thinking. So think about your character moving from one pose to another (one facial expression to another). Think about how long they adopt that pose for and what they may do while in that pose and vary the way the character moves into each of these poses.

First think about what your character has to do in a scene. Think about it for as long as possible. If you can go out for a walk or have a cup of coffee – do it! Act it out in front of a mirror or videotape yourself (or if you are very persuasive, somebody else). When you have

decided what your character has to do, write it down in list form in as simplistic a way as possible. Write down the minimum that your character has to do to make the scene understandable to an audience (when you start animating you can elaborate on it). Write down some notes about how many frames each of these poses needs to be seen for. If you're not sure, guess.

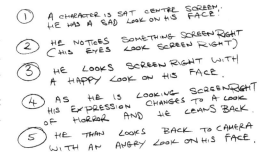

① A CHARACTER IS SAT CENTRE SCREEN, HE HAS A SAD LOOK ON HIS FACE.

② HE NOTICES SOMETHING SCREEN RIGHT (HIS EYES LOOK SCREEN RIGHT)

③ HE LOOKS SCREEN RIGHT WITH A HAPPY LOOK ON HIS FACE.

④ AS HE IS LOOKING SCREEN RIGHT HIS EXPRESSION CHANGES TO A LOOK OF HORROR AND HE LEANS BACK.

⑤ HE THAN LOOKS BACK TO CAMERA WITH AN ANGRY LOOK ON HIS FACE.

You could write this directly onto an x-sheet in the action column, marking the frame where each of the poses takes place. If you're not confident enough with your timing, shoot the drawings first and then make changes. When you are happy with the timings mark them down on an x-sheet.

Whether you use x-sheets or not, always note down your timings. There is no way that you will be able to keep all this information in your head and animate.

Once you've sorted out this list, do a drawing that illustrates each of the items on the list. Just do very rough thumbnail sketches.

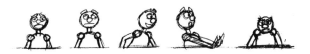

Shoot this collection of thumbnail drawings as a 'pose test' on a line tester (take a look at acting_quick_thumbs.avi and acting_slow_thumbs.avi in animations010, chapter010 of the CD-ROM). Vary the amount of frames that each of the pose drawings is held for until it works as a pose test (i.e. the audience has just enough time to clearly understand what each of the facial expressions is and means). Mark this on an x-sheet (slug it out). Then draw each of the drawings full size (or blow them up on a photocopier). Now you can start animating them. Think how long the audience needs to register an

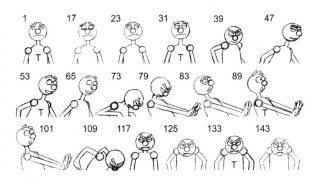

expression. An audience needs a minimum of half a second. Always keep thinking of your audience and whether they will understand what is going on. Draw all the key positions. These are all the poses where the character adopts a posture and facial expression. Do a key position at the start of these poses and one at the end just before you anticipate into another pose. If a character does something while in this pose (look at a watch for example) sort out key positions for this action. Do the anticipation keys out of a pose and the overshoot keys into the next pose. When they are done shoot them on a line tester and fiddle with the timing again.

The subtlety of the animation depends on the positions of the anticipation keys and the speed and arcs of the in-betweens. In this and the previous illustration, I've used the same basic key positions as the thumbnail sketches (those positions marked with a 'T') but changed the amount of frames between these major keys. I have also changed the anticipation and overshoot keys. The previous

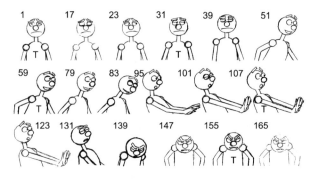

illustration has quite extreme anticipation and overshoot positions and moves between these positions quickly (less frames). As such it has a sharper 'pose-to-pose' feel. This illustration has much less extreme anticipation and overshoot positions and the movement between these keys is slower (more frames). This gives it a more full animation look.

Take a look at acting_quick_keys.avi in animations010, chapter010 of the CD-ROM to see the timing of the illustration on p. 199. Take a look at acting_slow_keys.avi in animations010, chapter010 of the CD-ROM to see the timing of the above illustration.

When you reach each of the expression poses, don't just have your character staying stock-still. This will make your character look dead. Give your character something to do when in one of these poses. One of the best things is to slightly change the expression on the character's face. For example when our character sees something and moves into a pose where they look happy have your character slightly move forward slowly and increase the size of their smile.

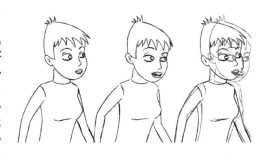

This can be used with all facial expressions within a pose. You could go from a small expression to a larger one, a large expression to a smaller one or from one expression to another.

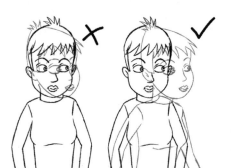

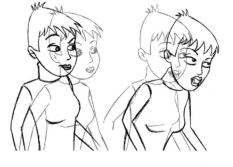

It's always a good idea to move the head and upper body slightly in these instances. Keeping the head clamped to the spot will look stiff and wooden. Remember almost everything moves in an arc and a lot of the movement of the upper body stems from the base of the spine. Don't just move

the head on its own without some shoulder movement and upper body movement. In order to compensate for the movement of balance at the top of the body the legs will have to bend and shift to maintain the correct balance. So even a simple look to the side of the screen may result in the whole body moving.

In a situation where your character is moving while pulling a facial expression that the audience needs to see, you have to keep the expression the same while the character is moving and hold that expression for longer. Don't try to change the expression on the character's face because there is already a lot going on and your audience won't register the change. This is called a moving hold. Moving holds aren't limited to the face. The hands could stay in the same position (for example, when the character is pointing) while the rest of the body is doing something else.

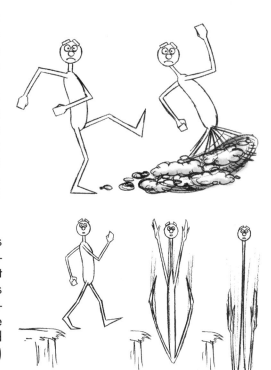

Another way to make sure an audience sees an expression (for example, when a character is falling out of screen and is looking at the audience), is to move the head slightly as the body moves rapidly. This gives an impression of the head being left behind while the neck stretches. When the audience has had enough time to see the face (8 to 12 frames) it then zooms out of screen after its body.

What happens when your character is constantly moving in a scene and there isn't time to adopt any poses?

When you have to cram many facial expressions into a small amount of time, you will need to 'snap' the facial expressions from one to the other, as the character moves. You need to ensure the audience has enough time to register each expression during the movement. In simple terms, this uses several moving holds in a row. If you make the character screw their face up from one expression and then pop it out into another, this can work well.

Anticipation and overshoot can be used within the face to get from one facial expression to another. For example if a character is happy and they see something that makes them sad,

their happy expression could first become more happy (bigger smile, narrower eyes, more crow's-feet) and then they can move the facial features into a frown. Make the frown slightly more exaggerated to start with and then tone it down slightly during the pose.

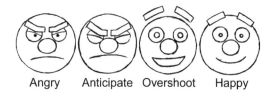

Angry Anticipate Overshoot Happy

One of the main problems with sorting out the poses first and then completing the in-betweens is that you can end up with a rather stiff and wooden, clunky piece of animation. One way around this is to use your pose drawings as a 'marker post' to aim for and animate everything straight ahead, hopefully ending up at points roughly the same as your pose drawings. If the pose drawings have to be changed slightly, so be it. Animate everything in rough first.

exercises

the facial expression in 2D

One of the simplest exercises to explore facial expressions is as follows: a character is sat centre screen, facing towards us, with just the head and shoulders in view. It sees something off screen and pulls a facial expression as a result of what it has seen. The character then realizes that it's not quite what it seems and changes the expression as a result. The character then looks back at the camera with another expression.

Work out a list of what the character will do (as in the top illustration on p. 199). Then draw a series of thumbnail sketches and test them. Slug out the basic timing onto an x-sheet and draw the thumbnails full size, adding extra key positions for anticipations, overshoots and held poses. Work out the timing charts so you have a reminder of how to complete the in-betweens.

Here is one interpretation of this scenario (I've made it very over the top).

First draw a series of thumbnail sketches. Have a look at the thumbnail sketches in the middle illustration on p. 199 and the series of pose drawings in the bottom illustration on p. 199.

The following exercise uses the bottom illustration on p. 199 as a guide.

Start with our character centre screen, looking sad. The character blinks and glances to screen right.

The character does a double take and looks screen right with a happy look on its face.

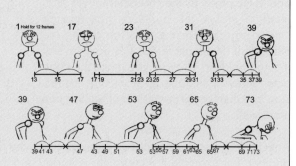

The character then recoils back in shock.

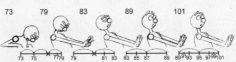

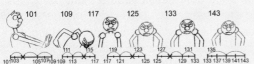

The character then turns back towards the camera with an angry look on its face.

Take a look at acting_quick_2D.avi in animations010, chapter010 of the CD-ROM.

It may help you to think about what your character has seen and why they have reacted in this way. In the example above, the character has seen an ice cream van and smiled at the thought of getting an ice cream. It then notices the extortionate price of the ice cream and recoils back in horror. The character then looks at us angrily because it can't afford one.

Other suggestions for close-up exercises are as follows.

A character is sat centre screen holding a telephone listening to the receiver (make it a mobile phone – no wires to worry about). Depending on what the character hears, its facial expression will change from one look to another. Do about four facial expressions and use expressive body language to augment these.

A character is sat at a table waiting to be served a meal. It is taking a long time to turn up which is annoying. The character looks to one side to see the plate placed in front of it. The character looks down at the plate with a happy expression and licks its lips. The character forks up a portion of food and pops it into its mouth with a look of ecstasy on its face and starts chewing. The face turns to one of disgust as it realizes that the food tastes awful. The character spits the food out and looks angrily in the direction that the food came from.

A character tries to attract somebody's attention off screen (make it to one side of the screen or the other – it's much more difficult to do this straight to the camera). They may be waving and smiling or looking angry and waving their fist (anything you want). The character is ignored by the person off screen. They react as a result of being ignored. They may get angry (or angrier) or become sad or nonchalant (again it's up to you).

A character is trying to complete a complicated task, for example build a house of cards. As they place one set of cards against another there is a look of concentration on their face. When they place the final two cards at the top, they have a look of triumph. They might then sneeze and blow the house down and end with a fed up look on their face. Think about there being three major facial expressions.

A character could be sat watching TV and reacts as a result of what is seen and heard. Again think of three facial expressions and how to get from one to another.

the facial expression in 3D

There are two ways of animating facial expressions in 3D.

You can put bones into the head and make each of the bones operate a distinct feature on the face (for example the corner of the mouth). It's as if a bone is replicating one of the muscles of the face. This method can be quite confusing because there are a vast amount of muscles in the face and you could end up having hundreds of bones trying to control them all. I think of this method as being like puppetry, the bones opening and shutting the mouth like the fingers of a puppeteer operating a glove puppet.

The other method is to build one head (or mouth) and then copy it and re-model it so it is pulling a new facial (or mouth) expression. Save this head, copy the original head and then give this third head another expression. Continue doing this until you have enough facial expressions to do the piece of animation you want to do. You then get your program to morph from one facial expression to another, saving keys as you go. This can make the face look as if it is oozing from one expression to another if it is not done right and if you aren't thorough it is easy to miss building one expression. However, it is the most popular method professionally. I think of this method as being similar to model stop frame animation where they have several heads that they replace one after the other depending on what facial expression is required. It's also similar to clay animation where they sculpt each facial expression from one frame to the next.

The model on the CD-ROM is built using the morphing method and in order to keep it as simple as possible it consists of a stick on mouth that is morphed from one shape to another.

Copy the folder that contains your model (maya-man_mouth, maxman_mouth, lightwaveman_mouth or xsiman_mouth) onto the C drive of your computer (in the case of xsiman_mouth copy this into the data folder).

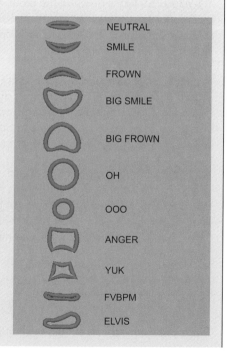

	NEUTRAL
	SMILE
	FROWN
	BIG SMILE
	BIG FROWN
	OH
	OOO
	ANGER
	YUK
	FVBPM
	ELVIS

Load up mayaman_mouth.mb (Maya), max-man_mouth.max (3DS Max), lightwaveman_mouth.lws (Lightwave) or xsiman_mouth.scn (SoftImage XSI). These are in the folder man_mouth_models in chapter010 of the CD-ROM.

It's basically the same model as the character but with a mouth and eyebrows. The mouth can be morphed to produce different mouth shapes (each program uses a slightly different method), the eyebrows are moved by bones inside them. I'll go into more detail about how to morph the mouths in each individual program later in the chapter.

The majority of facial expressions can be done with a minimum of 11 basic mouth shapes and

the position of the eyebrows. The same basic mouth shapes can be used to speak the majority of words.

These consist of neutral, smile, frown, big smile, big frown, oh (like when you say the word pot), ooo (like when you say the word pool), anger, yuk (as in disgust or contempt), fvbpm (the bottom lip is tucked under the top lip when you say these consonants) and Elvis (one corner of the lip is pulled up).

Take out your animation drawings of your expression change acting (or copy the positions from the illustrations in the exercise section on facial expression in 2D). Work out the body language and the eyebrows first by setting keys for the whole body and head all the way through the scene.

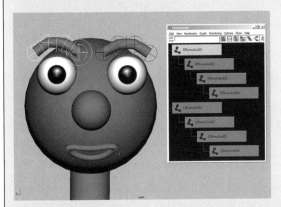

The eyebrows have bones (joints) running through them and can be rotated and moved. They can have keys saved on them as with any other bones. They are called R_Brow and L_Brow. The bones within them are called R_BrowBone01, etc.

To one side of the character there is a pile of mouth shapes. These are the reference shapes that the mouth on the face of the character can morph to. Always keep them out of scene, otherwise you end up with strange mouths floating around.

For the example of face_acting_3D.avi, the mouth shape is a frown between frames 1 and 31. It is then neutral for frames 33 and 35. It's a smile between frames 37 to 41. It becomes a big smile between frames 43 and 67. It goes into a frown between frames 69 and 79. It then goes into a half oh shape and a half frown shape between frames 81 and 85. Between frames 87 and 101 the mouth is an ooo shape. Between frames 103 and 115 the mouth is in a frown position. And for the remainder of the scene the mouth is in an angry position.

Hopefully you will have something that looks like face_acting_keys_3D.avi in animations010, chapter010 of the CD-ROM.

All that needs to be done now are the breakdown positions to help sort out the way the computer in-betweens between the key positions. Follow the timing charts from the illustrations in the exercise section on facial expression in 2D.

Once this is done you should end up with something like face_acting_3D.avi.

animating the mouth with Blend Shapes in Maya

First animate the body, head, eyes and eyebrows.

Open up the Blend Shape window by going to the Main Menu > Window > Animation Editors > Blend Shape. In the Blend Shape window are a series of sections called blendShape1 through to blendShape10. These are the controls that relate to the different basic mouth shapes. They can be maximized or minimized by left clicking the triangle next to the word blendShape

Maximize one of them and you will see that it consists of a slider and several buttons that relate to creating and deleting keys. Move one of the sliders and the mouth on the face of the character will change. We create movement of the mouth by moving the Time Slider to the correct frame and then moving a Blend Shape slider to a position where the mouth is the right shape and then setting a key by clicking the Key button underneath the Blend Shape slider. You can change the value of several of the Blend Shape sliders to get almost any mouth shape you could ever want.

Go through your animation and at the appropriate points change the shape of the mouth to suit your drawings (or the illustrations in the exercise section on facial expression in 2D). Keep experimenting with different mouth shapes until you have something you are pleased with.

Take a look at face_acting_3D.avi in animations010, chapter010 of the CD-ROM.

animating the mouth with Morpher in 3D Studio Max

First animate the body, head, eyes and eyebrows.

Select the mouth in one of the views and make sure the Modify tab is selected in the command panel. Make sure Morpher is selected in the Modifier Stack. In the Channel list there is a list of all the mouth shapes (apart from 'oh' which is the mouth shape you get to start with). Next to each of the mouth shapes are boxes that have percentages in. When you

vary the percentage number in the box, the mouth on the character's face will morph into the mouth shape named by the box. 0 means 0% of the mouth shape and 100 means 100% of the mouth shape. Have a practice by changing the percentages of one of the mouth shapes. Go into animation mode (outside of views goes red) change the mouth shapes as they are needed and set keys on them.

Go through your animation and at the appropriate points change the shape of the mouth to suit your drawings (or the illustrations in the exercise section on facial expression in 2D). Keep experimenting with different amounts of mouth shapes until you have something you are pleased with.

Take a look at face_acting_3D.avi in animations010, chapter010 of the CD-ROM.

animating the mouth with Animation Mixer in SoftImage XSI

First animate the body, head, eyes and eyebrows.

In the top left view port, open up Animation Mixer (left click on the views menu and choose Animation Mixer). Click update. Right click on a track (one of the horizontal green bars going across the window) and choose Add Track > Shape twice to create two shape tracks.

In the bottom left view ports, open an explorer (left click on the views menu and choose Explorer) Make sure that Show > Mixers is selected. From the explorer list open up Scene_root\ Mixer\Sources\Shape node. There you will find each of the 11 mouth shapes. These mouth shapes can be dragged and dropped onto one of the shape tracks in the Animation Mixer, where they become a 'clip' (not dissimilar to a movie editing program like Adobe Premier). When on one of the shape tracks the clips can be dragged shorter or longer, they can overlap each other from one shape track to the other to create further shapes and the clips can be mixed from one to the other by going to Mix > Standard Transition Tool. Left click on one clip and then left click onto the clip you want to mix to and a transition will be created (right click to get out of this mode). If you scrub the timeline back and forth, one shape will mix to the other. There is no need to set keys.

Go through your animation and at the appropriate points drag the shape of the mouth to suit your drawings (or the illustrations in the exercise section on facial expression in

2D) from the explorer onto the shape tracks of the animation mixer. Keep experimenting with different mouth shapes until you have something you are pleased with.

Take a look at face_acting_3D.avi in animations010, chapter010 of the CD-ROM.

animating with Morph Targets in Lightwave
First animate the body, head, eyes and eyebrows following the drawn example.

Select the mouth shape on the character (the starting shape is 'oh').

Open up the Object Properties and choose the Deformations tab. Select the Current Object as oh and select the Morph Target as smile (or whatever mouth you want). Left click the E button next to the Morph Target box and up will come the Graph Editor with the curve that relates to the oh there already. From the Keys menu in the Graph Editor select Create key. Up will come the Create key window. Leave Frame at 0 and leave Value at 0% as well. Left click OK. Select Create Key again and this time set Frame to where you want the next mouth shape to be (let's say frame 10) and put Value to 100%. This will make the mouth01 morph to 100% of mouth02 at the frame you've set your key at (you could also set the key at 50% or any other percentage if you like). Then for the next mouth shape, put the word smile (the mouth shape that was the Morph Target) in the Current Object box of the Object Properties window and make the next Morph Target yuk. Tick the Multi target/Single Envelope box. Then create the next key and set it at 200%. Continue in this vein. Each subsequent mouth shape will occupy the next 100% of the graph. So the third mouth shape would be at 300% the fourth at 400%, etc. You can jump back to other mouth shapes (by specifying a lower percentage at the relevant key) and you can also scale and move the lips as well.

Take a look at face_acting_3D.avi in animations010, chapter010 of the CD-ROM.

chapter 11

animation of acting – two or more characters

two characters on screen together

Two characters in a scene together will interact with each other. Even if one is ignoring the other, there will be a certain level of interaction.

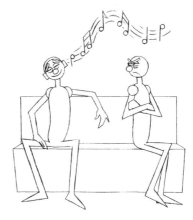

When two characters interact the action should be like a game of tennis. One character will have the audience's attention, then the other character. Divide a scene to make sure the action and events happen at different times. If one character acts, the second character responds to this. Then the first character reacts to the

response. If the two characters do something at the same time it will be too confusing for the audience and they will miss part of the action (unless this is what you want).

When one character is performing an action the audience must see, the other character should make a minor movement. This should be just enough to keep them looking alive, but not so much that they start to distract attention from the action that matters.

personal space

People standing or sitting side by side who don't know each other will acknowledge each other's presence. It may not be obvious, but they will acknowledge each other subconsciously. We all have a concept of personal space. That is, we all have an area around ourselves that we consider ours and we only allow people that we are comfortable with into this space.

Having said that, we like to feel accepted and to make other people feel accepted. Because of this we won't sit or stand as far away as possible from others. When we sit on a park bench or in a train carriage we sit an acceptable distance away from those we don't know. When in a queue we give each other room to feel comfortable. If we were too close it would make us feel very uncomfortable.

Having said this, there are situations when personal space has to be reduced. A good example is when we are crammed into a tiny space such as a full railway carriage. In this situation people tend to look upwards or shut their eyes in order to avoid eye contact.

One of the best places to observe this is on an underground train.

When two people know each other well they allow each other into their personal space. The degree to which you allow your characters into each other's space gives an audience an idea of how familiar they are. Another indicator of this is the way your characters touch each other. If people are only acquaintances nothing should go beyond touching the outside edge of the arms and shoulders, or shaking hands. Often touching the outside edge of an arm is used when the person doing the touching wants something from the person being touched. This may be a favour or money or it

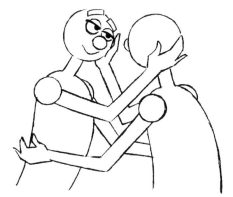

could be to offer consolation, commiseration or reassurance.

People who know each other better can cuddle, touch the other person on the face, kiss, and touch hair or the outsides of the legs.

If your characters touch each other more intimately than this they are either lovers or closely related.

Of course very young children are unaware of these taboos and, in their innocence, move into other people's space freely.

When children reach their early teens (or earlier) they shy away from this sort of contact. They are in the process of learning their body language and become more self-conscious.

The concept of personal space is learnt and is different depending on differing cultures.

mirroring

When two people know each other well and are in close proximity, for example; they are engaged in a conversation, they will mirror each other. This means that each character adopts body language that is similar to the other character. They may cross their legs in the same way, lean on their elbows on the table in the same way or angle their head in the same way. These are only a few examples of the many different ways in which your characters can mirror each other.

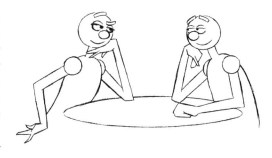

The amount that people mirror each other depends on how well they know the other person and also how well they want to know that person. The degree to which your characters mirror each other is an indication to the audience as to what sort of relationship they have. Two teenagers trying to look cool will adopt postures that suggest boredom together. An office junior trying to impress his boss will imitate his/her body language.

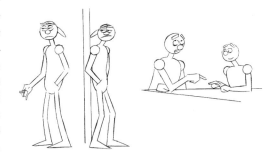

When a couple are on that oh so important first date, if they are attracted to one another they will end up mirroring the other person's behaviour. They will be trying so hard to mirror each other that their movements may seem forced. They will occasionally slip out of

mirroring when they are distracted; for example, when a waiter asks whether everything is OK with their meal, and will act as themselves. To show to the other person that they are attracted, they have to learn to mirror them.

When a couple have known each other for a while they will mirror automatically and feel at

ease in each other's company. Their body language will suggest that they are together to the rest of the world. They will hold hands or hug when they walk.

When two characters have been in a long-term relationship there may be a level of boredom with each other. As a result, they will try to reinforce their own identity. When together they tend to, almost deliberately, not mirror each other's body language. One may read a newspaper whilst the other is looking at their surroundings. They will deliberately occupy different poses. When interrupted they will start mirroring each other, because this is their natural state.

When mirroring, people will take drinks from their glasses at roughly the same time. They will take bites of their food at the same time. When walking along together their strides will synchronize.

how characters look at each other

Again this all depends on how well the characters know each other and what their relationship is.

When two characters are in love they will stare directly into each other's eyes. Each character is essentially giving themselves to the other person and not covering anything up, and they will look at each other with a happy questioning look. Because each character is looking into the two eyes of the other person, their own eyes will swap from side to side. Both eyes focus on one eye and then on the other (make the

eyes stay in one position for a second or so and then click the pupils to a second position, repeat at random). This gives a very open look. Combine this with an occasional slow eye blink and dilate the pupils.

When characters are staring at each other competitively, staring each other out, the eyes

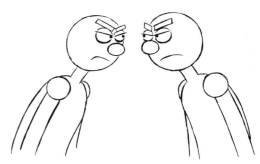

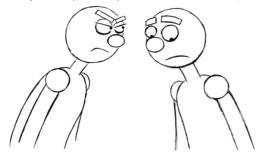

remain locked on one point of the others face (between the eyes). The eyes will not swap. Each character's eyes will blink as little as possible and the pupils will be contracted.

When two people don't know each other as well as lovers, their eyes will meet only for a short period of time. In some ways staring at somebody is an intrusion of their personal space as much as grabbing hold of them is. The more confident person will maintain eye contact for longer.

When somebody is attracted to someone, a stare is a way of getting attention. Let's take the very stereotypical situation of a man and a woman who are attracted to each other. A woman will look at the man and when she gets a look back from him, will look away. If she is happy with the situation, she will steal a look back with the body and head facing away from the man. A man on the other hand will stare and continue staring at the woman. If he receives a positive reaction, it's time to walk over and introduce himself. If he receives a negative reaction it's time to try something else.

two characters acting with each other while talking

First character talking.
Second character listening.

First character looks at second to check his reaction

When two characters are talking to each other, depending on what is being discussed, the character talking can often be highly animated. The speaker will look in different directions to emphasize a point and

First character looks away and continues talking.

First character finishes what he says with a look

will occasionally look at the listener to check their reactions. The listener will be looking at the speaker (hopefully in rapt attention). When the speaker is finished, the person will look at the one listening. This signals to the listener that the speaker has finished and that a reply can be made. Having said this the person listening may want to say something further and will adopt a suitable body posture. The listener may try to interrupt the person talking. Both characters could end up talking at the same time.

Now the rolls are reversed. The second character talking, gesticulating and looking in different directions to emphasize different points and the first character will be doing the listening. Should the first character want to butt in when the second character is talking, they will stare more intently and may be on the edge of their seat. They may get the first couple of words of their statement out depending on how determinedly the other character is talking.

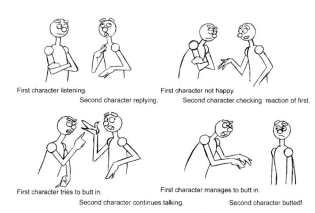

First character listening.
 Second character replying.

First character not happy.
 Second character checking reaction of first.

First character tries to butt in.
 Second character continues talking.

First character manages to butt in.
 Second character butted!

When two characters interact it has to be like a game of tennis. One character has the audience's attention then the other character.

If the listener is bored the person will look up or away from the speaker. The person will yawn or do anything other than look engrossed at the talker.

A bored listener who is trying to look attentive will stare rather too intently at the talker, but will occasionally find something else interesting and look away or stifle a yawn.

two characters alternating from one shot to another

Having two characters acting in one scene is only used in animated film making occasionally (e.g. when there is physical contact between the two characters or when you need to see the two characters together). More often than not a basic film-making technique is used

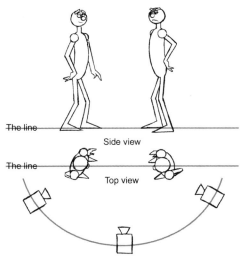

The line Side view

The line Top view

Camera will always stay this side of the characters

where we cut from one character to the other as the conversation or action continues.

The most important rule to learn is do not cross the line. Imagine that your characters are on stage together and the camera is the audience. Imagine a line running between each of these characters. The camera has to stay on one side of this line.

Start with an establishing shot that shows both of the characters. Follow with a close-up of the first character talking or acting. This will then be followed by a close-up of the second character replying.

When animating your characters in close-up we follow most of the techniques described earlier in this chapter. The difference being that only one character is on screen at a time.

Always bear in mind that your character is looking off screen at the other person. Depending on the relationship with the person off screen, the way your character looks at them will change.

Longshot of two characters.

Medium shot of two characters.

Close-up shot of first character.

Close-up of the second character.

Close-up of first character.

Back to medium shot.

To make a character look more dominant arrange the camera to look up at them.

To make a character look more submissive arrange the camera to look down on them.

a large group of characters on screen at the same time

With a large group of characters on screen at the same time the most important thing is to make sure that your audience is looking at the right character at the right time. This is done in a combination of ways.

Firstly using focus. If the main characters are in the foreground and the rest of the crowd is in the background, the background characters can be slightly out of focus.

Secondly, lighting and colour. If the background characters are slightly duller in colour or are lit more darkly than your main characters, the audience's eye will be drawn to the characters that matter.

Finally the main way to get your audience to look at the important characters is to make them more animated than the lesser characters. Don't move the background characters around too much because they will be too distracting. Any movement these characters

make must be a down-played version of the movements they would do if they were the main characters in a scene.

If you watch any film (animated or live action), look at the characters in the background. They will move in a way that will not be distracting to the audience. In live action films there are a whole subsection of actors that do nothing other than be extras. It's as though the acting knob has been turned down. Many actors on their way up (and on their way down) get acting work playing these roles. In animated films this is where junior animators can cut their teeth, because the quality of animation required is not as great as that of the main characters.

exercises

double acting in 2D

Have two characters in a scene side by side. One of the characters has to attract the attention of the other. The other character reacts to this.

When animating two characters interacting with each other always animate the character that initiates the action first and then animate the character that reacts. Keep each of these characters on different pieces of paper. This means that if you need to change the timing of one of your characters you only have to re-draw that character.

Here are some ideas of what you could do.

Situations...

Two people sat at a bar.

Two people standing at a bus stop.

Two characters sat at a park bench.

Two characters waiting in a queue.

Two characters having an arm wrestle.

What they could do...

Have the passive character occupied with something. Reading a book or newspaper, reading a poster, cleaning their glasses or listening to a Walkman. Have another character trying to get their attention.

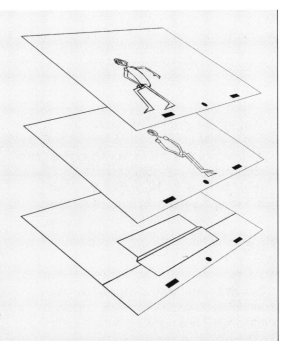

One of the characters sees something off screen and tries to get the other character to look at it.

One character asks the other character for something, the time, some change, a match or the way.

how to animate it

The first thing to do is write down what is going to happen in the scene. Then draw some thumbnail sketches and shoot them to get an idea of the timing. In this little scenario we have two characters on a park bench. The first character is using a pair of headphones. He switches them on and starts head nodding to the music. The second character hears the music and is disturbed by it. The second character gets more and more wound up by the sound and finally, through hand signals, asks if the first character can turn the music down. The first

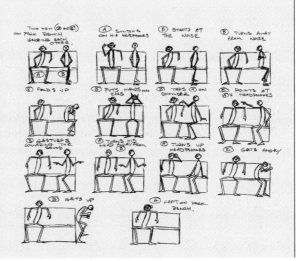

character looks at the second character gesticulating, gets bored and then looks away from the second character and turns the music up! The second character gets even angrier and storms out of scene. It's 450 frames (18 seconds long).

Take a look at 2_act_thumbs.avi in animations011, chapter011 of the CD-ROM.

Once this is sorted (and remember always to err on the side of being slightly too slow rather than too fast) draw the thumbnails full size or blow them up on a photocopier. Work out the key positions (the anticipations and overshoots, follow-through and what a character does when they are in a particular pose) but put each character on a separate sheet of paper.

When working out the key positions start animating the character that initiates the action. In this case it's the character that has the headphones (the entire sequence of keys are on the CD-ROM).

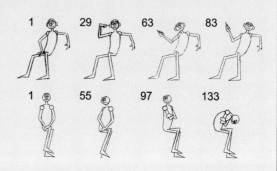

The first character switches on the headphones and starts head nodding to the music (the nodding of the head is a cycle). Have the second character make a small amount of movement.

When the first character starts head nodding to the music the action moves to the second character getting annoyed at the sound of the music (put one of the drawings of the first character on your light-box and work out the keys for the second character's reaction on separate paper). When the second character taps the first character on the arm the action passes back to the first character.

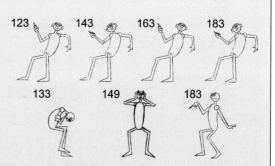

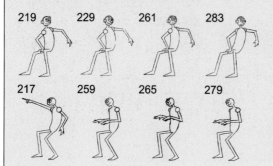

The action is with the first character who reacts to being tapped on the shoulder, but the action goes back to the second character who indicates turning the volume down.

As the second character makes this 'volume lowering' repetitive action the first character very deliberately turns away

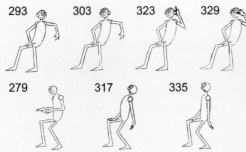

293 303 323 329

279 317 335

and then turns up the volume on the headphones.

Finally, have the second character look flabbergasted and then get angry and storm out as the first character continues head nodding to the music.

Mark up the drawings on an x-sheet, using three columns (one for the background, one for the first character and one for the second character). Test these key positions, adjust as necessary and work out the timing charts (there is a full copy of the x-sheet and all the keys on the CD-ROM).

353 373 393 413

357 373 395 411

SEQUENCE NO:			LENGTH:			SHEET NO:	1 of 9	
			HEADPHONES MAN					
				STRESSED MAN				
					CHAIR			
	LEVELS;			▽	▽	▽		
FRM NO	6	5	4	3	2	1	B.G.	CAMERA
1					1	1	BG	
2								10 F 1 s of
3					2	3		12 F C
4								
5					5	5		
6								
7					7	7		
8								
9					9	9		
10								

Take a look at 2_act_keys_2D.avi in chapter011 of the CD-ROM.

Then in-between all the drawings by following the timing charts.

Take a look at 2_act_2D.avi in chapter011 of the CD-ROM.

double acting in 3D

Load the character with the mouths and eyebrows onto your program from your C drive (or data folder in the case of XSI). (lightwaveman_mouth.lws, xsiman_ mouth.scn, mayaman_ mouth.mb or maxman_mouth. max).

Once the character is loaded you need to duplicate it (there are

several ways to do this), so you have two characters that look exactly the same (you may want to change the colour of one). Then build a basic park bench out of simple cubes.

You will then need to make a pair of headphones for one of the characters. Build these out of several cylinders of varying depths and parent them all to the head bone so that they will move with the head.

how to load two identical characters into the same scene

3D Studio Max

In 3D Studio Max to get a second character open maxman_mouth.max and move your character over a bit. The go to the main menu and left click File > Merge … and select the same scene; maxman_mouth.max. Up will come the Merge window. Left click All and OK. Up will come the Duplicate Name window. Tick the Apply to All Duplicates box and then left click the Merge button. You will now have a second character in your scene. Save this scene as double_maxman_mouth.scn.

SoftImage XSI

Open xsiman_mouth.scn. Move it over a bit. Then go to the main menu and left click File > Merge … and select the same scene. Left click OK and the same character will be loaded into scene. Save this scene as double_xsiman_mouth.scn.

maya

Open up mayaman_mouth.mb. Move it over a bit. Then go to the main menu and left click File > Import and select the same mayaman_mouth.mb in the Import window. Left click the Import button and you should have a second character in your scene.

LightWave

Load lightwaveman.lws into the scene. Move it over a bit. Then go to File > Load > Load Items From Scene and up will come the Load Items From Scene window. Select lightwaveman.lws and left click Open. With any luck you will have two characters in the scene.

With all the programs make a note of the new names that all the components have been renamed, so you don't get too confused.

Follow your drawn animation to the letter (or follow the first six illustrations in the 'How to animate it' section and the illustrations on the CD-ROM), working on one character first and then as the action passes to the second character work on that animation.

Take a look at 2_act_3D.avi in chapter011 of the CD-ROM.

chapter 12
lip-sync

Many aspiring animators are slightly afraid of getting their characters to talk. They shouldn't be. Lip-sync is much easier than you think and, as long as you follow a few basic rules, the timing is sorted out for you. Rather than having to guess or rely on your experience to get the timing right, your timing is worked out from the dialogue that your character is speaking. The main thing to remember is that the quality of acting by your character is the most important part of lip-sync. The mouth shapes

only make up a small part of a lip-sync scene. If the acting is good you can get away with murder when it comes to the mouth shapes.

recording and breaking down a dialogue track

In order to animate a piece of lip-sync it helps if you first record your dialogue (you can take advantage of the dialogue to help with your timing and characterization).

Record a piece of dialogue or take a section from a feature film, TV show, radio show or CD. You can even download .wav files from the Internet.

The simplest way to record your dialogue is to use the Sound Recorder on your PC. Go to the Start button, then go to Programs > Accessories > Entertainment > Sound Recorder and up will come the Sound Recorder window. Insert a cable between the audio out of a video recorder, midi-disk player, CD player or microphone into the microphone socket of your computer. Press play on your sound equipment and press the record button on the Sound Recorder. Save the sound as a .wav file.

The Sound Recorder does not give the best sound quality and you may want to try a specific sound recording program. There are lots of sound recording and editing programs available in either shareware or demo versions on the Internet. You may even have one with your sound card.

I've included two pieces of dialogue on the CD-ROM in the sounds folder in chapter012. They are called hello.wav and moment.wav.

Once you've got your dialogue, you need to break it down. That is, you need to work out frame by frame where each sound of your piece of dialogue occurs during the scene that you are animating. This then needs to be marked onto the sound column of an x-sheet.

DigiCel Flipbook can be used to break your sound track down. In fact any program that divides up your sound track into units of 25 frames per second (PAL) or 30 frames per second (NTSC) can be used.

It's best to record your dialogue in short pieces (the length of a scene, say, or one person talking) rather than your entire movie at once. This will give you more freedom when it comes to editing your movie.

Trim your dialogue to the correct length and save what you've recorded as a .wav file. If you downloaded your piece of dialogue from the Internet, you can miss out the information about recording.

Now open up DigiCel Flipbook and import your sound track onto an XSheet (right click on the word Sound on the XSheet and in the Sound Properties window click Change, find your .wav file and click OK; the sound will now be loaded into the sound column). Scrub through the sound slowly and mark onto a paper x-sheet the frames where each of the sounds of the dialogue start and end.

When breaking down a sound track I always play the dialogue through a few times and write what is said at the top of my paper x-sheet. When I'm scrubbing through the dialogue slowly the first thing I listen for are the silences. These occur between some words and where there are sounds produced by the mouth shut consonants. These are M, B, P, F and V. During speech these quiet sounds occur when the mouth is shut. Consequently little sound comes out of the mouth and the sound track is quiet or silent at these points.

Then I listen for the 'S' sounds in the dialogue. They tend to sound like a shhh or hissing sound. If the hissing sound lasts for 3 frames, mark it down on your x-sheet for 3 frames.

Keep scrubbing backwards and forward through your dialogue. The next sounds to listen for are T and C. T makes a tut kind of sound and C makes a kar sound.

Keep scrubbing backwards and forward through your dialogue. Listen out for the consonants at the start of each of the syllables of each of the words. Once these are done all that remain are the vowels. Listen for the loudest ones first. These will generally be the vowels that have the mouth wide open (jaw dropped). A and O are the loudest of the vowels. I and E tend to be quieter because the mouth is less open and less sound can come out of the mouth as a result.

how we speak

Breaking down a sound track like this is a very good way to get an idea about how we speak.

In order to produce a noise out of our mouth the vocal cords in the throat vibrate. This causes air molecules to vibrate and they pass this vibration through millions of air molecules until they, in turn, cause your eardrum to vibrate. The information gathered by your eardrum is then passed to your brain.

The mouth can open and shut independently of the jaws, but to get the mouth as open as possible the jaw has to be dropped. The more open the mouth the louder the sound that could come out of the mouth.

Generally with most of the words that we speak there will be a consonant at the start of a syllable, and then a vowel (and often another consonant at the end). The consonant at the start gives shape to the sound and the vowel provides the power. So the mouth will usually be more open when it is speaking a vowel.

When we watch somebody speak we see a combination of the mouth opening into different shapes and the jaw opening and closing to augment these mouth shapes.

One way to work out where the jaw should open and close is to speak the piece of dialogue yourself while holding your index finger on the top of your nose and your thumb under your jaw. As you speak your thumb will be pushed down and up by your jaw

The most important mouth shapes are the mouth shut consonants. These are M, B, P, F and V. It's at these points, during speech, that only a small amount of sound (or none at all) will come out of the mouth. There will be a humming sound with M and B. No sound at all with P, all the sound comes as the mouth opens with a slight spitting noise. A slight escaping of air with F and a combination of a hum and escaping of air with V.

The reason why these mouth shapes are so important during speech is because they are highly noticeable to an audience. Before a mouth shut consonant occurs the mouth will usually be open and then shut quickly. After a mouth shut consonant the mouth will open quickly. Most other mouth shapes during a piece of dialogue will slur from one to the next. An audience uses these mouth shut consonants as markers to see if it is the person they are looking at who is talking.

When writers rewrite a script for a foreign language film that will be dubbed into English, they will write the script in such a way that mouth shut consonants will coincide in the script and with the mouth shapes being spoken by the characters on screen.

Generally we are quite lip lazy. That means that our lips don't accurately make mouth shapes but move from one shape to another. Unless you are animating something for effect with very exaggerated mouth shapes concentrate on hitting the mouth shut consonants and the large vowels. The rest of the mouth shapes can be regarded as in-betweens.

acting with dialogue

When animating a scene with dialogue it's always best to leave the mouth shapes till last and concentrate on the body language and facial expressions first!

Listen to the dialogue over and over. It's probably best to do this with a Walkman. You'll drive everybody in the room crazy, playing the same track over and over.

Act out the dialogue as you play it on your Walkman. Watch yourself in a mirror. Listen to the piece of dialogue till you're sick of it. It's at this point that you start living it! You'll notice that there are certain words that are the main emphasis points. At each of these emphasis points, your character should be put into a suitable pose. This technique is called 'phrasing'. You can divide your animation up into major emphasis points and minor emphasis points. The major ones involve a movement of the body, the minor ones perhaps only involving a movement of the head.

Use the information in the last three chapters to work out the key poses that are appropriate for your dialogue.

If a character says, 'hello (pause) how are you?' the two major emphasis points are 'hello' and 'how'. The character could lean forward as he says 'hello' and then put the head to one side to say 'how are you?'. Within this movement you can put in a minor emphasis point on the '... you' at the end of the dialogue. So the head has been put on one side to say 'how are ...' and then the head nods on '... you', while the body stays in the same position. There would also need to be small anticipation positions out of, and overshoot positions into, each of these poses (see the 2D animation exercise for a full description).

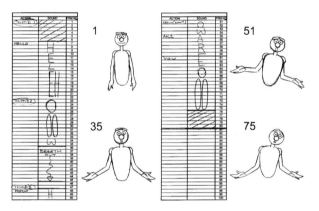

Don't try to put in too many of these emphasis point poses. At the most do about one a second. Anymore than this and it will look as if your character is shaking far to violently.

Because your audience has to absorb far more information while watching a character talk, than with a mute character acting, you don't want to distract the audience with too much activity. The extremity of any poses depends on the character you are animating and the mood they are in. When your character is in one of the major emphasis poses you still have to give them something to do. Sometimes the minor emphasis points are enough; sometimes you have to put in a bit more.

When you've worked out your basic poses, shoot them on a line tester with the dialogue, giving them enough frames to take them to the next pose. How does it look? If some of the

poses don't fit the dialogue, re-draw them and shoot them again. Are the poses hitting at the right time?

If the character is talking enthusiastically or aggressively, it might be best to hit the poses slightly early. About 2 to 4 frames early.

If your character is talking in a neutral manner hit the poses exactly at the same time as they say the phrase.

If your character is talking in a relaxed or hesitant manner hit the poses slightly late. About 2 to 4 frames late.

Don't try and be too clever about this. If in doubt hit the poses at the start of the word where the pose should start.

quick from pose to pose

If a character is angry, excited, nervous or worried they will move quickly from one pose to another and will seethe in each of these poses.

slow from pose to pose

If a character is calm, relaxed, happy or moody, sad or sulky they will move from one pose to another in a calm relaxed way.

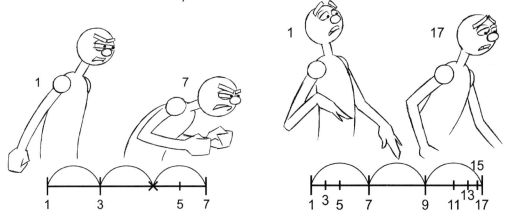

erratically from pose to pose

This type of movement would be used when the mood of a character changes. For example; they may be talking calmly and then notice something that excites or angers them. They then start moving quickly from pose to pose.

How early or late that you hit these poses will give an indication of the mood of your character.

mouth shapes

As mentioned before, we tend to be 'lip lazy' when we speak. This means that we slur the mouth from one shape to another and only define the mouth shut consonants. When we are communicating something precisely, we will clearly define each word.

It's always best to animate the mouth shapes last, on top of the animation of the body language and the facial expressions.

Remember that some mouth shapes have a jaw open. Generally, they are the loud vowel shapes A and O.

Also animate the mouth shapes straight ahead rather than key to key. This will give the lips a livelier look. As a guide, put in the mouth shut consonants first and then do the large vowels (these are where the jaw will be open). Always keep mouthing the words to yourself in a mirror.

mouth shut consonants

Let's start with the most important mouth shapes, the mouth shut consonants. In order to make sure an audience sees these mouth shapes hold them for a frame longer than written on the x-sheet. In this case our character is saying 'moment'.

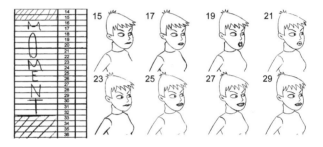

When animating into and out of these mouth shapes keep the previous mouth shape as one frame then go into the mouth shut consonant on the next frame (no in-betweens). When you get to the mouth shut consonant the lips will be placed together slightly differently depending on the sound.

Generally the jaw will be shut when your character is making the sound of a mouth shut consonant. If the sound after a mouth shut consonant has a jaw open the jaw can start opening while the lips are still shut in a mouth shut consonant shape.

M

The lips are shut and a humming sound is produced. Both lips are tucked under against each other, wrapping over the teeth. When animating into and out of an M it tends to be slower than with B and P. It takes longer to un-tuck the lips from each other! At the start of your M mouth shape make the lips squash together. Towards the end of

your M shape make a slight movement of the lips opening and then go straight into the next mouth shape.

B

The lips are pressed together but not tucked under as much as with M. A humming sound is produced but at the front of the mouth rather than the back. When animating into a B shape create a small amount of squash in the mouth as it closes. When animating out of a B shape pop the mouth straight open.

P

With a P mouth shape the lips are squashed together and are pushed outwards. When animating into the P mouth shape move quickly from the previous mouth shape and then show the lips squashing outwards for the first part of the P. When animating out of the P shape, imagine you're trying to spit some grit off your lips. The mouth opens quickly with the lips pushing outwards and upwards. This jutted out lip position is reflected in the first frame of the next mouth shape.

F

When the mouth is making an F sound, the bottom lip is tucked under and bitten by the teeth. Most of the sound comes from air hissing out from between the teeth and the lips. The shape of the top lip varies depending on the mood of your character. When happy or relaxed the top lip would be relaxed and almost covering the teeth. When angry or aggressive, the lip would be tensed up and pulled back to reveal the teeth; for example, when saying a naughty word. When ani-

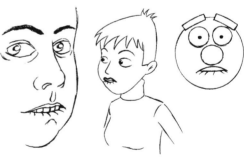

mating into the next sound the teeth are raised and the bottom lip is flicked forward and downwards into the next mouth shape.

V

As with F the bottom lip is tucked under the teeth but not as much. The sound made is a mixture of hissing air between the teeth and the lips and a humming sound. When animating out of a V sound the bottom lip doesn't pop out as far as with an F.

the vowels

OOO

The next most important mouth shape is OOO as in pool. This is because it takes the lips quite a long time to pull an OOO shape

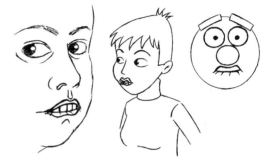

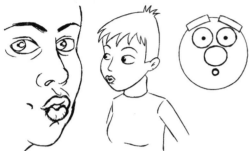

and then to pull out of it, so it's a mouth shape your audience notices.

The next most important mouth shapes are the loud vowels. These are the vowels that

produce the most noise and mean that the mouth should be widely open. For these the jaw should be dropped.

O

O as in pot. A large oval shaped mouth with the jaw dropped.

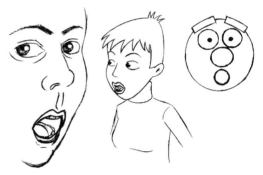

AR

AR as in car is like O but has a slight smile to it.

A

A as in dad. This is a large but narrow smiling mouth shape.

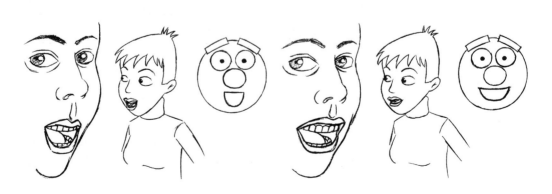

EH

EH as in wet. A large wide smiling mouth with the jaw dropped. Not quite as dropped as in O and A.

EE

EE as in squeeze is still quite loud but the jaw will not be as open as the other loud vowels. It consists of a wide smile.

the quieter vowels and consonants

The quieter vowels and the less defined consonants can be considered as in-between shapes that go between the mouth shut consonants and the loud vowels. The mouth shape can be almost any shape you like, the same sound will come out.

N, T, I, C, D, Y, Z, K etc.

The other thing to remember is that a mouth shape will be influenced by the mouth shapes before and after it. For example, if you say the word 'moment' the first M mouth shape will be quite narrow with slightly pursed lips. The mouth then pops open into a larger O and then animates into a smaller OOOO shape. The mouth then shuts into another pursed lip M shape. This will animate over 2 frames to a wide M mouth shape which in turn pops open into a wide mouthed EEEE shape. The mouth will pop open slightly for one frame for the T and return to a wide mouthed EEEE.

This is why it's often better to animate mouth shapes straight ahead.

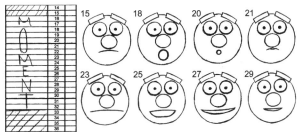

teeth

If your character has teeth, make sure your audience can see them in the majority of mouth shapes. Otherwise the teeth will keep flashing on and off and can be very distracting.

animating the mouth shapes early

Sound travels slower than light. This means that you usually see something before you hear it.

Some animators will animate their mouth shapes one frame ahead of the sound. I've always come unstuck when I try to do this, so I animate with the mouth shape hitting the same point on the x-sheet as the dialogue breakdown. Later, if it doesn't appear to fit the dialogue or it looks better, I will slip the dialogue a frame later when I line-test the animation. Sometimes it works sometimes it doesn't. Again, don't try to be too clever with the animation until you have a lot of experience under your belt!

exercises

lip-sync in 2D

Have a character act out one of the two pieces of dialogue that I have supplied on the CD-ROM. They are called hello.wav and moment.wav (you could always break down your own piece of dialogue and animate that!).

You will find copies of the x-sheets on the CD-ROM called moment_x_sheet and hello_x_sheet.

The two pieces of dialogue are 'hello … how are you?' and 'one moment … my good man'.

As always the first thing to do is to write down a list of character traits and then from that write down a list of what the character is going to do during the scene. Then work out a series of thumbnail sketches and shoot a pose test with them. With these you should have worked out the main emphasis points (or phrases) of the action.

'hello...' '...how are...' '...you?'

One moment... ...my good man.

For the piece of dialogue 'hello … how are you?' the main emphasis points are 'hello…' and 'how are you?'.

Notice that there are only three pose positions for the 80 frames of dialogue.

For the piece of dialogue 'one moment … my good man', the main emphasis points are 'one moment…' and '… my good man'.

Take a look at moment_thumbs.avi and hello_thumbs.avi in chapter012 of the CD-ROM.

The next thing to do is to work out the key positions and the in-betweens, making sure the action fits the feel of the dialogue.

For 'hello ... how are you?' we have the character anticipate backward and then lean forward on 'hell..'. The character then over shoots on the '..o..' and comes back to rest on the end of the '..o' sound (it's quite long). In the pause it anticipates its head to screen left and then leans its head to screen right on '...ho..' it will over shoot on the '..w..', then pull its head back again slightly on '..are..' and then put its head back down again for '..you', overshooting on the '..o..' and back up to rest on '..u'.

Take a look at hello_keys_2D.avi in chapter012 of the CD-ROM.

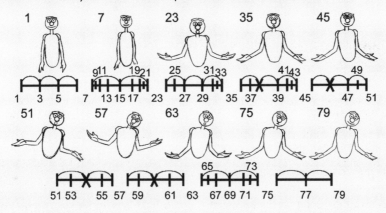

For 'one moment ... my good man' (a good chance to do a lot of mouth shut consonants) the head goes down on 'one...' in anticipation of the arm coming up and the body leaning forward on the '...moment...'. Have the character overshoot its pointing hand and body on '..mo..' and settle down on '..ment..'. It can pull its hand back in anticipation on '..my..', then moving the hand forward on '..good..'. Overshoot on the '..m..' of '..man' and come back to rest on the '..an' of '..man'.

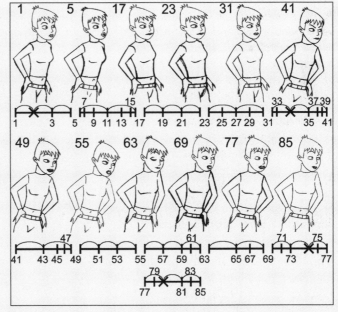

Take a look at moment_keys_2D.avi in chapter012 of the CD-ROM.

Finally, animate the mouth positions by drawing them onto the character's face one drawing at a time.

These could be animated straight ahead or you could work out where the mouth shut consonants are, then the ooo shapes, then the big vowels and finally all the other mouth shapes as in-betweens. Make the jaw open and shut on the big vowels. Line-test it to see if it is working. Experiment with slipping the sound up and down on the x-sheet (or by deleting or adding frames to the drawings).

Take a look at moment_2D.avi and hello_2D.avi in chapter012 of the CD-ROM.

lip-sync in 3D

Load the character with the mouths and eyebrows onto your program from your C drive (or data folder in the case of XSI) (lightwaveman_mouth.lws, xsiman_mouth.scn, maya-man_mouth.mb or maxman_mouth.max).

By following your drawn animation (or the bottom illustration on p. 232 and top illustration on p. 233) and the x-sheet with the dialogue, work out the basic body language and facial expressions.

Take a look at hello_keys_3D.avi in chapter012 of the CD-ROM.

This shows the basic body language but without any mouth movement or break-downs; it's letting the computer in-between the keys. Follow the timing charts in the top illustration on p. 233 to correct the way that our hero moves by adding keys at the breakdown positions.

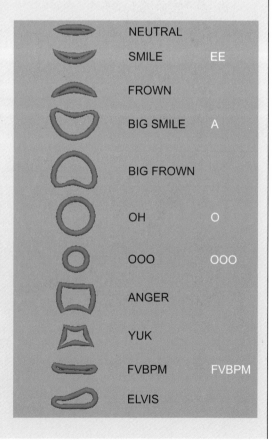

NEUTRAL	
SMILE	EE
FROWN	
BIG SMILE	A
BIG FROWN	
OH	O
OOO	OOO
ANGER	
YUK	
FVBPM	FVBPM
ELVIS	

Take a look at hello_mouthless_3D.avi in chapter012 of the CD-ROM.

This shows the body movement but there is still no mouth movement. If it's any good the body language should suggest the dialogue being spoken.

Once the acting is sorted out it's time to sort out the mouths. The basic mouth shapes can be made using the mouth shapes that come with the scene.

To get the various mouth shapes either use these mouth shapes as they are (manipulate the tools in your program so that they are at 100%) or use mixtures of the mouth shapes to get the desired mouth shape. The OH mouth shape is the basic shape with no distortion on it.

mouth shut consonants

Use the mouth shape FVBPM.

the vowels

OOO

OOO as in pool. Use mouth shape OOO.

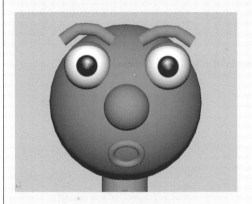

 O

O as in pot. A large oval shaped mouth with the jaw dropped. Use mouth shape OH.

AR

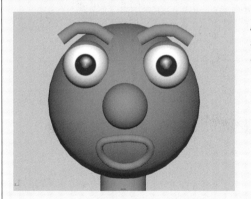

AR as in car is like O but has a slight smile to it. Use a mixture of OH and BIG SMILE.

A

A as in dad. A large but narrow smiling mouth shape. Have mouth shape BIG SMILE.

EH

EH as in wet. A large wide smiling mouth with the jaw dropped. Not quite as dropped as in O and A. Mix OH with BIG SMILE but don't have the mouth as open as AR.

EE

EE as in squeeze is still quite loud but the jaw will not be as open as the other loud vowels. It consists of a wide smile. Have a mixture of BIG SMILE and SMILE.

the quieter vowels and consonants

N, T, I, C, D, Y, Z, K, etc. Use almost any mouth shape you like as long as it in-betweens from one of the major mouth shapes to the next.

animating the mouths

Change the shape of the mouth depending on the mouth shape required for the given sound on the x-sheet. Each of the four programs has a slightly different way of chang-

ing the mouth shapes and setting keys, so follow the individual instructions for each program in Chapter 10.

There is also the facility to import the sound into each program. Have a look at 3DSMax_info, LightWave_info, Maya_info or XSI_info in chapter001 of the CD-ROM.

Take a look at hello_3D.avi to get an idea of what to do.

animation equipment suppliers

Cartoon supplies

All drawn animation supplies such as paper, peg bars, light boxes and pencils.

36125 Travis Ct
Temecula CA 92592
USA
909-693-5086
909-693-5087 (fax)
www.cartoonsupplies.com

Cartoon Colour Company, Inc.

9024 Lindblade Street
Culver City, CA
USA
90232-2584
310.838.8467
www.cartooncolour.com

Chromacolour UK

All drawn animation supplies such as paper, peg bars, light boxes and pencils.

Unit 5,
Pilton Estate
Croydon
CR0 3RA
UK
020 8688 1991
www.chromacolour.co.uk

Mawaha Engineering

All drawn animation supplies such as paper, peg bars, light boxes and pencils.

27 Picardy Road
Belvedere
Kent
DA17 5QH
UK
020 8311 7980
www.mawaha-engineering.com

Paper People

All drawn animation supplies such as paper, peg bars, light boxes and pencils.

Slade Farm
Morechard Bishop
Crediton
Devon
EX17 6SJ
UK
01363 85050
www.paperpeople.co.uk

index

Focal Press www.focalpress.com

Join Focal Press online
As a member you will enjoy the following benefits:

- browse our full list of books available
- view sample chapters
- order securely online

Focal eNews
Register for eNews, the regular email service from Focal Press, to receive:

- advance news of our latest publications
- exclusive articles written by our authors
- related event information
- free sample chapters
- information about special offers

Go to www.focalpress.com to register and the eNews bulletin will soon be arriving on your desktop!

If you require any further information about the eNews or www.focalpress.com please contact:

USA
Tricia Geswell
Email: t.geswell@elsevier.com
Tel: +1 781 313 4739

Europe and rest of world
Lucy Lomas-Walker
Email: l.lomas@elsevier.com
Tel: +44 (0) 1865 314438

Catalogue
For information on all Focal Press titles, our full catalogue is available online at www.focalpress.com, alternatively you can contact us for a free printed version:

USA
Email: c.degon@elsevier.com
Tel: +1 781 313 4721

Europe and rest of world
Email: j.blackford@elsevier.com
Tel: +44 (0) 1865 314220

Potential authors
If you have an idea for a book, please get in touch:

USA
editors@focalpress.com

Europe and rest of world
ge.kennedy@elsevier.com